HISTORIC PHOTOS OF
THE CHICAGO
WORLD'S FAIR

TEXT AND CAPTIONS BY RUSSELL LEWIS

TURNER
PUBLISHING COMPANY

The Horticulture, Choral, and Transportation buildings stand tall behind the intertwined pathways of the Wooded Island's Rose Garden.

HISTORIC PHOTOS OF
THE CHICAGO
WORLD'S FAIR

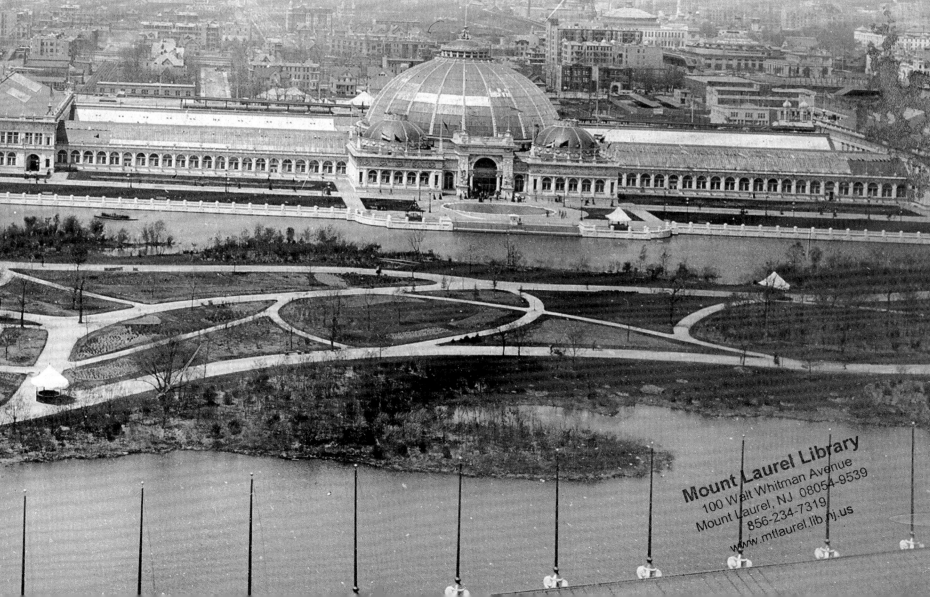

Turner Publishing Company
200 4th Avenue North • Suite 950
Nashville, Tennessee 37219
(615) 255-2665

www.turnerpublishing.com

Historic Photos of The Chicago World's Fair

Library of Congress Control Number: 2009939390

ISBN: 978-1-59652-569-6

Printed in China

10 11 12 13 14 15 16 17—0 9 8 7 6 5 4 3 2 1

Contents

Olmsted directed workers to create the Lagoon by dredging low areas of Jackson Park and using the fill to raise terraces that would support the fair buildings.

ACKNOWLEDGMENTS

This book, *Historic Photos of the Chicago World's Fair,* would not have been possible without the support and assistance of my colleagues at the Chicago History Museum. I am grateful to the staff of the Research Center, who helped with the logistics of retrieving, copying, and digitizing images from the collection. My thanks go to Debbie Vaughan, Michael Featherstone, Mathew Krc, and Benjamin Bertin. I am also indebted to the members of the Rights and Reproduction staff who guided me to various White City collections, gave me unfettered access to the images, and played a key role in the process of making digital files of the images in this book. Rob Medina, Bryan McDaniel, and especially Erin Tikovitsch were extremely helpful. Photographers John Alderson and Jay Crawford used the highest professional standards in their scanning and digital conversion efforts. Rosemary Adams lent her critical editorial eye to the text and improved both prose and grammar, and I am grateful to her for her kind assistance. Finally, Gary Johnson, President of the Chicago History Museum, has been supportive and encouraging of this book, and he has been an ongoing champion of the Museum's partnership with Turner Publishing. At Turner Publishing, I am grateful to Michael McCalip, Gene Bedell, Christina Huffines, and Todd Bottorff for all of their efforts to make the publication of this book possible.

This book is dedicated to Joseph H. Levy, Jr., Life Trustee of the Chicago Historical Society and extraordinary friend and supporter of the Chicago History Museum.

With the exception of touching up imperfections that have accrued over time and cropping where necessary, no changes have been made to the photographs. The focus and clarity of many photographs is limited to the technology and the ability of the photographer at the time they were taken.

PREFACE

The World's Columbian Exposition of 1893 was the most photographed event in the nineteenth century. Images of the Court of Honor, the Ferris wheel, and the Midway Plaisance remain fresh in our minds, providing critical documentation for historians and a visual record that satisfies the public's thirst to imagine the experience of visiting this world's fair. Equally important, fair organizers consciously used photography to create an official image of the fair and aggressively promoted it. The fair's Department of Publicity and Promotion (the Columbian Exposition was the first world's fair to have a formal publicity operation), which operated under the able leadership of Moses P. Handy, flooded the nation with photographic images of the exposition. Taking advantage of the growing popularity of publishing halftone photographic images in newspapers and magazines, Handy brilliantly engineered a mass distribution of official photographic images that shaped Americans' perceptions of the White City and encouraged them to attend the exposition.

The Columbian Exposition was also the first world's fair to restrict photography and grant an exclusive license for photography to one individual. Charles Dudley Arnold, commissioned by fair organizers to photographically document the construction of the fairgrounds, was granted with his partner Harlow D. Higinbotham the exclusive right for commercial photography on the fairgrounds. Amateur photographers, who had increased significantly in recent years thanks to the introduction of George Eastman's Kodak snapshot camera and inexpensive film and film processing, were eager to make their own photographs of the fair. They were charged $2 per day for fairground use of a handheld camera that made images no larger than four by five inches; the Streets of Cairo concession on the Midway charged an additional $1 to photograph there. Because tripods were forbidden, amateur photographers resorted to ingenious solutions to steady their cameras—placing them on tabletops, clamping them on the backs of chairs, and using railings or ledges. This combination of official photographs and amateur snapshots compose a remarkable visual record of the World's Columbian Exposition that not only captures the scale and grandeur of the exposition grounds and structures but also documents the visitors' experiences and point-of-view.

The Chicago History Museum has one of the nation's richest collections of materials on the World's Columbian Exposition, and its extensive holdings of photographs are a key aspect of these remarkable documents and artifacts. Including both official views of the fair by C. D. Arnold, photographs by William Henry Jackson made for Daniel H. Burnham, portraits by James J. Gibson, and amateur snapshots (by identified and unidentified photographers), the image collection provides a powerful reminder of the importance of this event in American history. However, the photographs gathered in this volume can give the reader only a hint of what visitors experienced in the White City. The scale of the fairgrounds, the amazing array of events and programs organized daily on the fairgrounds, and the personal experiences of visitors make it impossible for any book to comprehensively document the Columbian Exposition as a place and as an event. While much of the fairgrounds is photographically documented in great detail, other parts are not, and thus despite all we know about the White City, complete knowledge about some aspects of the fair remain elusive and await future research.

Finally, this book builds on the wonderful body of scholarly works that first appeared in the 1970s and have continued to mine this rich moment in Chicago's and America's history.

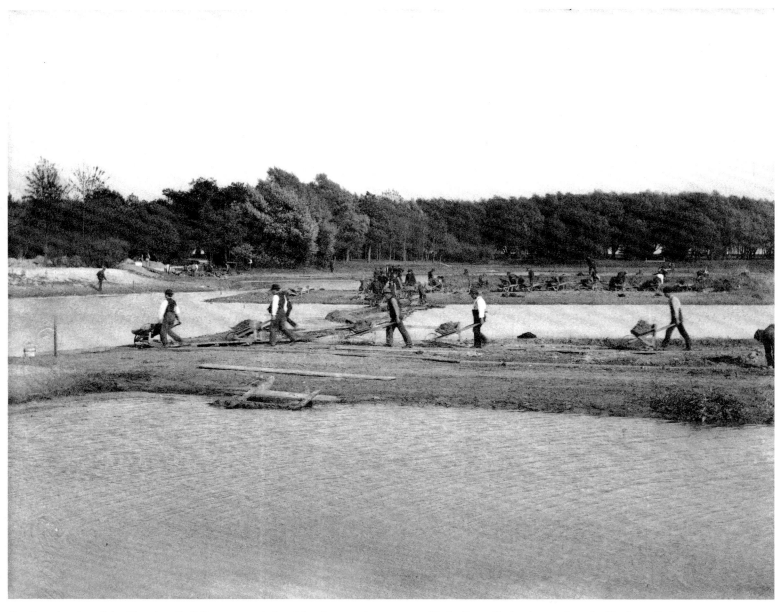

Grading the site of the Fine Arts Building proceeded quicker because it was part of Lake Front Park, the north end of Jackson Park that had already been improved.

BUILDING THE WHITE CITY

Congress selected Chicago in April 1890 to host the World's Columbian Exposition, and within months key decisions regarding its location and basic plan had been made. Daniel H. Burnham, chief of construction, and his partner, John Root, supervising architect, worked with landscape architects Frederick Law Olmsted and Henry S. Codman to transform the swampland and sand dunes of Jackson Park into a compelling design. Stretching across 685 acres, the plan called for a Court of Honor formed by a grand basin that was surrounded by five major exposition halls. To the north sat a lagoon with a large island connected by a system of canals and waterways. The goal was to create a vision of harmony and beauty through an orderly arrangement of architecture, nature, and art.

Burnham selected five East Coast architects to design the Court of Honor buildings and five Chicago firms to design the other structures. The scale of the project was daunting—nothing less than the erection of an entire city—and the engineering and architectural challenges could be met only because the buildings were temporary structures. Drawing on their expertise in wood and steel framing, Chicago workers erected sturdy structures in a minimum amount of time. The exteriors were coated with staff, a plaster-like material that allowed for the massive classical architectural edifies while hiding the steel and wooden trusses and columns. Fair directors commissioned the nation's most talented artists to create murals, sculptures, and fountains to complement the buildings and the landscaping, with the aim of giving visitors the most powerful artistic experience ever conceived.

Tens of thousands of Chicagoans joined the exposition dedication and celebration on October 21, 1892. The fairgrounds finally opened on May 1, 1893, but with unfinished buildings and landscaping. Visitors could choose among lake steamers, railroads, or coaches to reach the fairgrounds.

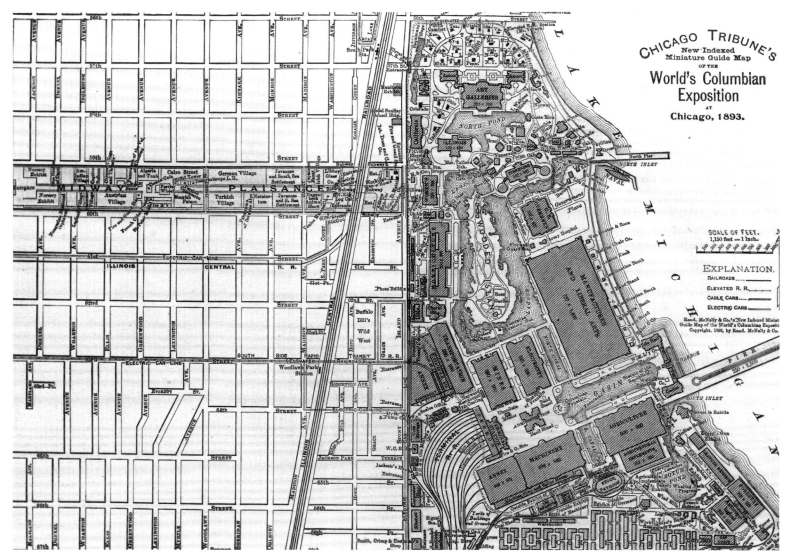

The exposition grounds encompassed 685 acres, just a little over one square mile. The major buildings were aligned with three major bodies of water: Lake Michigan, the Lagoon at Wooded Island, and the North Pond.

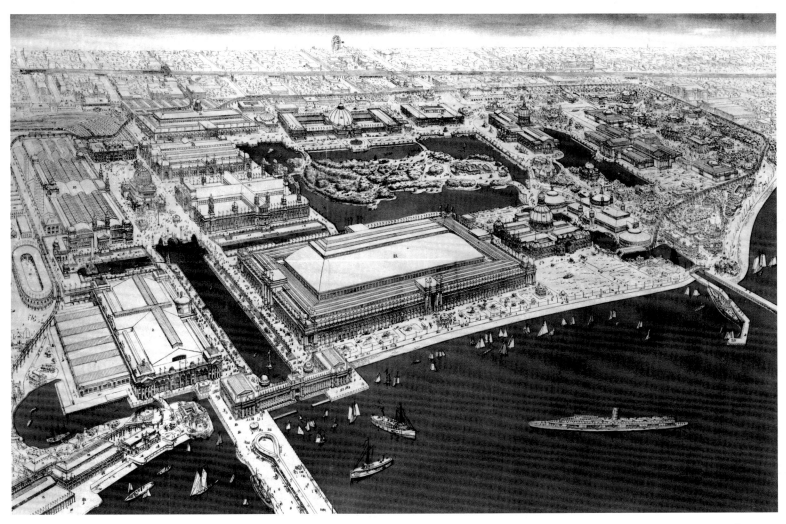

This faithful bird's-eye view reveals the scale of the fairgrounds and buildings spread across seven key areas: the Court of Honor, the Lagoon, government buildings, state buildings, the Midway Plaisance, the southeastern section, and the southwestern section.

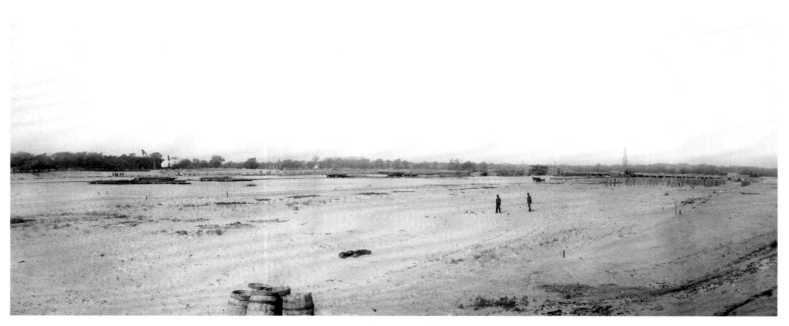

This photograph of the Manufacturers and Liberal Arts Building site was taken in October 1891. Rather than eliminate the plentiful water on the site, Frederick Law Olmsted made it a main feature and theme of the exposition, establishing a network of basins, lagoons, canals, and ponds that linked the different parts of the grounds.

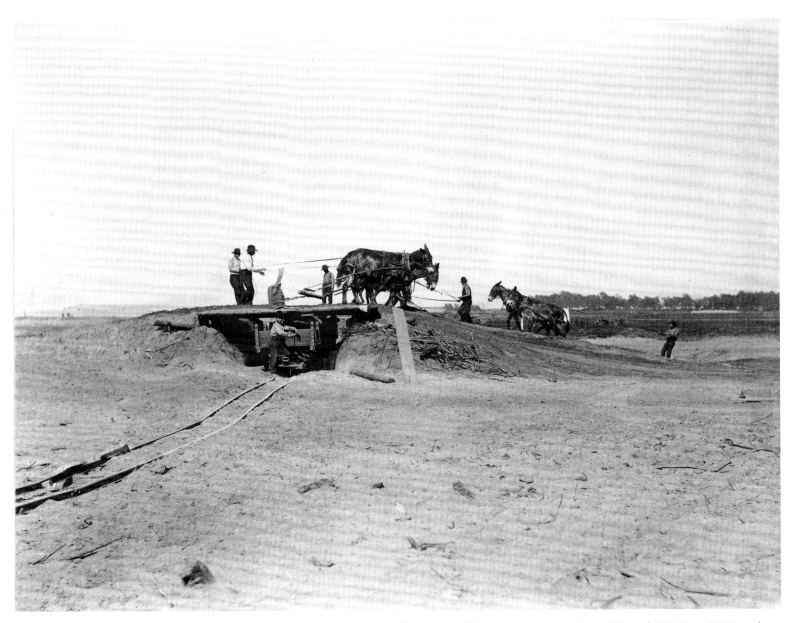

Work on the fairgrounds began in June 1891 with 5,000 to 6,000 workers.

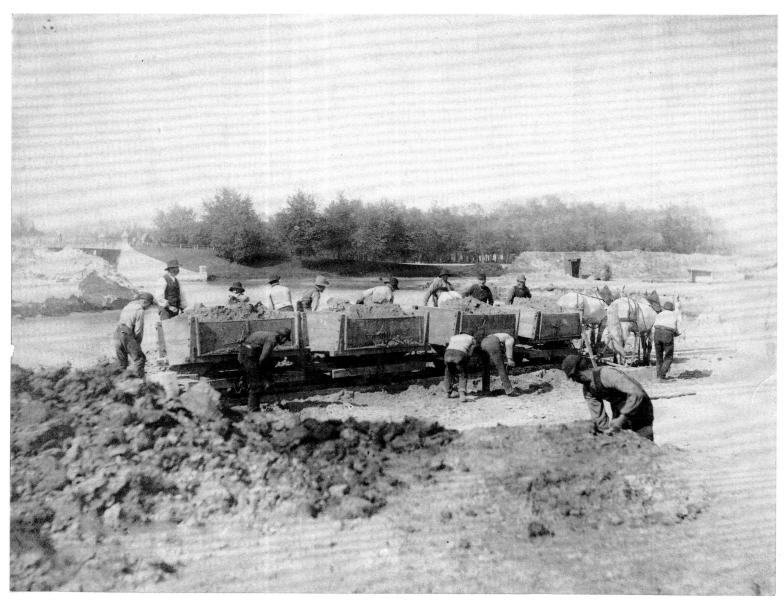

Construction began with the massive movement of earth and the grading and filling of land. By the end of construction, workers had moved more than 1.2 million cubic yards of earth at a cost of $500,000.

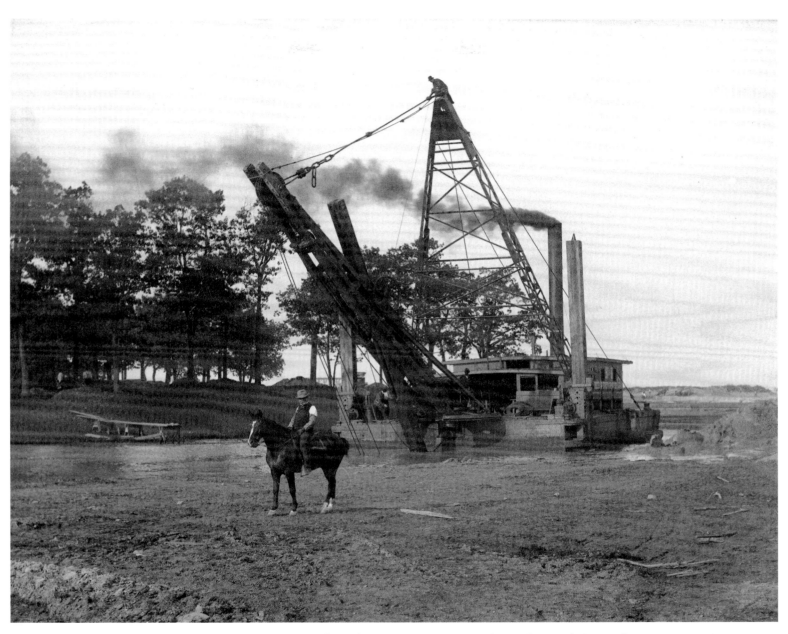

Dredging to form the Lagoon was a priority during the initial phases of construction in August 1891.

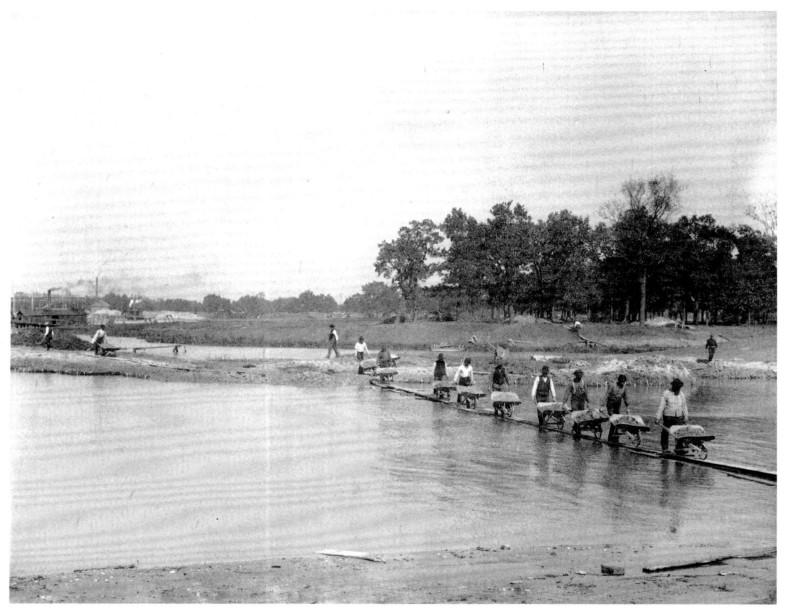

Burnham, Root, Codman, and Olmsted's exposition plan made landscape design a key component of transforming the Jackson Park site. Root's role as supervising architect, however, was short lived due to his sudden death in 1891.

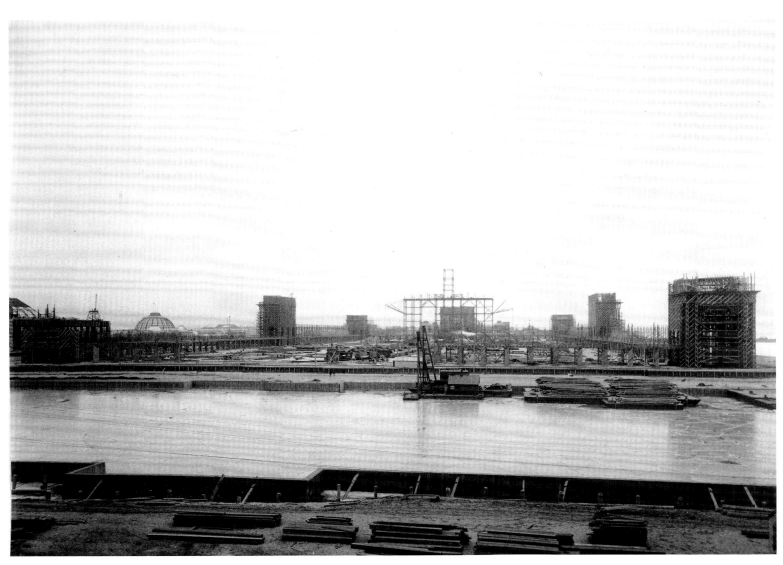

By 1892, the skeletal silhouette of a city emerged in Jackson Park. This view north from the Agriculture Building across the Great Basin shows the Manufacturers and Liberal Arts Building, designed by George Post, and the dome of the Horticulture Building.

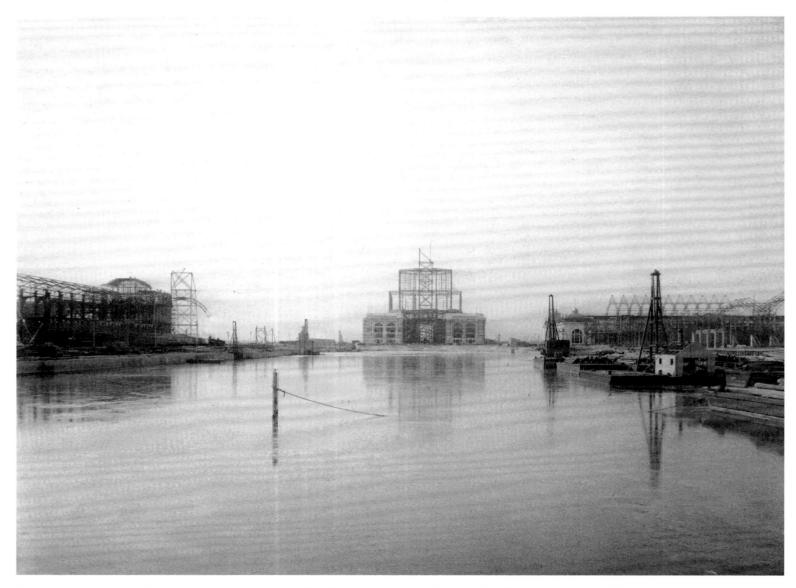

Looking west across the Great Basin are the Agriculture Building, left, the Administration Building, center, and the Electricity Building, right, under construction. The Administration Building was designed by prominent architect Richard Morris Hunt, also known for designing the Great Hall of the Metropolitan Museum of Art and the pedestal of the Statue of Liberty.

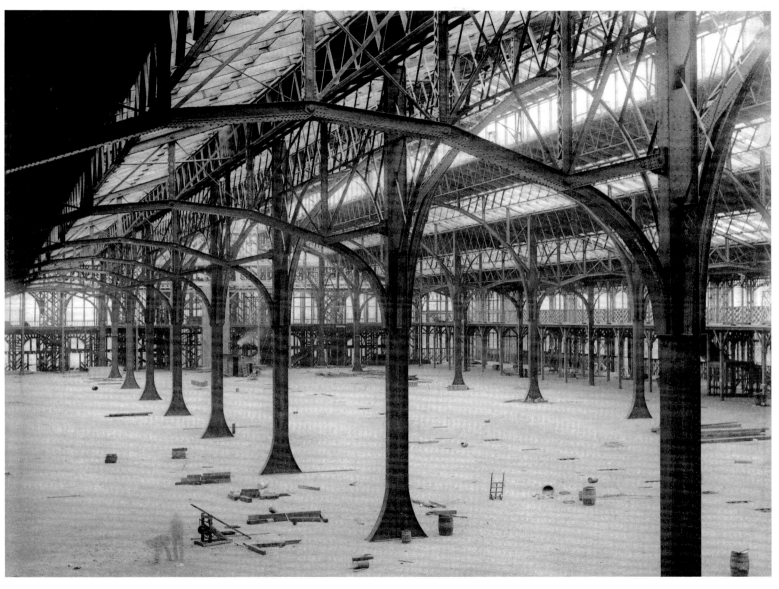

The interior of the Mines and Mining Building shows the structure's steel trusses. The ghostly image of the workers (left) give a sense of scale of the framing and the building.

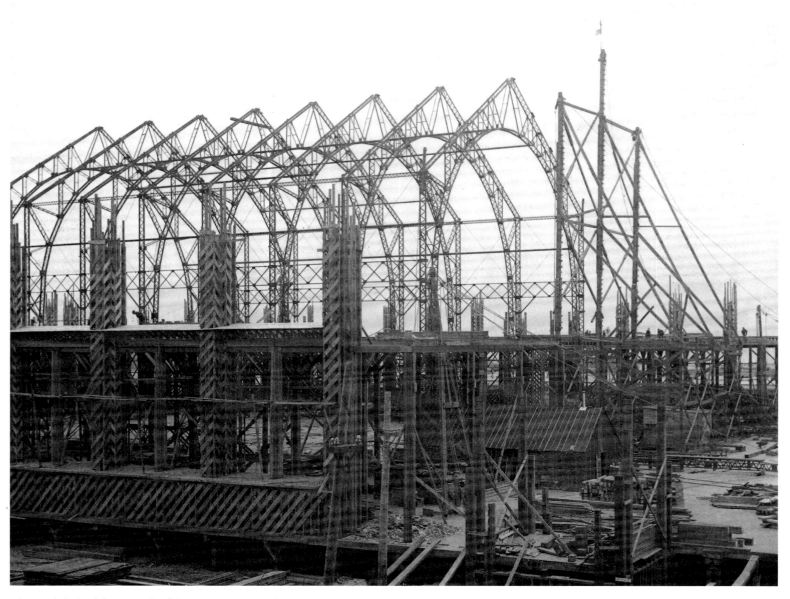

The steel skeletal framework of the Electricity Building dominates the view looking east from the Mines and Mining Building, December 1891. Constructing the framing of the buildings was hazardous work, and progress was delayed by bad weather and strikes.

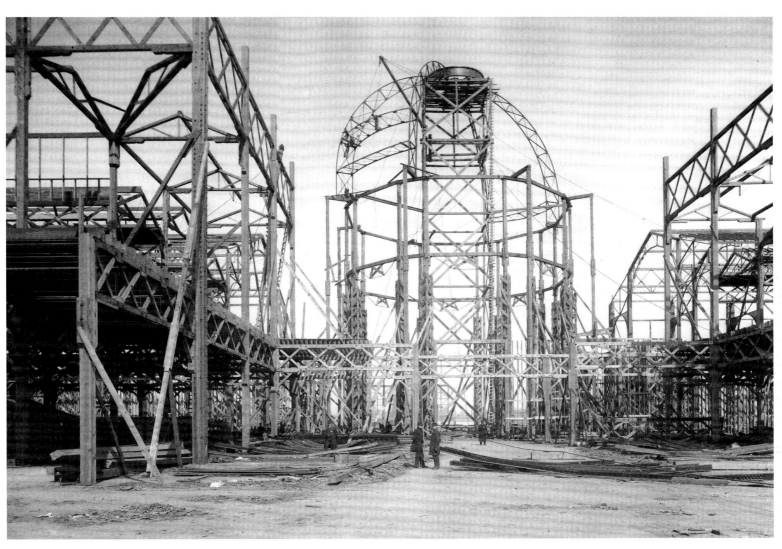

The central dome of the Agriculture Building is recorded in this view. Artist G. W. Maynard was commissioned to decorate the colonnades, porticos, and the dome of the building. The architects specified wooden framing to support most of the building.

Constructing the Manufacturers and Liberal Arts Building was a Herculean task. The plaster classical facade masked the steel skeleton, which was the foundation of modern architecture and construction methods.

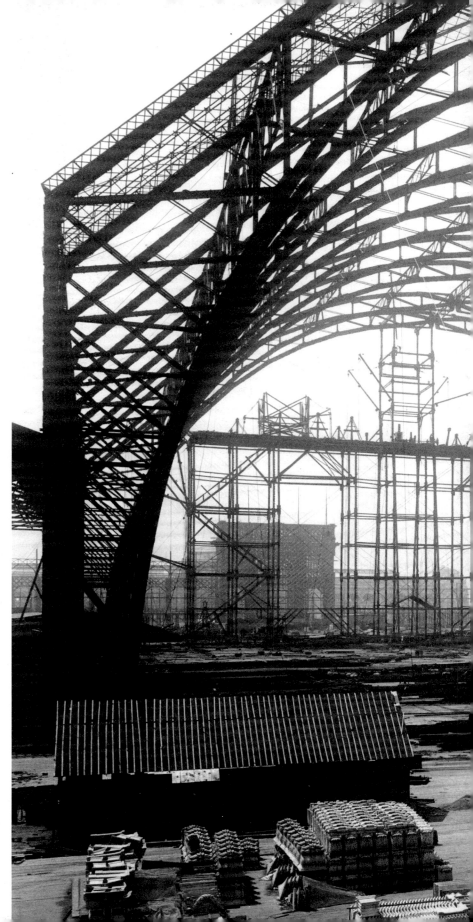

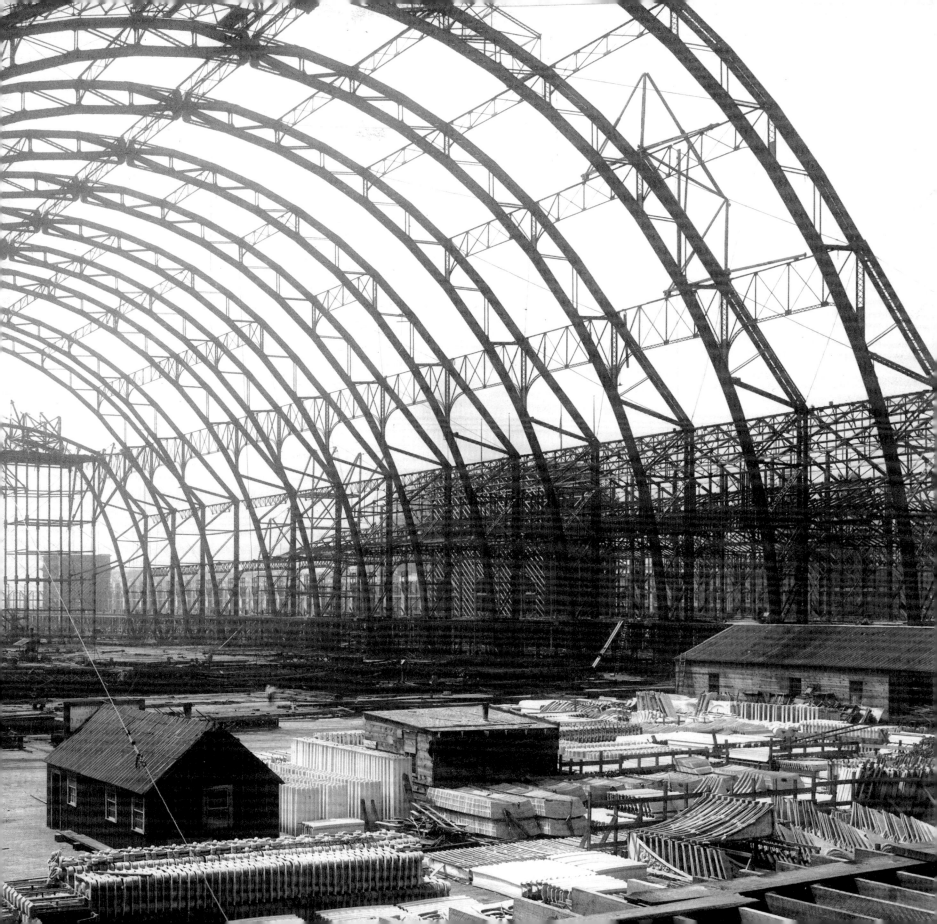

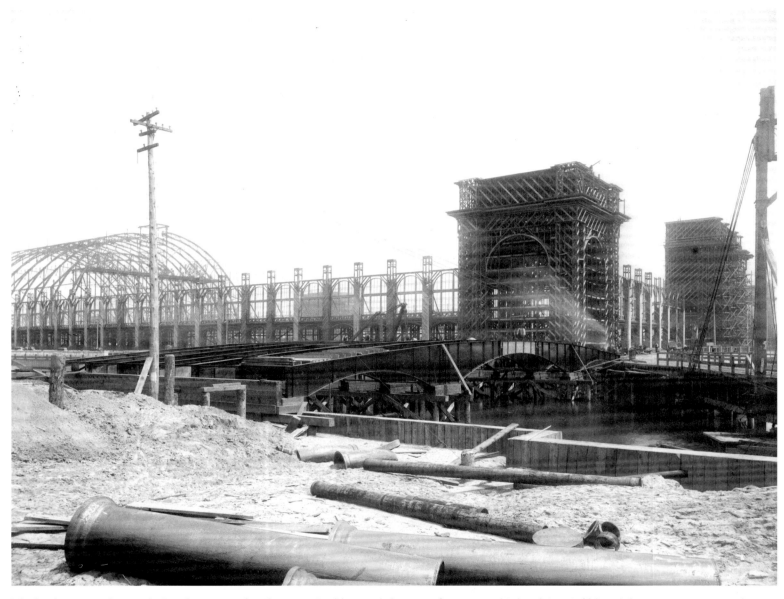

The bridge across the North Canal connects the Electricity Building and the Manufacturers and Liberal Arts Building. This photograph of the construction site was taken on June 4, 1892, a few months before the fair's dedication ceremony.

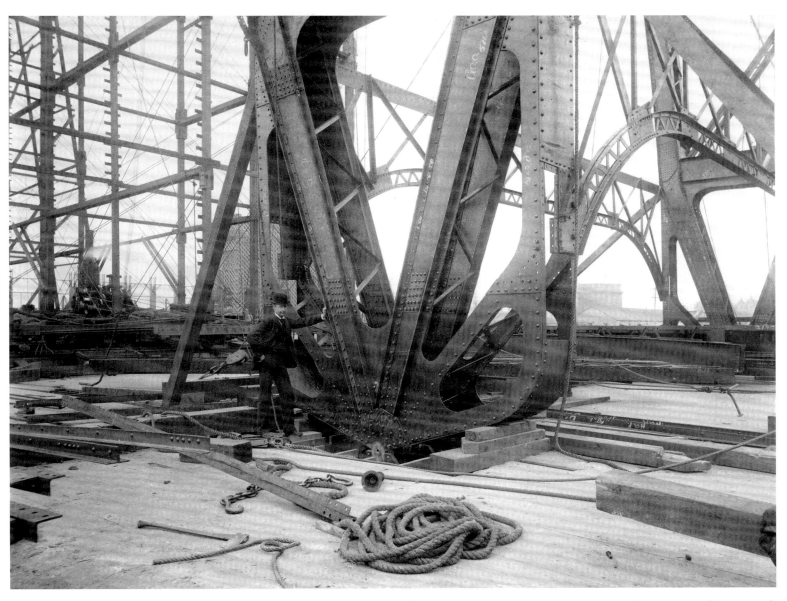

This suited man leans against the massive foot of one of the steel arches in the Manufacturers and Liberal Arts Building, March 26, 1892. Chicago's familiarity with steel-frame construction was a key factor in erecting the exposition structures quickly.

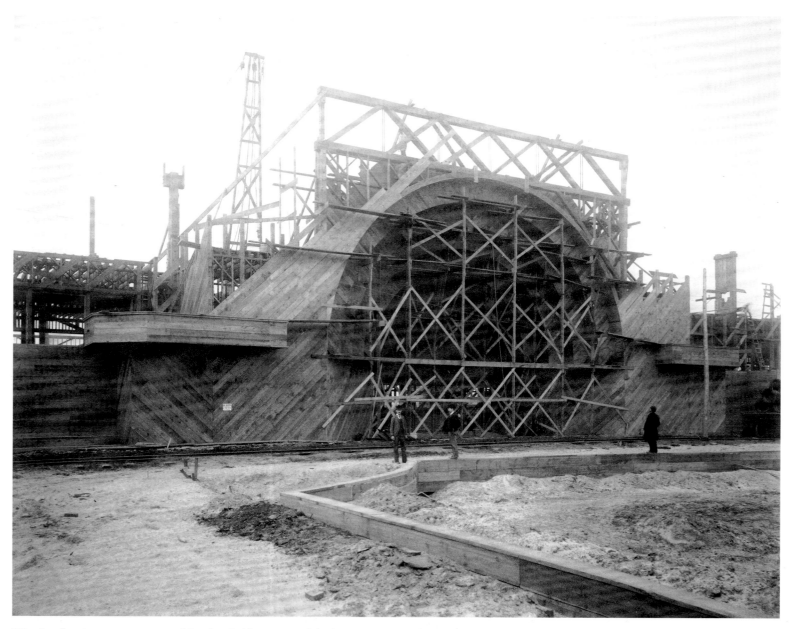

Wooden framing was constructed for the Golden Door of the Transportation Building. Architect Louis Sullivan designed the Transportation Building with modern elements and several colors, making the building stand out as the only structure of its kind in the White City.

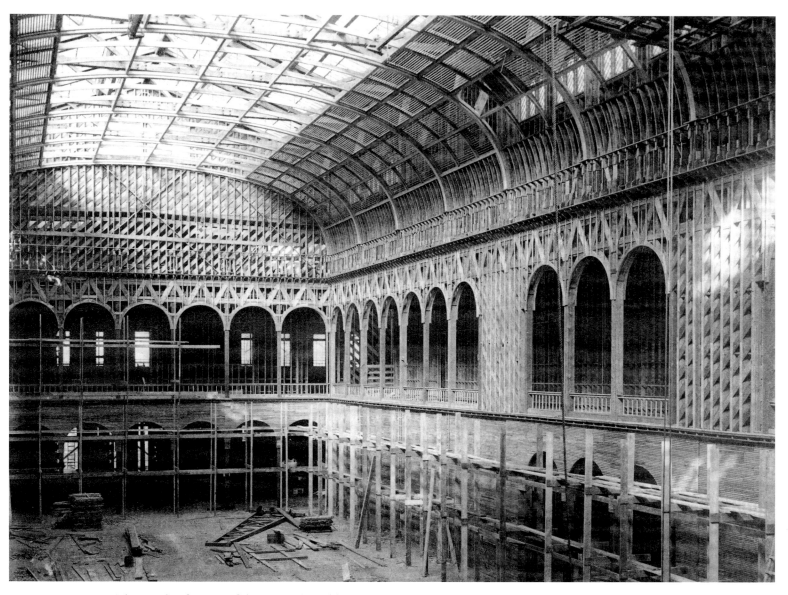

The wooden framing of the Woman's Building is pictured on March 30, 1891. The Woman's Building, one of the first structures enclosed at the fair, was designed by 22-year-old Sophia Hayden, the first American woman to receive a degree in architecture. Hayden was paid a meager $1,000 to complete her design.

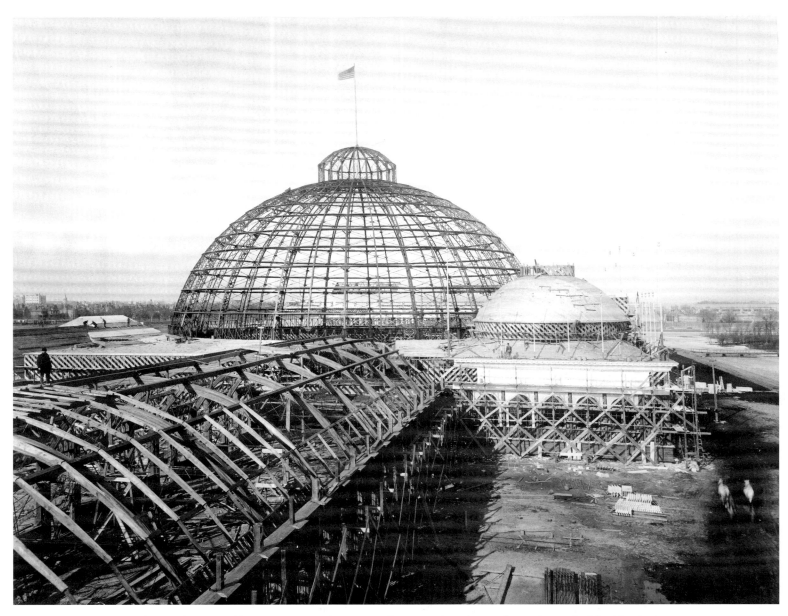

Construction continued during the unusually severe winter of 1892. Workers complete their tasks on the roof of the Horticulture Building on February 5, 1892.

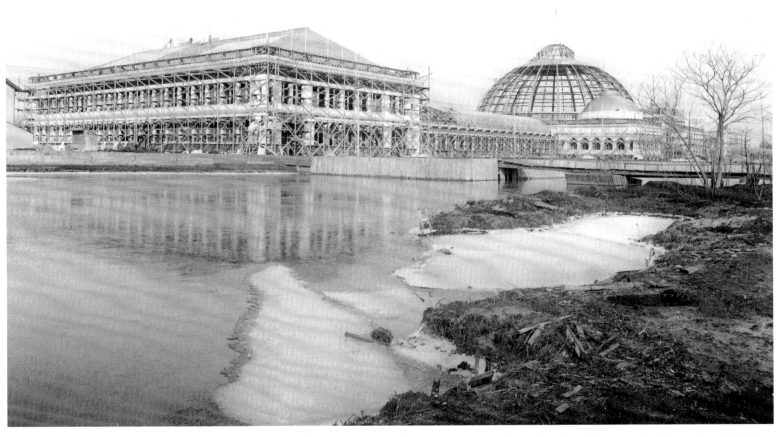

This view from the Wooded Island depicts exterior work on the plaster facade of the Horticulture Building.

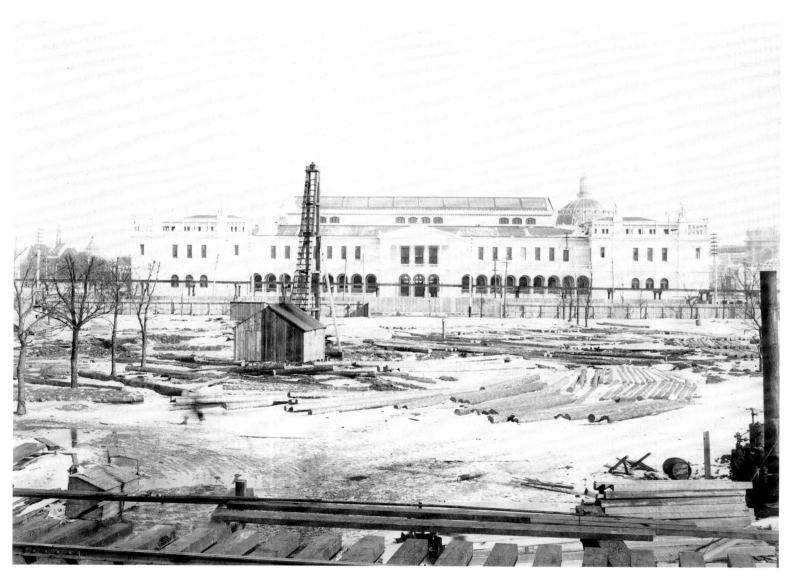

This winter view of the western facade of the Woman's Building was recorded on February 12, 1893, a few months before the fair opened. The Italian Renaissance–style building housed 7,000 books provided by various states and countries.

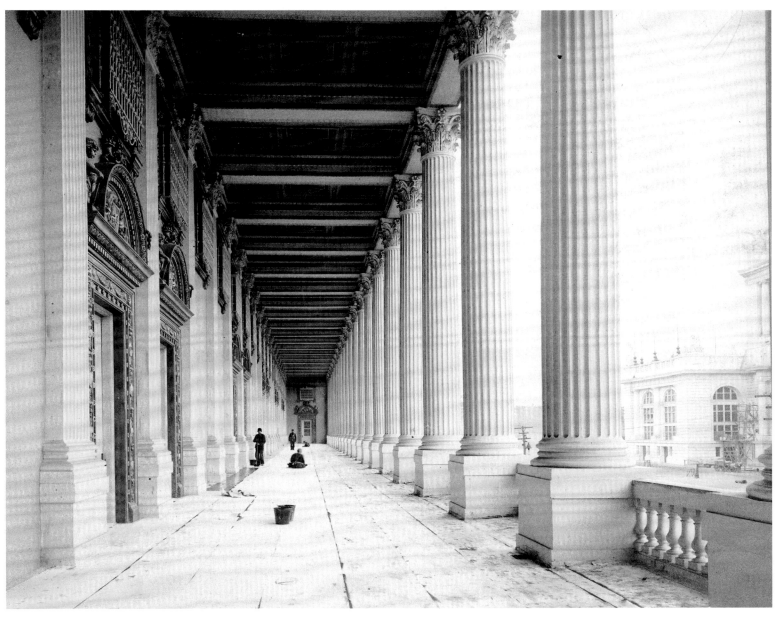

Workers apply finishing touches to the loggia of the Machinery Building. The Administration Building is visible to the right. The $1.2 million Machinery Building contained the power plant for the entire fair.

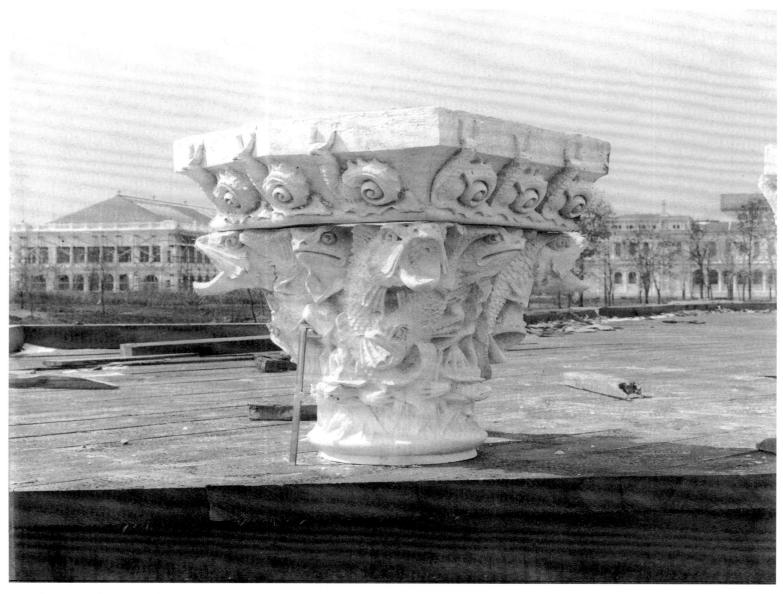

The plaster capital designed for the Fisheries Building is seen here on March 15, 1892. The use of cast architectural elements gave architects and builders great flexibility in the design and construction of exposition structures.

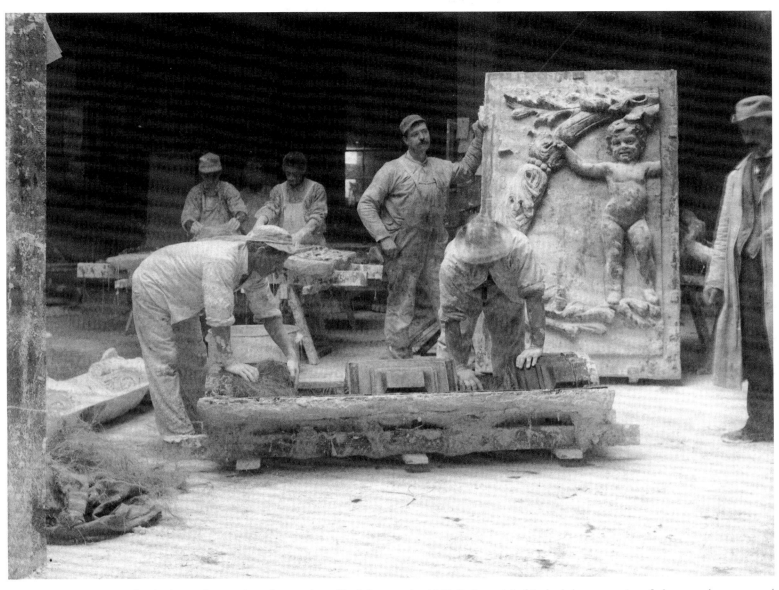

Staff, which was first used on the exterior of buildings at the 1889 Paris world's fair, had the properties of plaster and cement and hardened into an ivory-like surface resembling marble. Workers used gelatin molds to make multiple copies of bas-relief panels.

This sculptural model was made for the Transportation Building. Artists did much of the modeling work for sculpture and ornamental pieces in the Forestry Building.

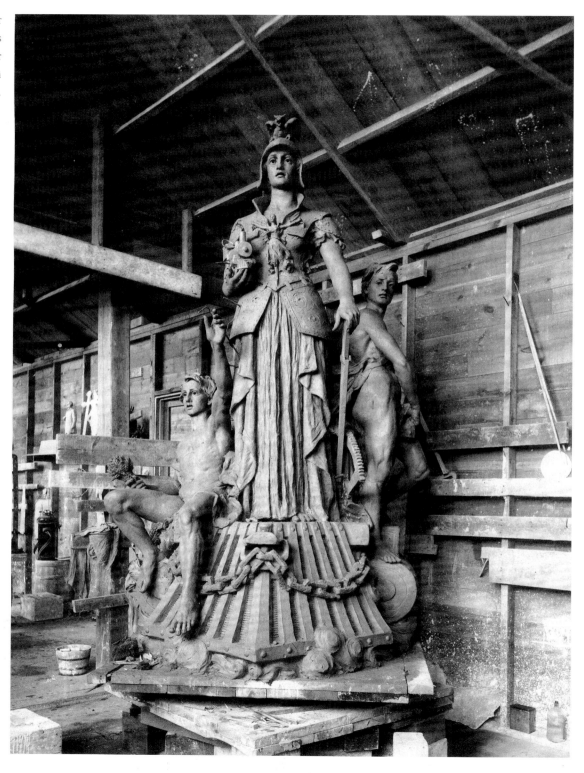

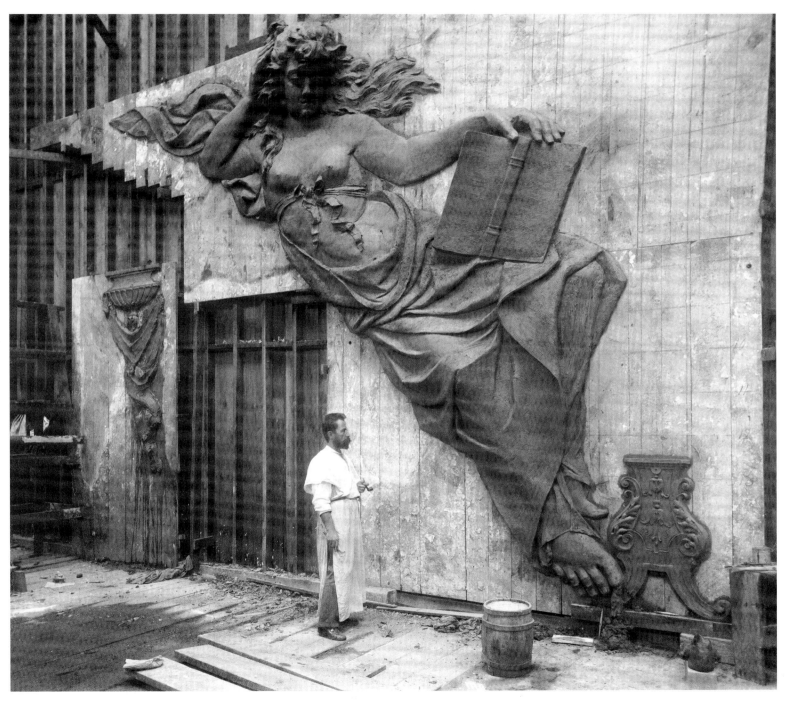

Charles Dudley Arnold photographed this model for a sculptural ornament for the Electricity Building, along with its sculptor, on August 27, 1891. C. D. Arnold was designated the official photographer of the exposition.

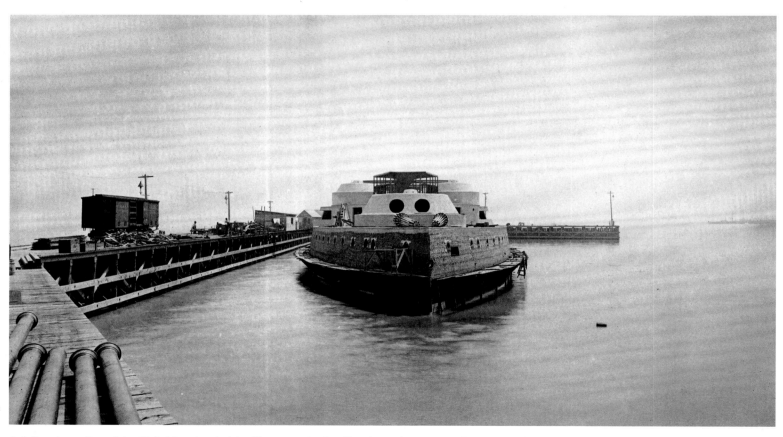

A full-scale replica of the U.S. Navy battleship *Illinois* was built of bricks and cement and was part of the Naval Pier exhibit near the North Pier.

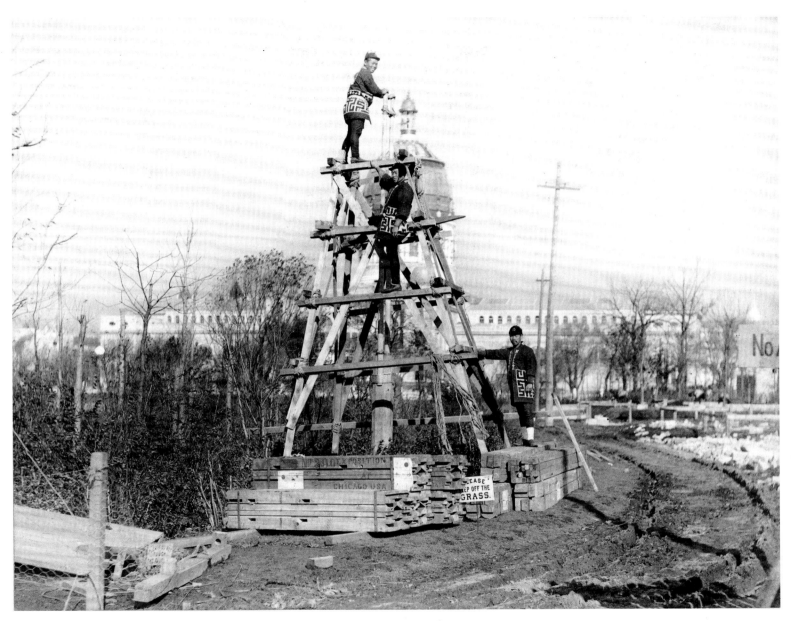

The Ho-o-den or Phoenix Palace was a replica of the famous Ho-o-den temple, Nji, near Kyoto, Japan. Japanese government architect Kuri Masamichi designed the structure and shipped numbered parts to Chicago for assembly. Japanese craftsmen from Okura & Company reassembled it at the north end of the Wooded Island, one of the few buildings allowed on the island.

George Washington Ferris did not begin building his revolving wheel until January 1893, during one of Chicago's coldest winters. The towers and axle were in place by late March, but the rest of the structure and the hanging cars were not complete until June 21.

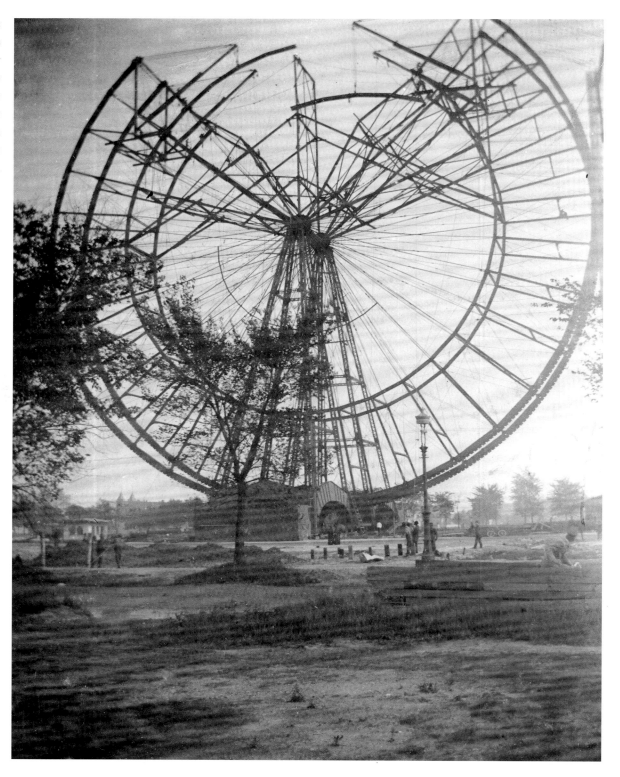

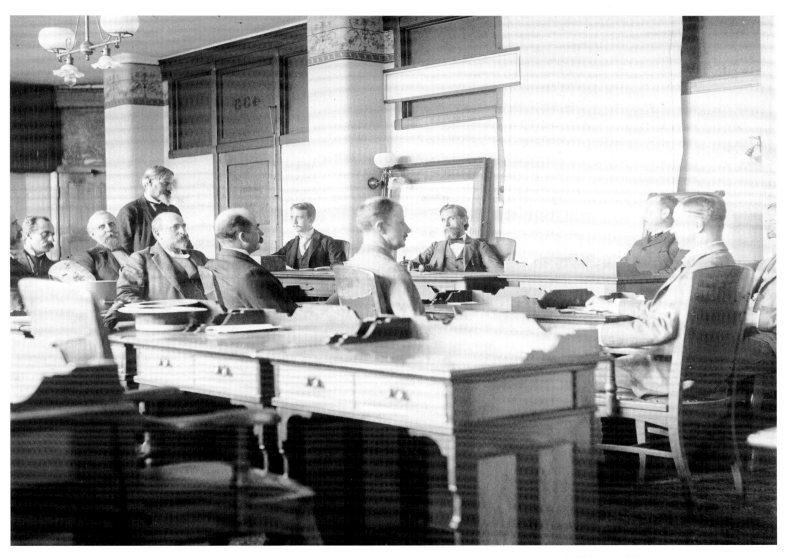

A meeting takes place among the world's fair officials, including George R. Davis (standing), director general of the World's Columbian Commission; and Harlow N. Higinbotham (seated facing, right of center), president, World's Columbian Exposition.

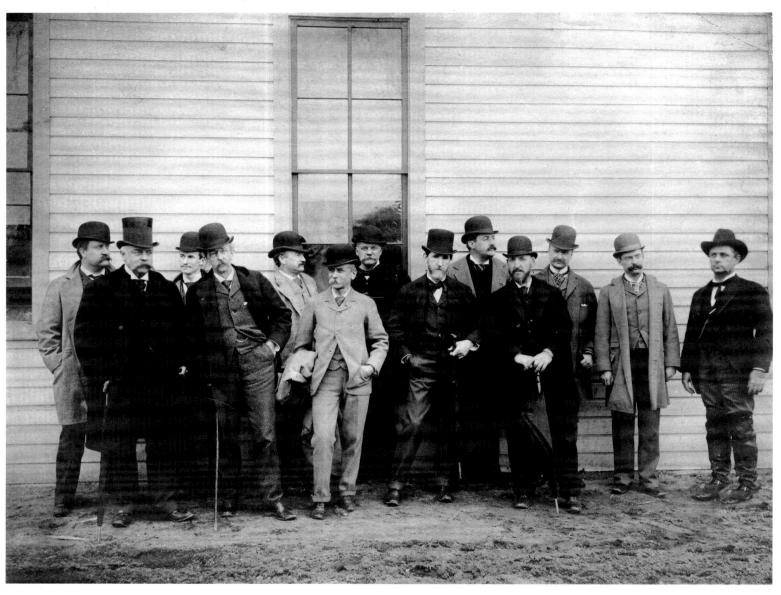

Posing are members of the World's Columbian Exposition staff (left to right): Daniel H. Burnham, director of works; George B. Post, architect of the Manufacturers and Liberal Arts Building; M. B. Pickett, secretary of works; Richard Van Brunt, co-architect of the Electricity Building; Francis D. Millet, director of decoration; Maitland Armstrong, artist; Colonel Edmund Rice, commandant of Columbian Guard; Augustus St. Gaudens, advisor on sculpture; Henry Sargent Codman, landscape architect; George W. Maynard, muralist for the Agriculture Building; Charles F. McKim, architect of the Agriculture Building; Ernest R. Graham, assistant director of works; and Dion Geraldine, general superintendent.

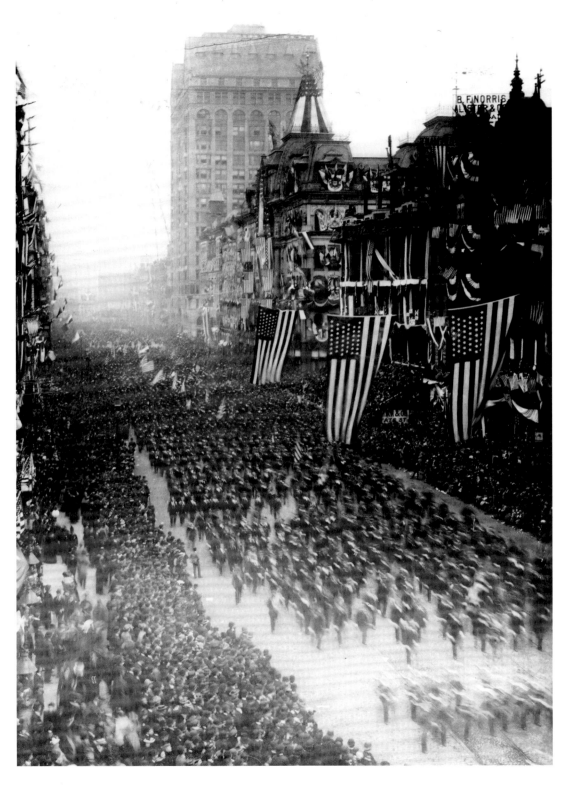

On October 20, 1892, the day before the official dedication of the World's Columbian Exposition, more than 100,000 people joined chief marshall Major General Nelson A. Miles as part of a grand civic and military parade marching down State Street, which was festooned with American flags and patriotic decorations.

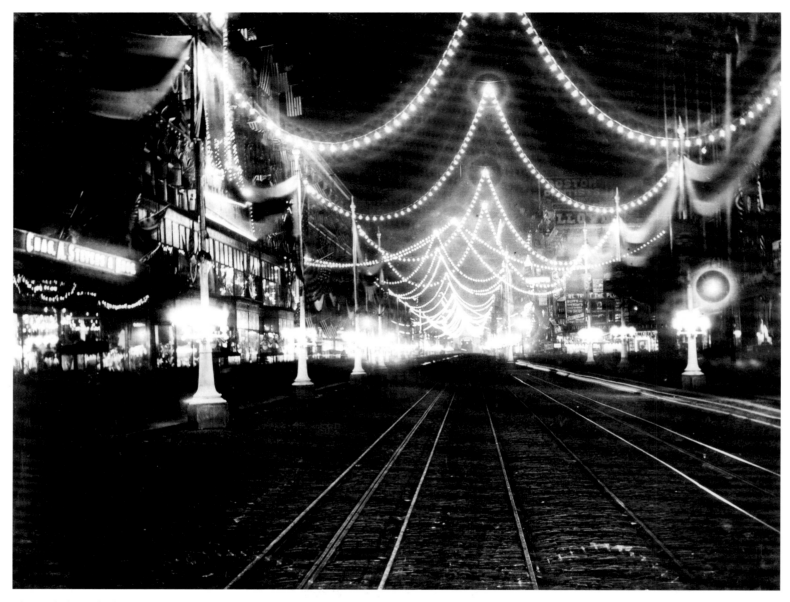

Electric lights, which would become a signature feature of the world's fair, illuminated State Street at night during the dedication festivities, contributing to the feeling of pride and patriotism that Chicagoans shared.

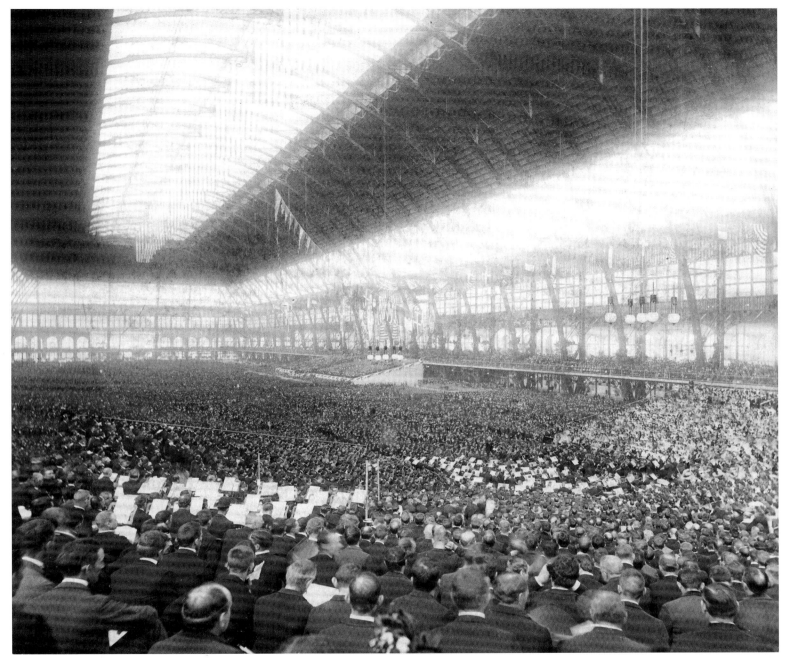

Tens of thousands of Chicagoans crammed into the yet unfinished Manufacturers and Liberal Arts Building for the October 21 dedication ceremony. The audience was entranced as a 5,000-person chorus performed the "Columbian Hymn" and accompanied an oration of Harriet Monroe's "Columbian Ode."

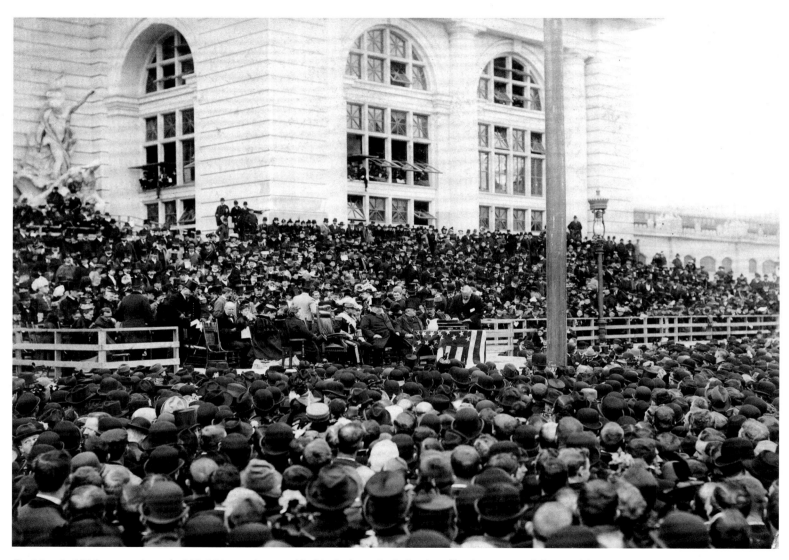

On May 1, 1893, approximately 200,000 people assembled in Jackson Park for the official opening of the World's Columbian Exposition. President Grover Cleveland, shown standing in front of the Administration Building, pressed an electric key that started the water fountains and opened the fair, although many areas remained unfinished.

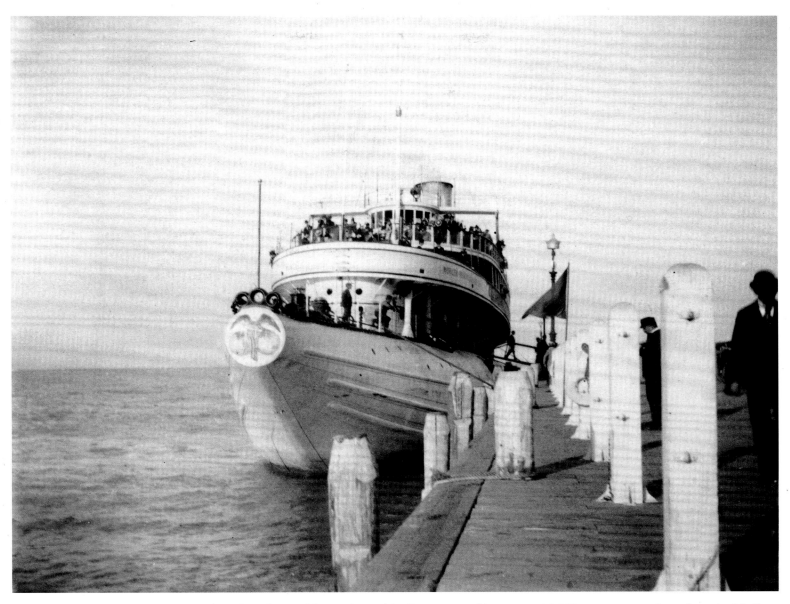

For a 25-cent roundtrip fare, the World's Fair Steamship Company could transport 15,000 passengers per hour from the lakefront pier between Monroe and Van Buren streets to the exposition pier opposite the foot of 63rd Street.

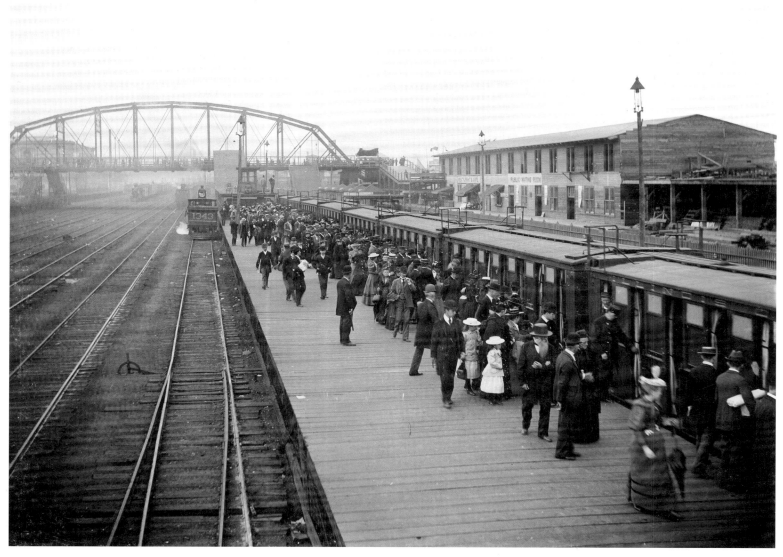

The Illinois Central Railroad offered special world's fair service every five to ten minutes from the Van Buren Street pier to the exposition ground for a fare of 10 cents each way. The Illinois Central claimed they could handle 50,000 passengers an hour. The bridge across the tracks connected to the pier for steamship connections.

Beauty and Grandeur Unrivaled

Most visitors to the fairgrounds were initially awestruck by the buildings: they were magnificent, and they were huge. But once they adjusted to this style and magnitude, the harmonious and formal arrangements of buildings proved to be the more powerful and enduring lesson for the public. The scale of the buildings and their white facades powerfully reinforced this vision of unity, harmony, and beauty. The Court of Honor—which included the Great Basin and the Peristyle, and the Agriculture, Machinery, Administration, Mines and Mining, Electricity, and Manufacturers and Liberal Arts buildings aligned along a northwest–southwest axis—was a visual and emotional focal point for the fair that forcefully reflected the ideology of a unified American culture and shared sense of progress.

The Lagoon was a second key feature on the fairgrounds. Unlike the Court of Honor plan, the Lagoon area followed an irregular pattern that mirrored the natural landscape features of Jackson Park along a north–south axis. The buildings near the Lagoon did not have the same strict limitations on height, width, color, and classical style that gave the Court of Honor its formal unified character, and the architects were allowed more freedom in their designs. The Lagoon's Wooded Island, which Olmsted had envisioned as a place of tranquil nature in the midst of man-made beauty and grandeur of the fair, framed how the surrounding buildings were seen—a vision unifying art, architecture, and nature.

The state buildings were clustered at the north end of the fairgrounds near the Fine Arts Building, which was one of the few permanent structures built and considered by many the finest example of architecture. The foreign buildings, which were mostly scattered south and west of the Fisheries Building, reflected national architectural styles and traditions, a contrast to the unified design of the Court of Honor.

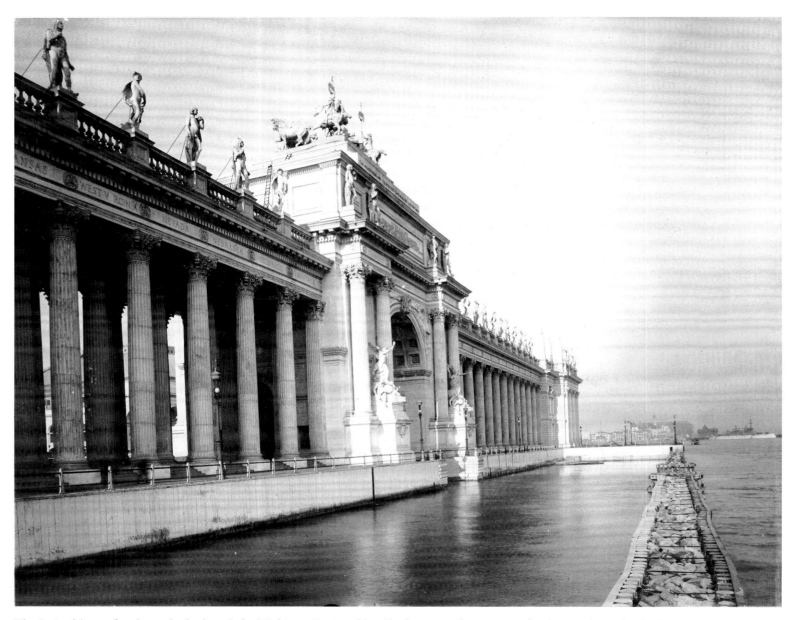

The Peristyle's east facade was built along Lake Michigan. Designed by Charles Atwood, it was 500 feet long and 150 feet high with a triumphal arch in its center. The Park Haven Pier, which stood at the south end of the Peristyle and jutted almost half a mile east into the lake, was one of the key points of arrival for visitors traveling to the fairgrounds by steamship.

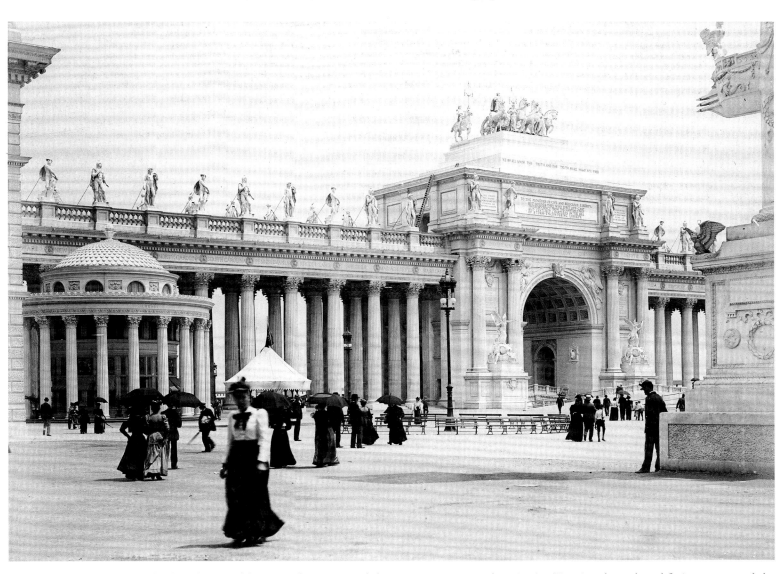

The 48 columns of the Peristyle represented the American states and territories. Topping the arch and facing west stood the *Columbus Quadriga*, a heroic sculpture by Daniel Chester French and Edward C. Potter that depicted Columbus standing in a chariot with four horses led by women. The Temple of Vesta, which sold chocolate bonbons, is at left.

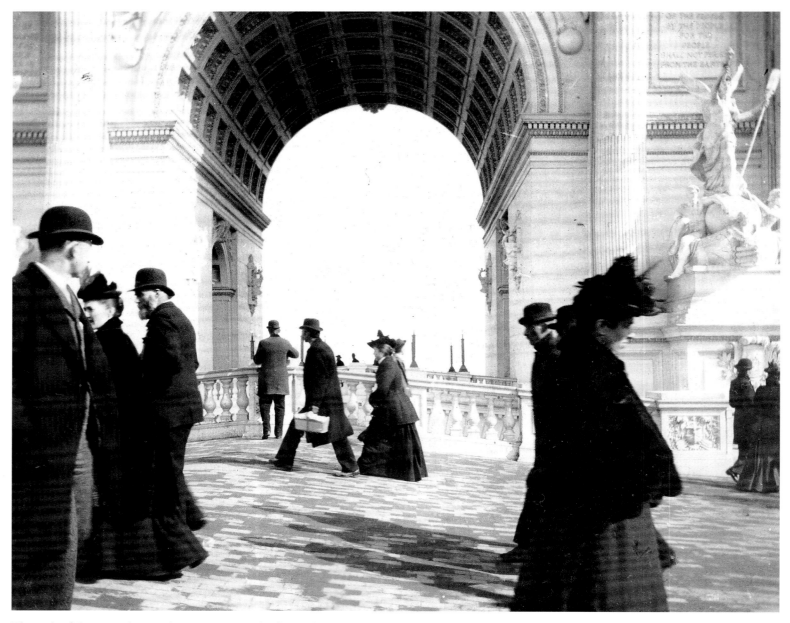

The arch of the Peristyle served as a gateway to the fair and a physical link between the exposition's waterways and Lake Michigan, a symbolic gesture to Columbus's voyage.

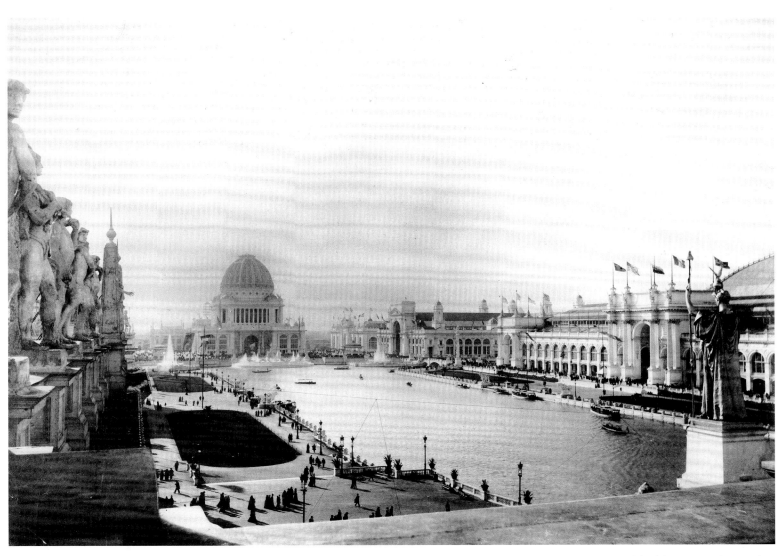

The Great Basin was the center of the Court of Honor. The uniformly scaled and classically inspired buildings were designed in relationship to each other, creating a balanced, harmonious, and orderly arrangement of architecture. For many Americans who typically lived in towns and cities built haphazardly, the Court of Honor was their first encounter with a powerfully designed grouping of structures, and they were stunned.

Daniel Chester French's imposing *Republic* rose out of the Great Basin to a height of 100 feet. A colossal work whose scale was accentuated by its gilding, the *Republic* forcefully expressed the ideology of American culture and progress.

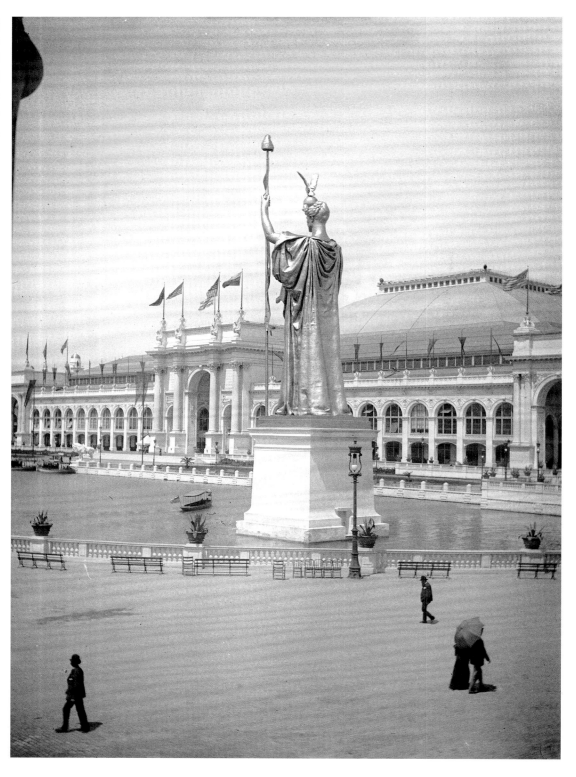

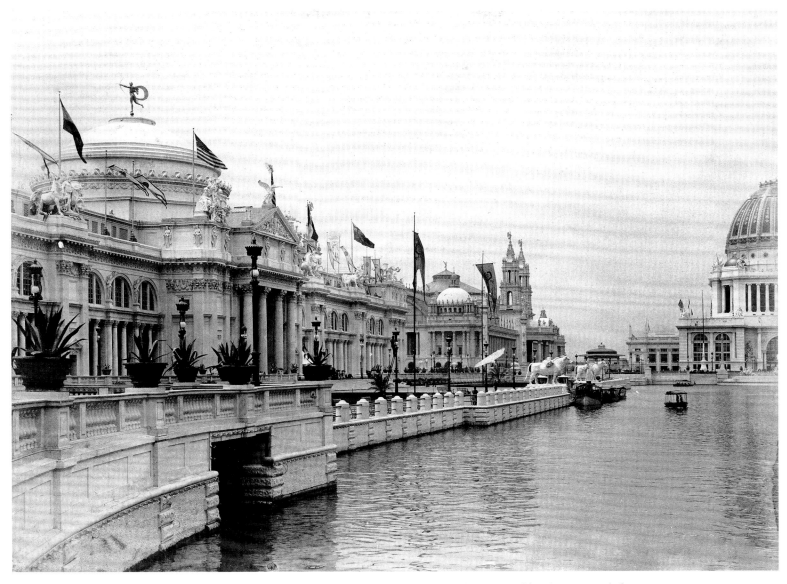

The Agriculture Building fronted nearly the entire length of the Great Basin on the south. Designed by the New York firm McKim, Mead & White, it measured 500 by 800 feet. Featuring Diana, the goddess of the hunt, on its dome, the Agriculture Building was the only structure at the fair that was systematically designed in one architectural style—Roman.

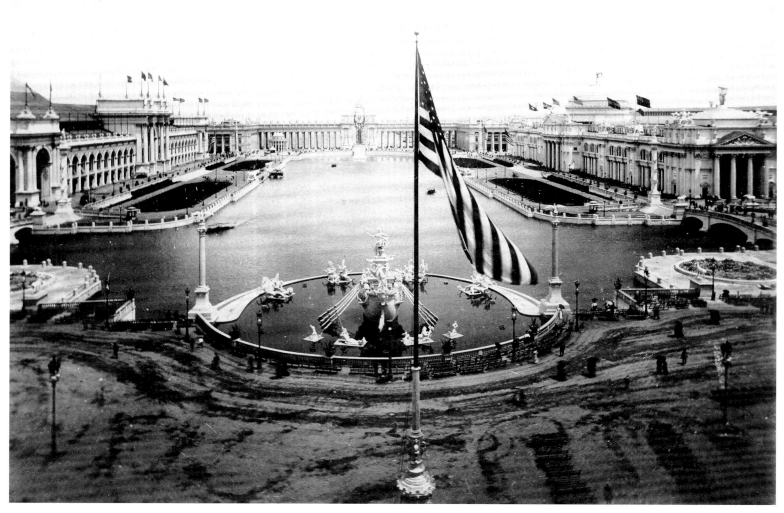

In this view from the Administration Building, the Great Basin opens east toward the Peristyle. The symmetrical balance of the height and building mass with the interplay of classical styles created a breathtaking vision of urban possibility and inspired dreams of new kinds of cities.

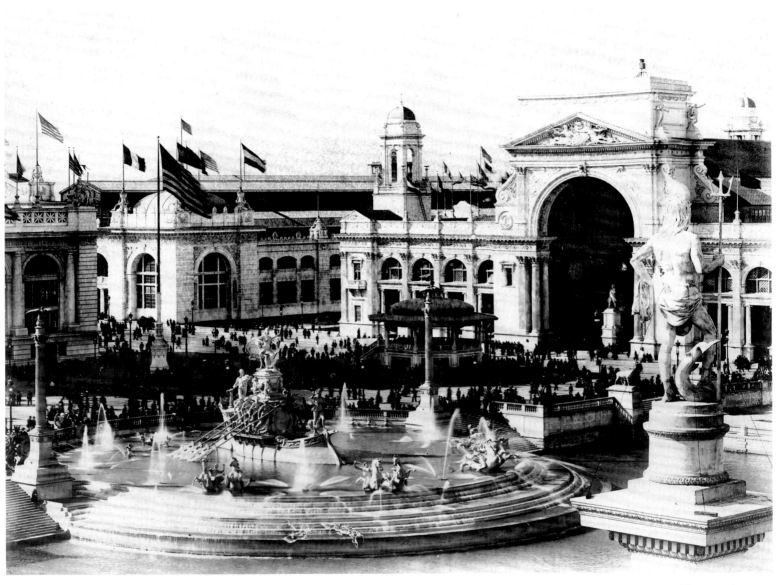

The *Columbian Fountain* anchored the western tip of the Great Basin directly in front of the Administration Building. In this view looking northwest, the Electricity and Mines and Mining buildings and a bandstand serve as a backdrop. Created by Frederick William MacMonnies, the fountain was an allegory of progress, with *Time* steering the barge, *Victory* standing in the prow, and *Columbia* seated in the middle on a throne with her feet resting on a globe.

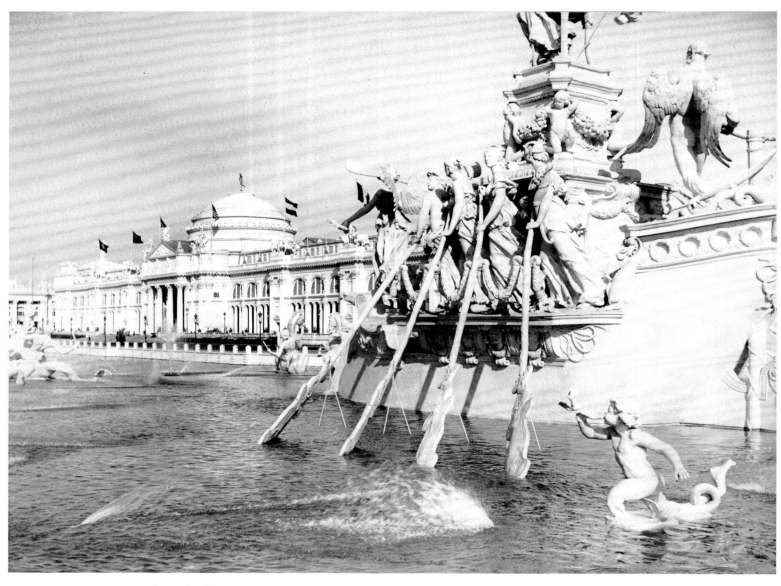

The *Columbian Fountain* was illuminated by electric lights at night and was flanked by two smaller electric fountains at the northwest and southwest corners of the Great Basin. According to the *Official Directory*, the fountain would, at times, "spout an iridescent deluge."

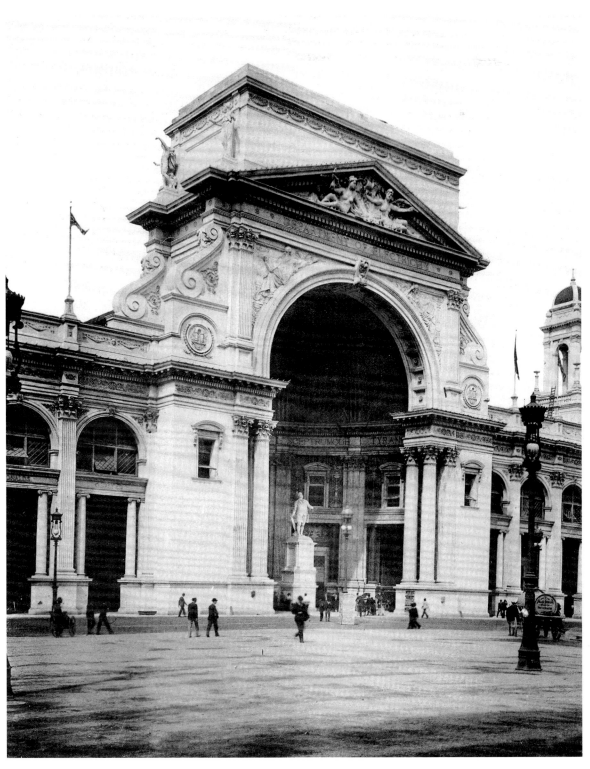

The Electricity Building, designed by East Coast architect Henry Van Brunt, was 345 by 690 feet. Located just north of the Administration Building, it used 40,000 windowpanes, more than any other fair building, and featured a statue of Benjamin Franklin by Carl Rohl-Smith at its entrance.

Boston architects
Peabody and Stearns
designed the Machinery
Building, also called the
Palace of Mechanical
Arts, in the style of
Spanish Renaissance. It
stood just south of the
Administration Building.

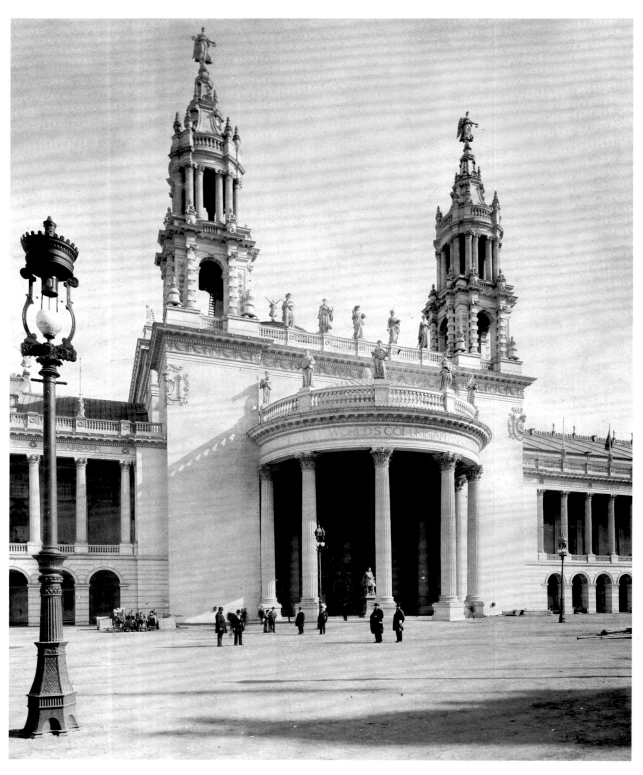

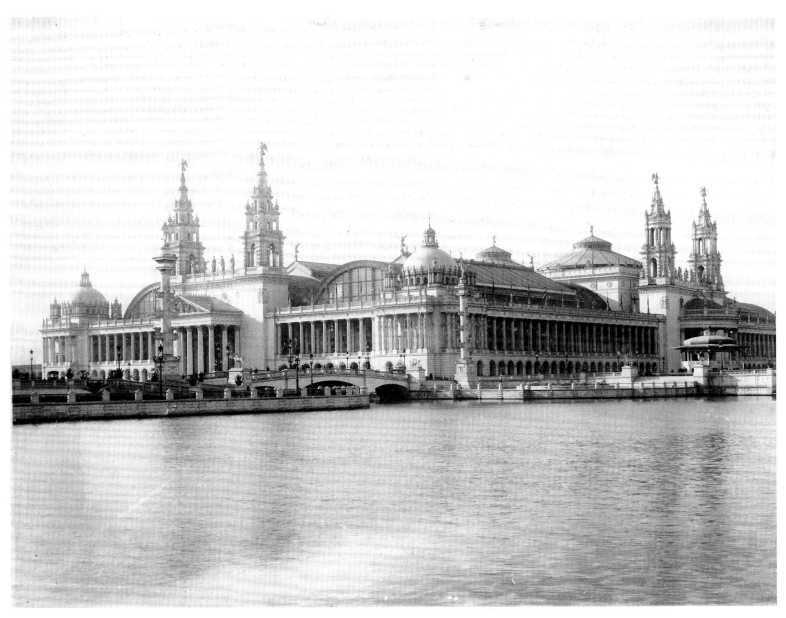

The Machinery Building stands southwest across the Great Basin. The main structure, which fronted on the South Canal, was 842 by 492 feet; the annex was 551 by 490 feet.

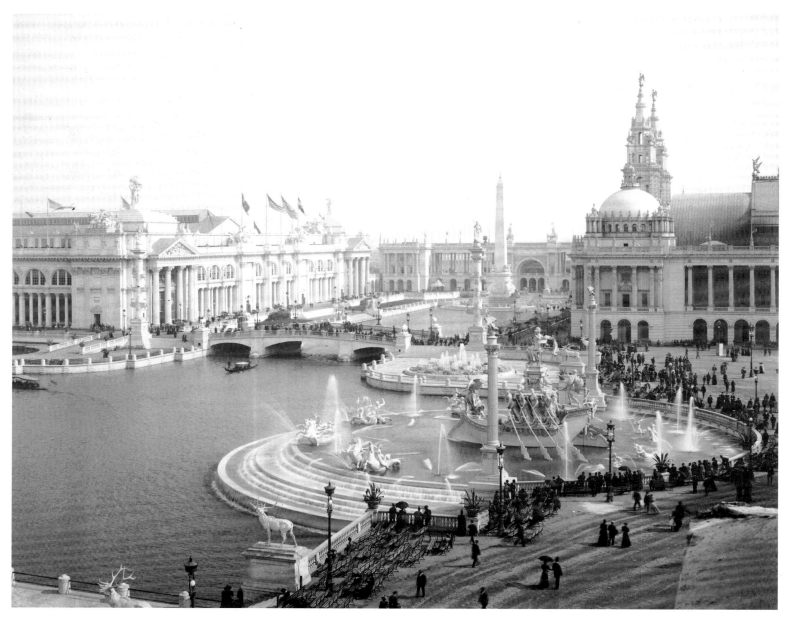

This view looks along the South Canal toward the Obelisk and Colonnade with one of the small electric fountains, the Agriculture Building, and the Machinery Building visible.

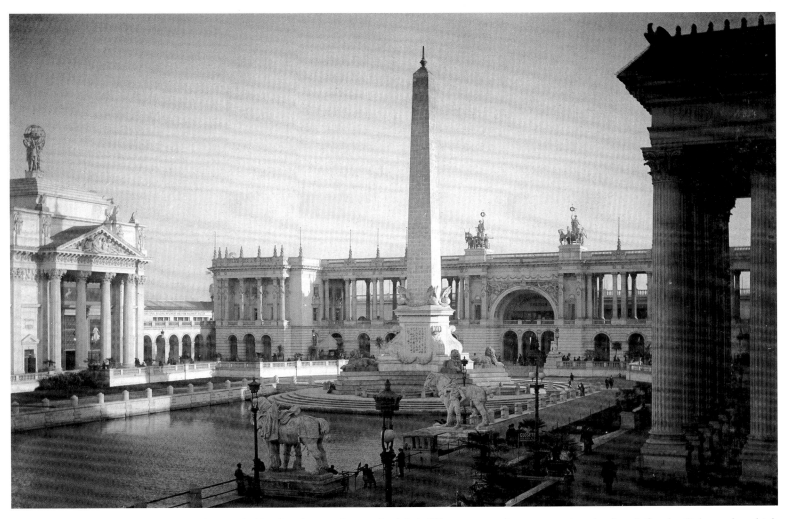

The Obelisk, guarded by four lion sculptures by M. A. Waagen, served as a convenient landmark for the Colonnade, which connected the Agriculture and Machinery buildings and served as the gateway to the livestock pavilion.

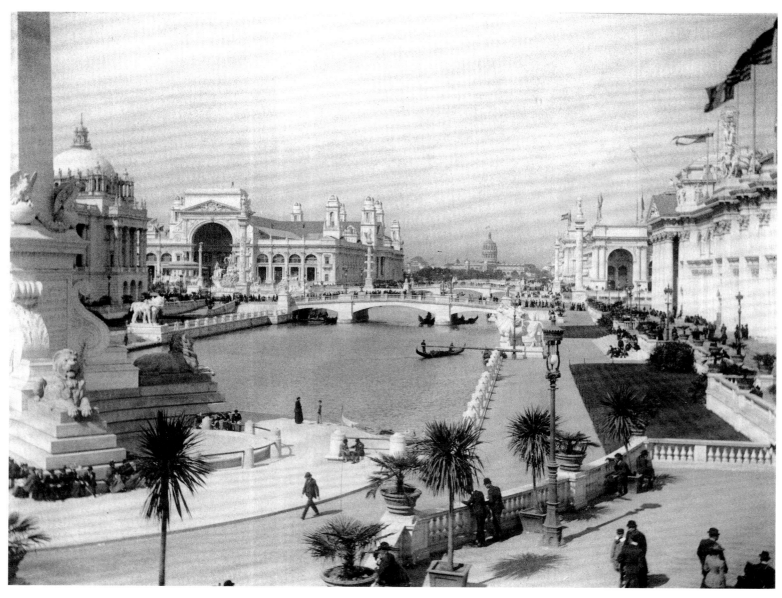

This view from the Obelisk faces north along the North and South canals. The dome of the Illinois Building, the largest and most expensive state building at the exposition, is visible in the distance.

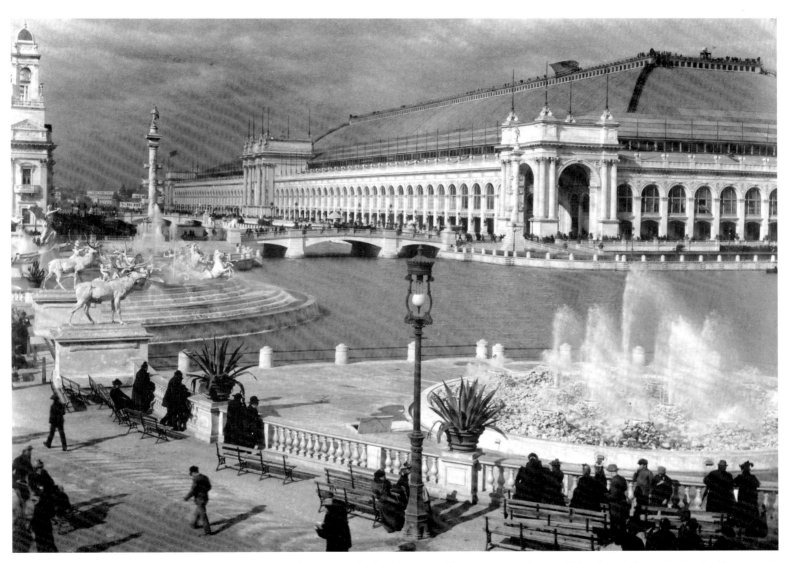

The southwest corner of the Manufacturers and Liberal Arts Building is seen with one of the electric fountains in the foreground. Designed by New York architect George B. Post in the Corinthian style, the structure measured 1,687 by 787 feet, the largest roofed building ever constructed up to that time.

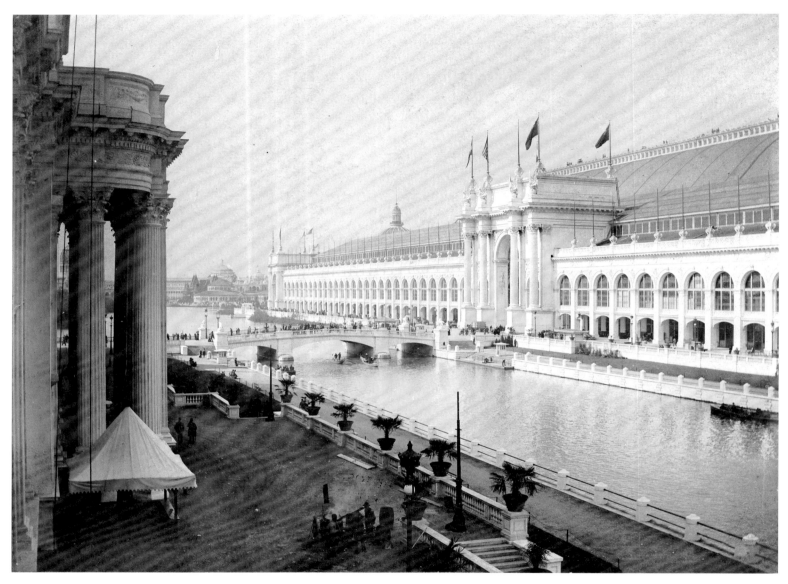

The west facade of the Manufacturers and Liberal Arts Building is visible from the Mines and Mining Building. Critics acknowledged the size of the structure as an impressive achievement, but they debated its artistic merit.

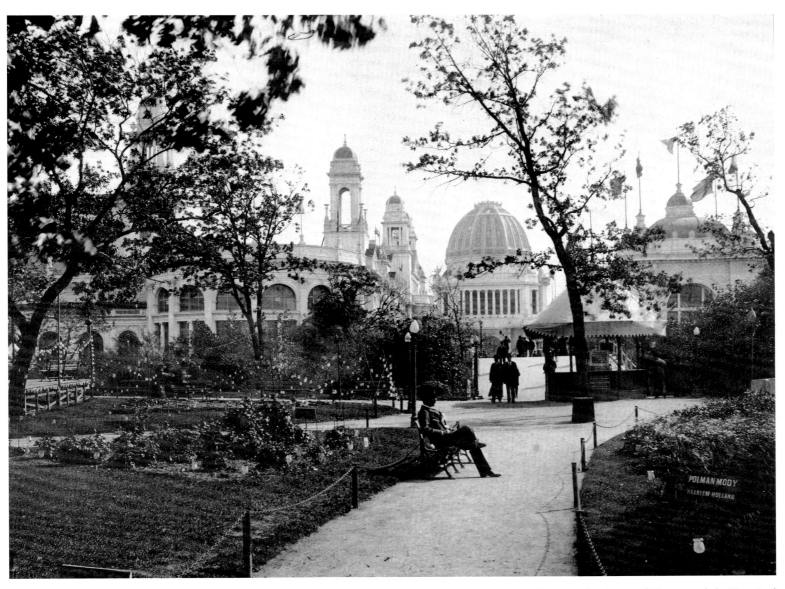

The park area behind the Administration Building was a pleasant transition space between the Court of Honor and the Terminal Station. The sign displayed on the booth to the right advertises spring water.

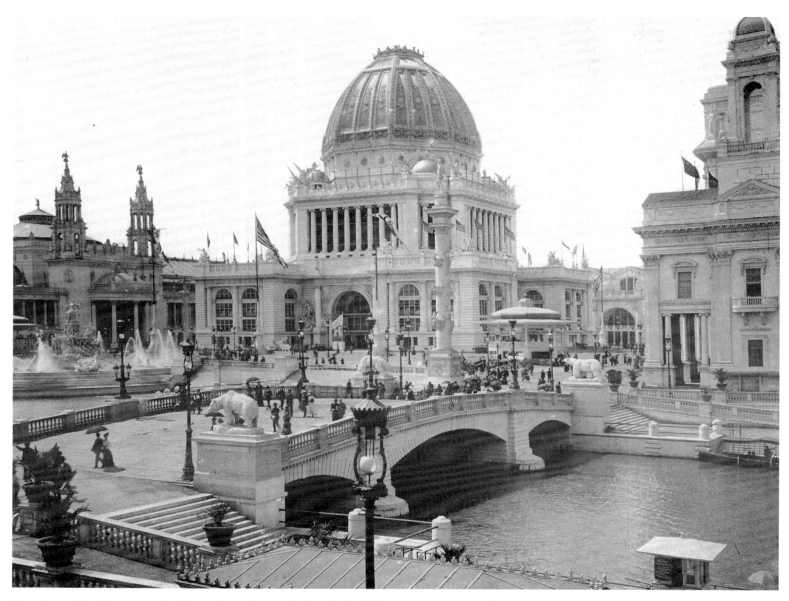

Seen from the bridge across the North Canal, the Administration Building boasts a majestic facade. Designed by noted American architect Richard Morris Hunt, the structure featured a golden dome, a complement to the gilded statue of the *Republic* standing opposite at the east end of the Great Basin.

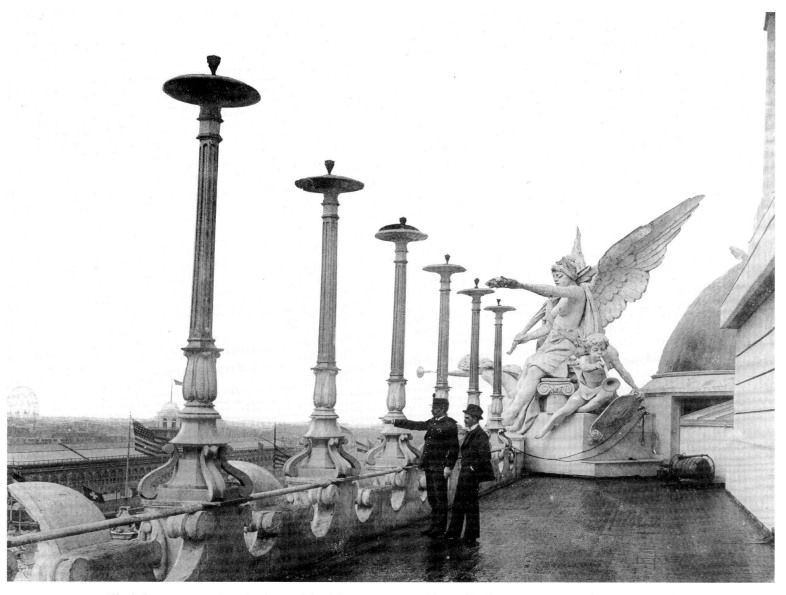

The balcony surrounding the dome of the Administration Building offered impressive east and west views, including a view of the massive Ferris wheel. Artist Carl Bitter created the sculptures surrounding the domes on the balcony.

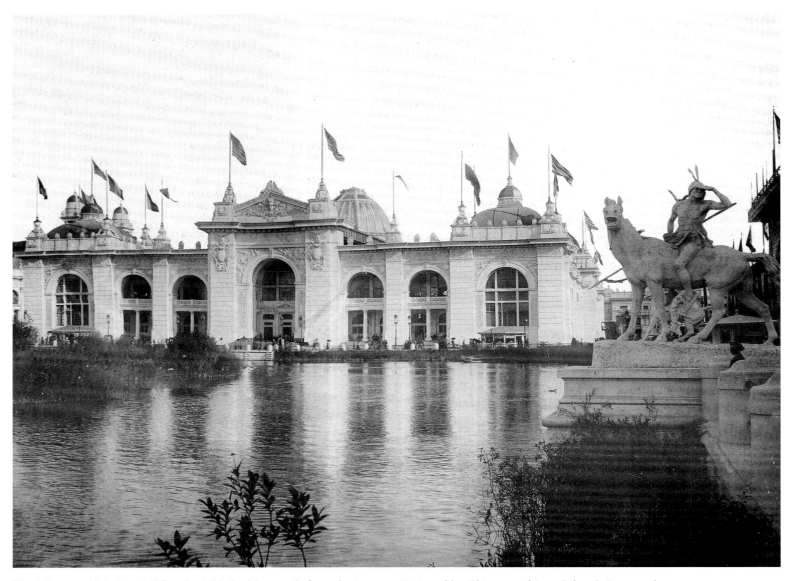

The Mines and Mining Building is visible looking south from the Lagoon. Designed by Chicago architect Solon S. Beman, the structure's dimensions were 700 by 350 feet. Beman also designed the Merchant Tailor Building at the fair.

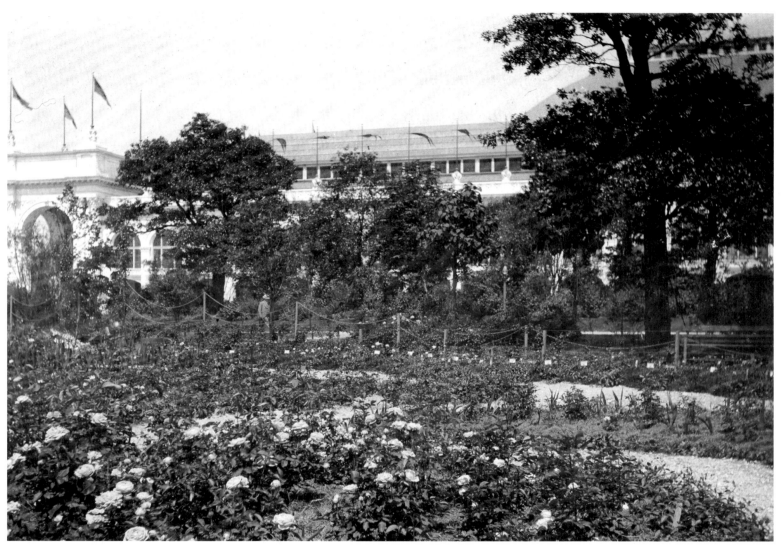

The Manufacturers and Liberal Arts Building hides behind the Rose Garden on the Wooded Island. Sixteen acres in area, the Wooded Island was an outdoor horticulture exhibit featuring Darwin tulips, roses, climbing plants, trees, and shrubs.

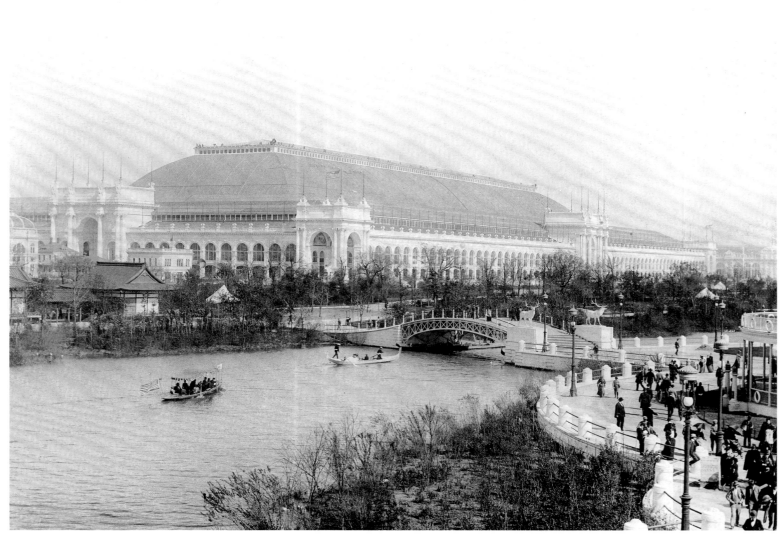

The Wooded Island and the Lagoon area created a different visual and emotional experience for exposition visitors. The relationship of architecture to nature was the most important design aspect for this area of the fairgrounds, and the floral and vegetation arrangements framed the view of the buildings.

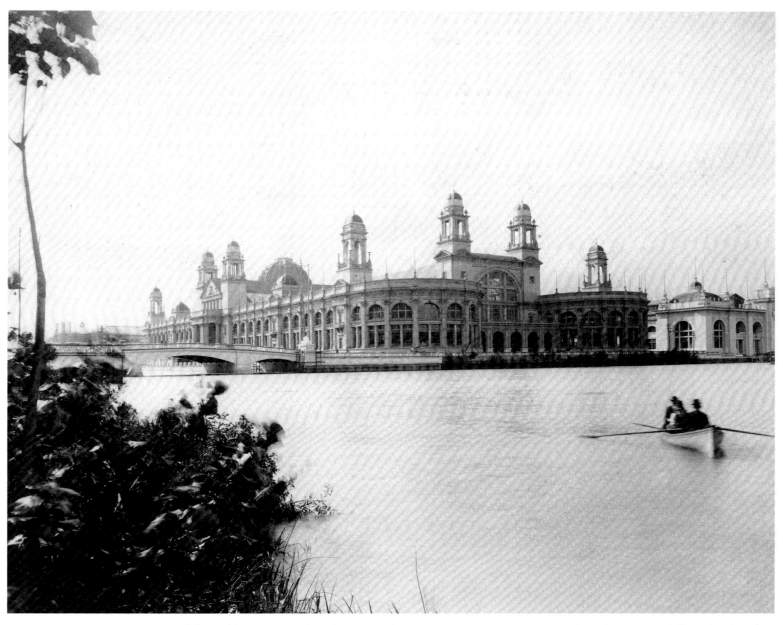

Visitors viewed the buildings surrounding the Court of Honor, such as the Electricity Building shown here, differently when they observed them from the Lagoon and the Wooded Island.

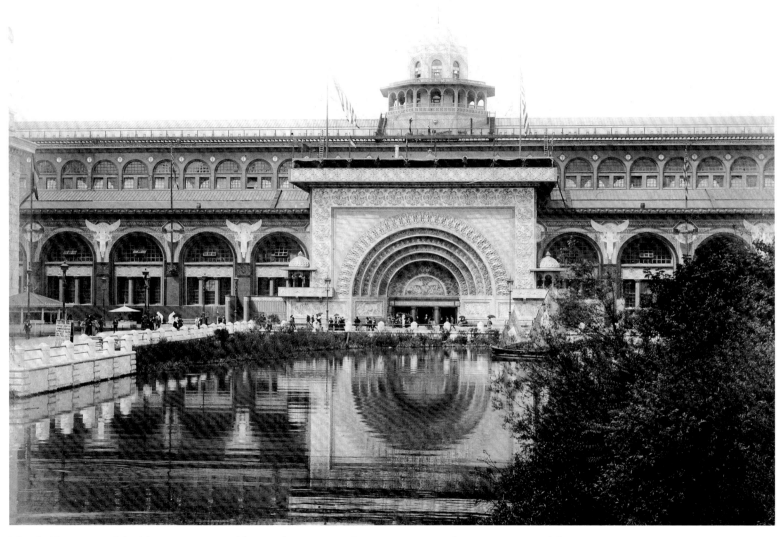

The Golden Door of the Transportation Building and its mirror reflection are seen in the Lagoon waters. The Lagoon was especially effective as a reflective surface, which further emphasized the visual merging of nature and architecture. To the left of the door is a sign advertising an Apollo Club performance at the Festival Hall.

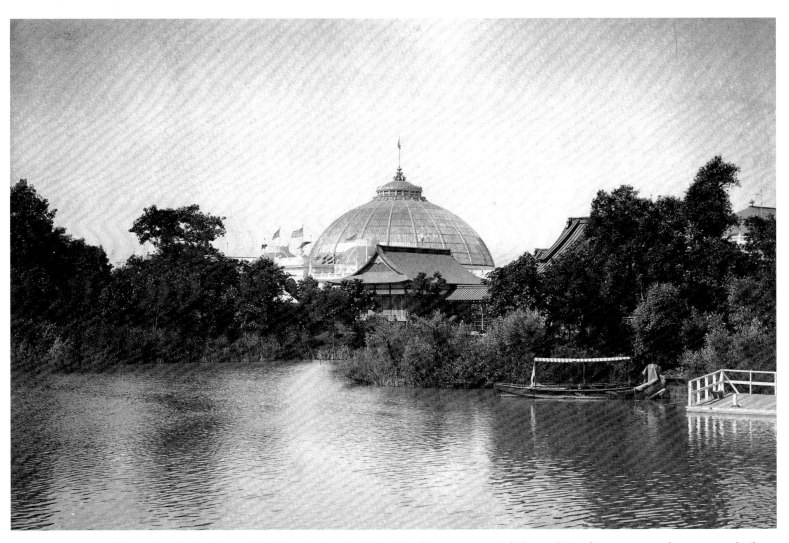

The steel and glass dome of the Horticulture Building is in sharp contrast with the traditional Japanese wooden structure built on the north end of the Wooded Island. This careful juxtaposition of two cultures gave visitors a visual index of the progress of western civilization.

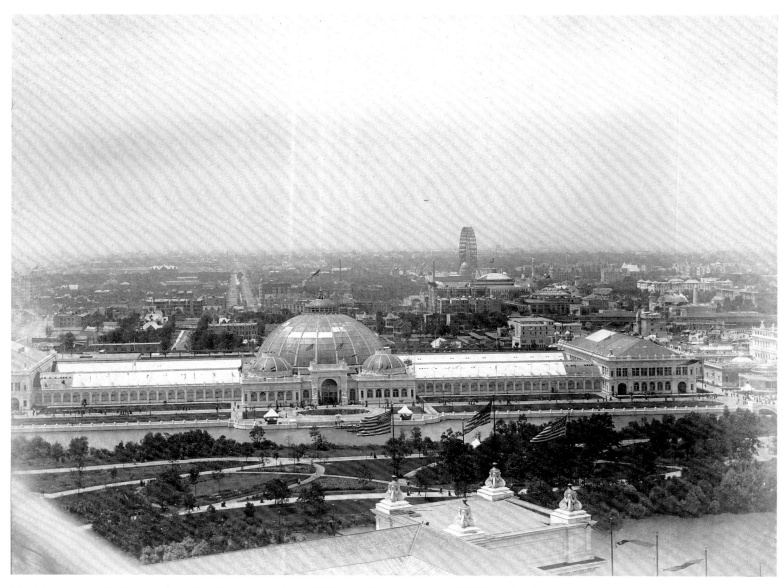

The Horticulture Building designed by Chicago architects William LeBaron Jenney and William B. Mundie presented a magnificent 1,000-foot-long front along the Lagoon opposite the Wooded Island. This view from the Manufacturers and Liberal Arts Building shows the fairgrounds in relationship to Hyde Park and the Midway.

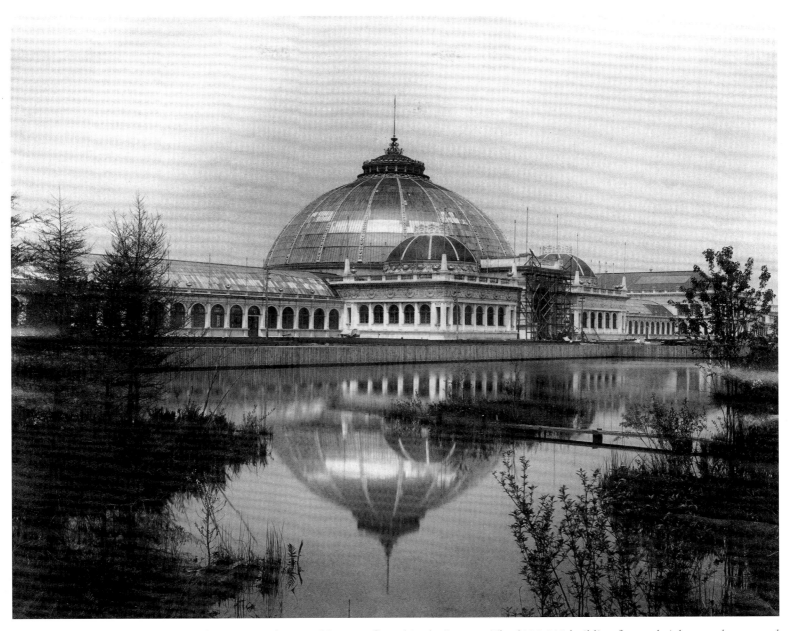

The dome of the Horticulture Building is reflected in the Lagoon. The $300,000 building featured eight greenhouses and a court with an orange and lemon grove.

The Fisheries Building, designed by Chicago architect Henry Ives Cobb in the style of Spanish Romanesque, features a distinctive red-tile roof.

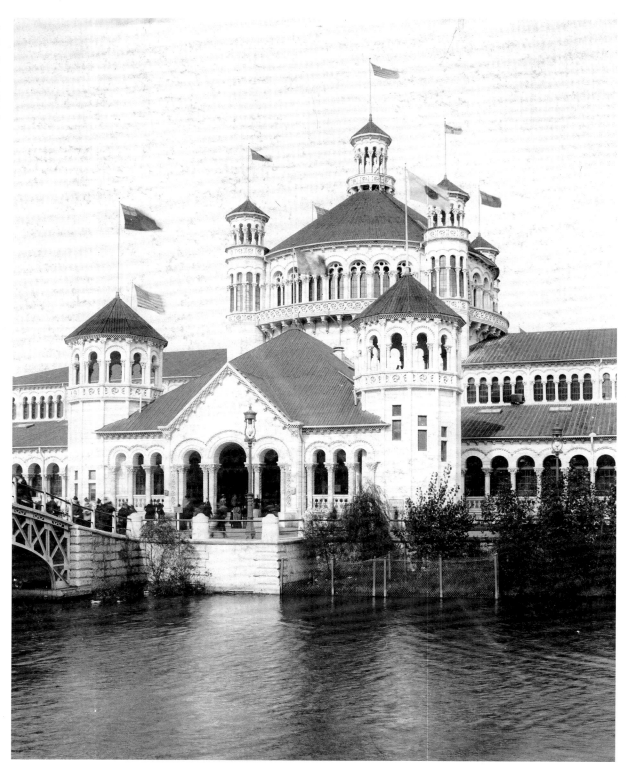

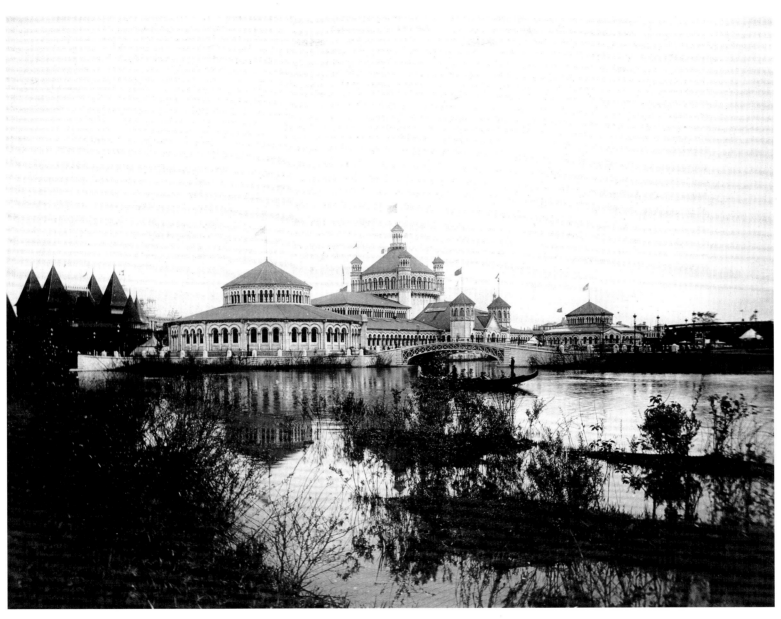

The Fisheries Building included a central structure and two smaller polygonal structures connected by arcades. The columns of the facade were covered with fish, and their capitals featured thousands of marine life-forms.

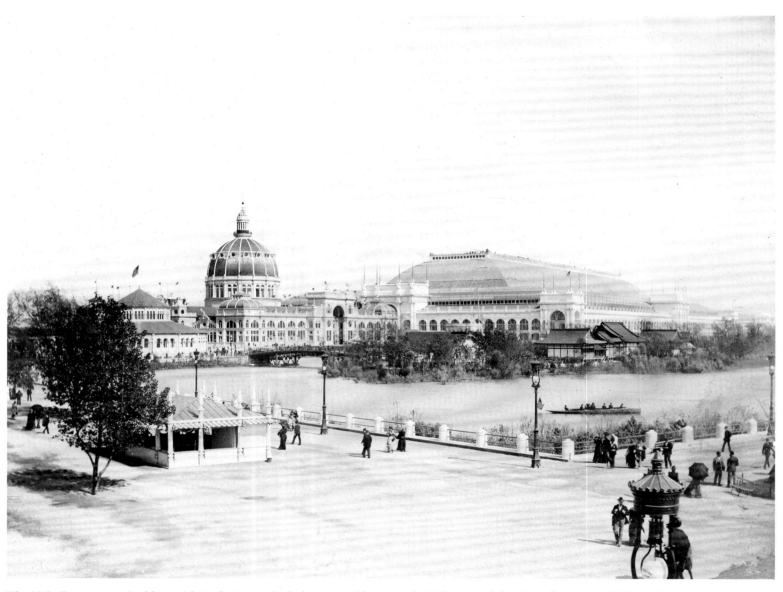

The U.S. Government Building with its distinctive high dome stood between the Fisheries and the Manufacturers and Liberal Arts buildings. Designed by treasury department supervising architect Willoughby J. Edbrooke, the building was criticized for being ostentatious and for its non-classical design elements.

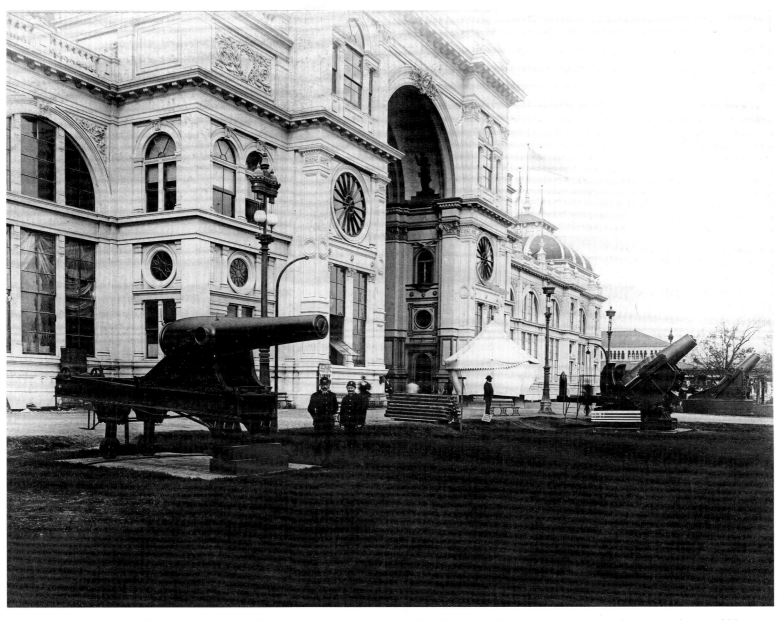

The artillery placed in front of the U.S. Government Building was a clue to America's imperialistic aims that would become evident to the world within five years.

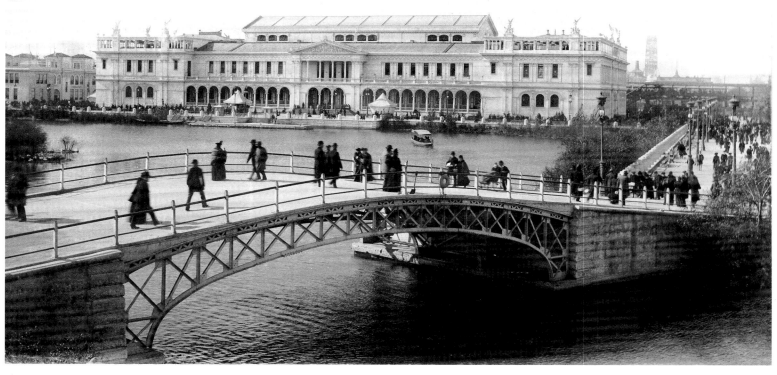

Sophia G. Hayden of Boston, one of only three women recognized as architects in the nation, won the competition to design the Woman's Building. Critics considered the Woman's Building, the smallest of the primary exhibition halls on the grounds (its dimensions were 388 by 199 feet), a modest architectural success.

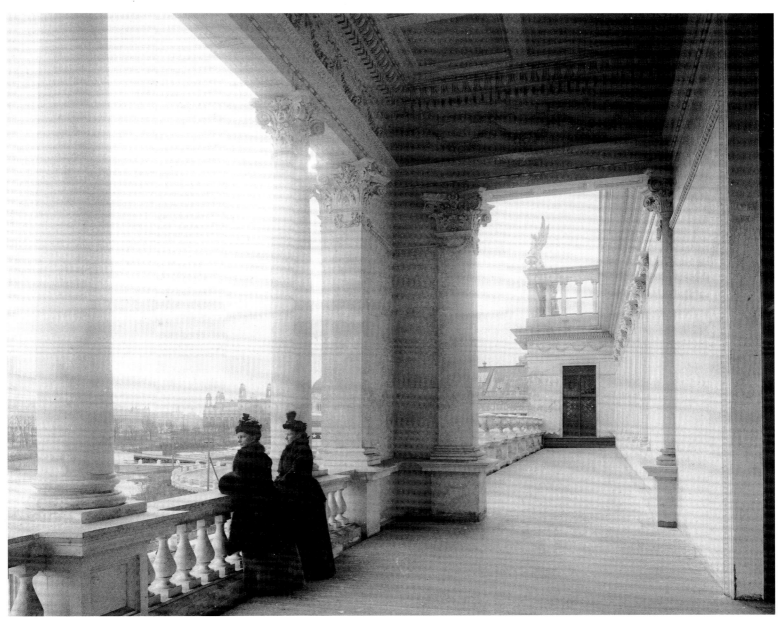

The loggia of the Woman's Building faces the Lagoon. Alice Rideout created the sculptural groupings that decorated the building.

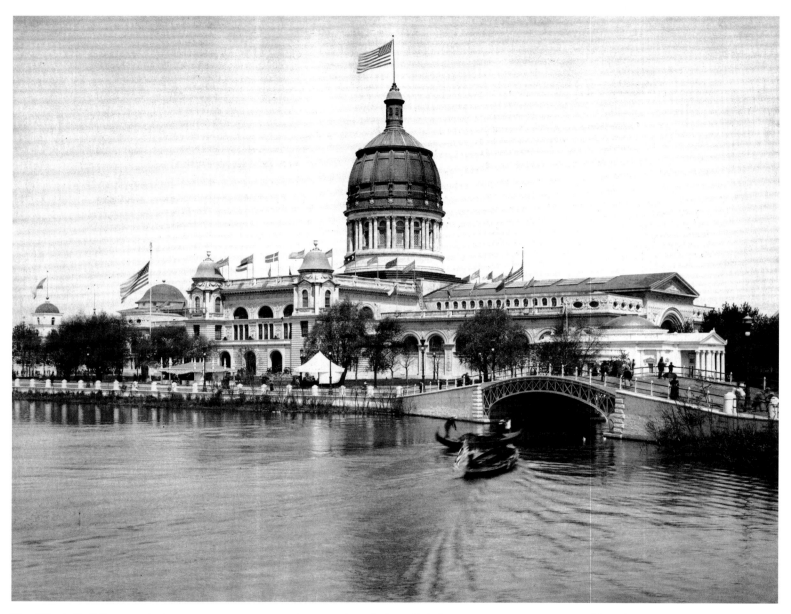

The Illinois Building was the largest state structure on the grounds and also called the most pretentious. Designed by Chicago architect W. W. Boyington & Company at a cost of $250,000, the building housed exhibits about the state and served as the headquarters for the Illinois commission.

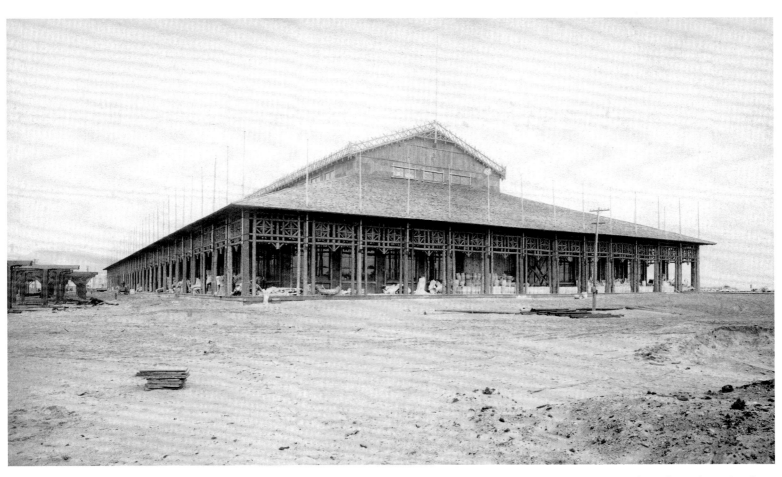

Chicago architect Charles Atwood designed the Forestry Building. Constructed of wood with a colonnade made of tree trunks from every state in America, the Forestry Building was 528 by 208 feet and was sited at the south end of the exposition grounds along the lakefront.

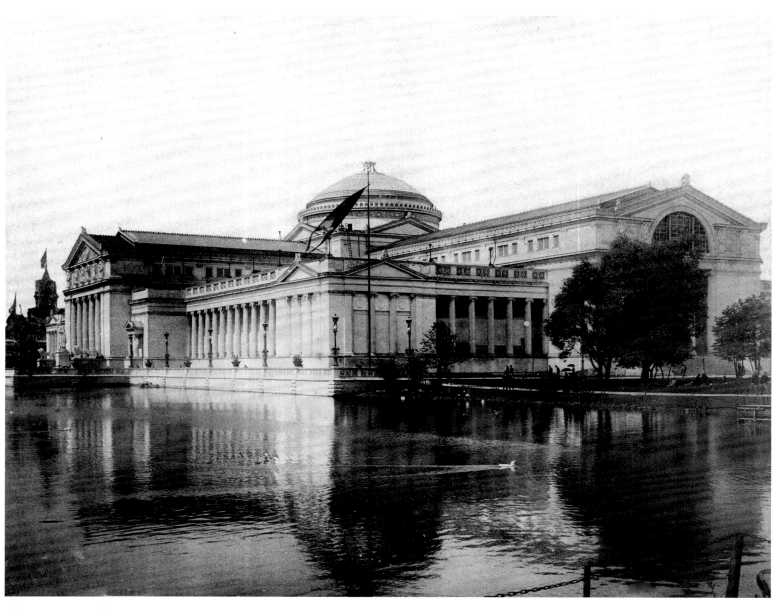

The Fine Arts Building, also called the Palace of Fine Arts, was one of the few permanent structures built for the fair. Charles B. Atwood designed the building in the Greek-Ionic style.

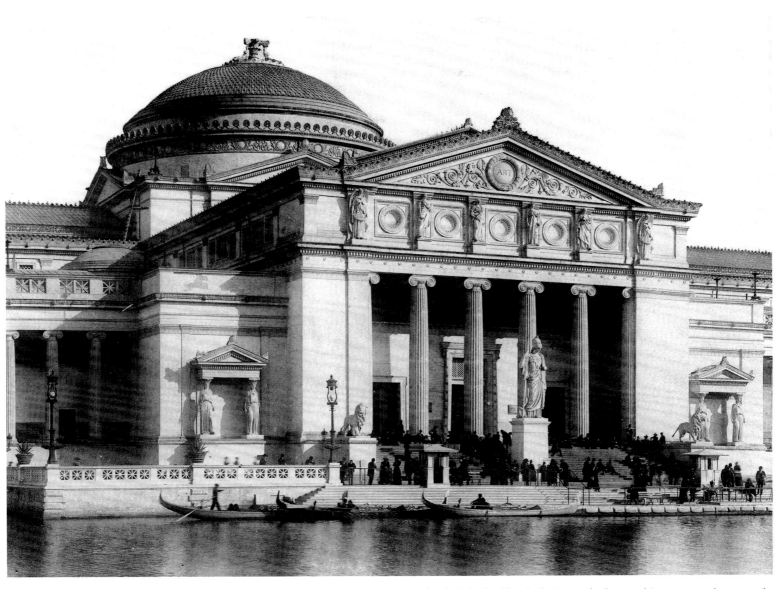

Steps from the North Pond led to the Fine Arts Building. Critics lauded the building's design as the best architecture on the grounds.

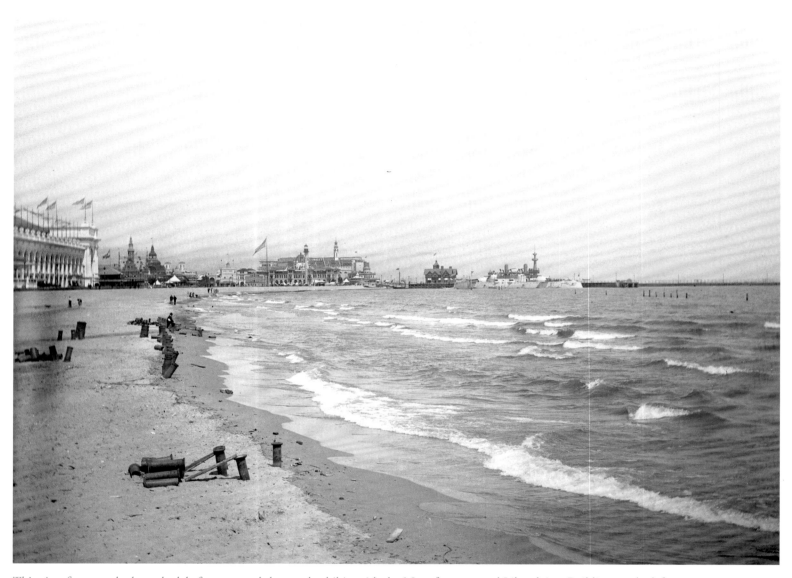

This view faces north along the lakefront toward the naval exhibit, with the Manufacturers and Liberal Arts Building on the left.

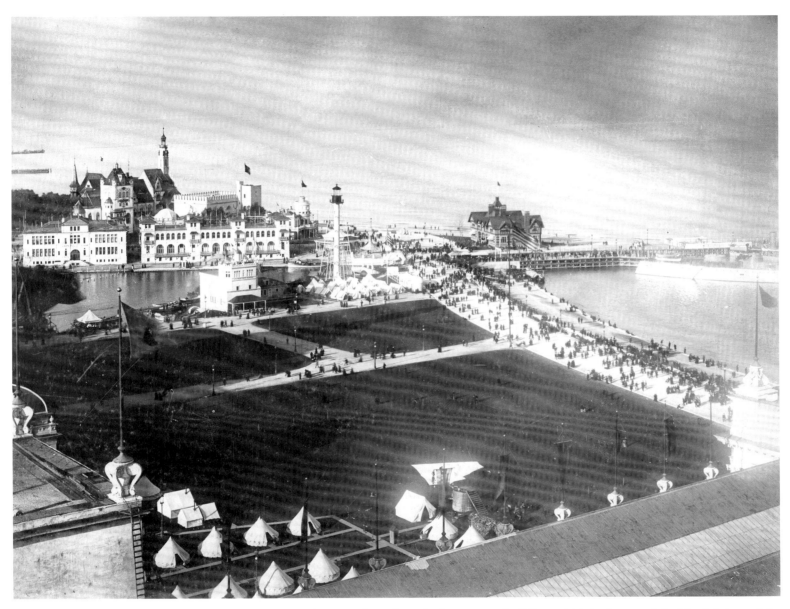

Pedestrians and tents dot the fairgrounds as seen from the U.S. Government Building, which looks toward the North Inlet and the foreign buildings area. The outdoor displays include a parade ground, a weather bureau, a naval observatory, a life-saving station, a lighthouse, and the battleship *Illinois*.

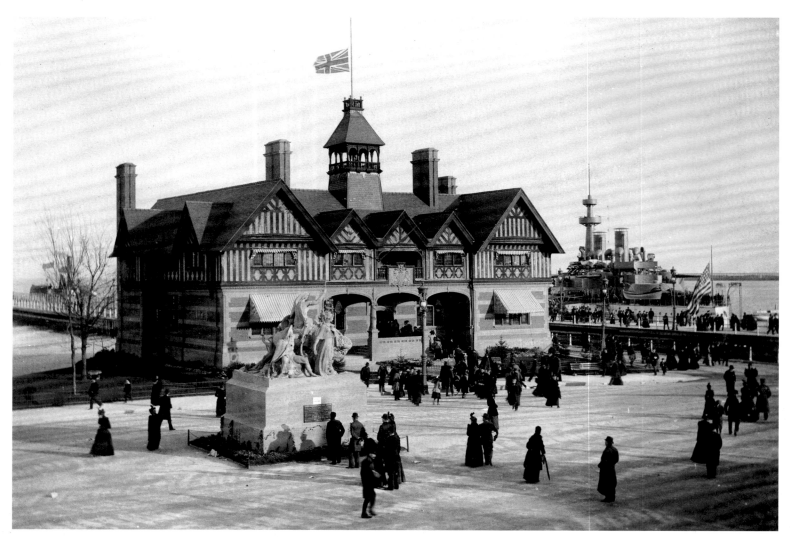

The Great Britain Building, called Victoria House, was an example of a typical half-timber country home from the Elizabethan period. The interior design copied elements from other well-known country homes, and the monogram *VR,* for Queen Victoria, was found throughout the building. In front of the building is *America,* a replica of a statue at the Albert Memorial in Hyde Park, London, part of a group of statues representing various regions of the world.

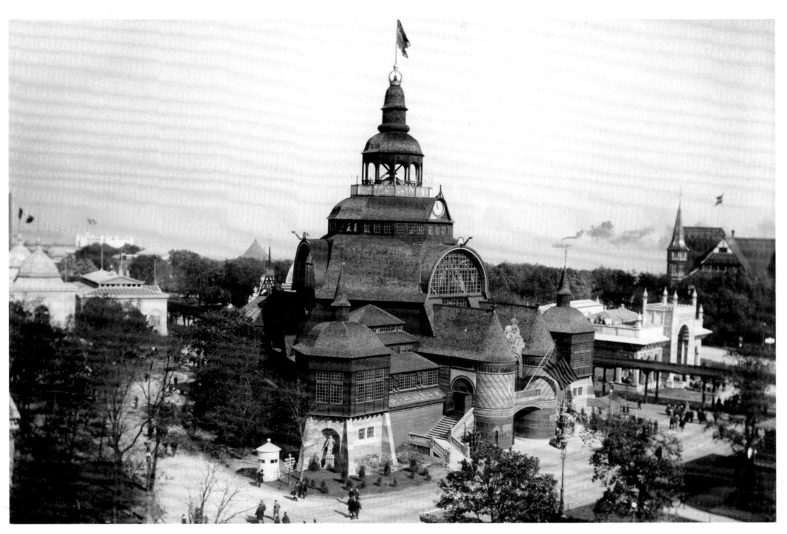

The Swedish Government Building was located north of the Fisheries Building on its east side. Designed in the spirit of Sweden's churches and gentlemen houses of the sixteenth and seventeenth centuries, the building follows the nation's tradition of covering the roof and sides with wooden shingles.

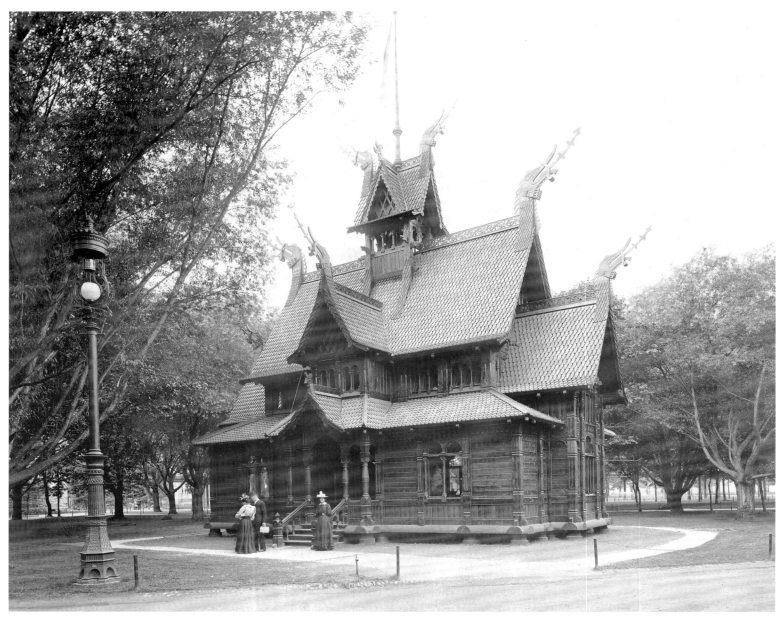

Norway's national building by architect W. Hansteen was based on the stave churches the Vikings built when they converted to Christianity. The electric light in front was illuminated by Westinghouse, who outbid General Electric as supplier of electricity for the fair.

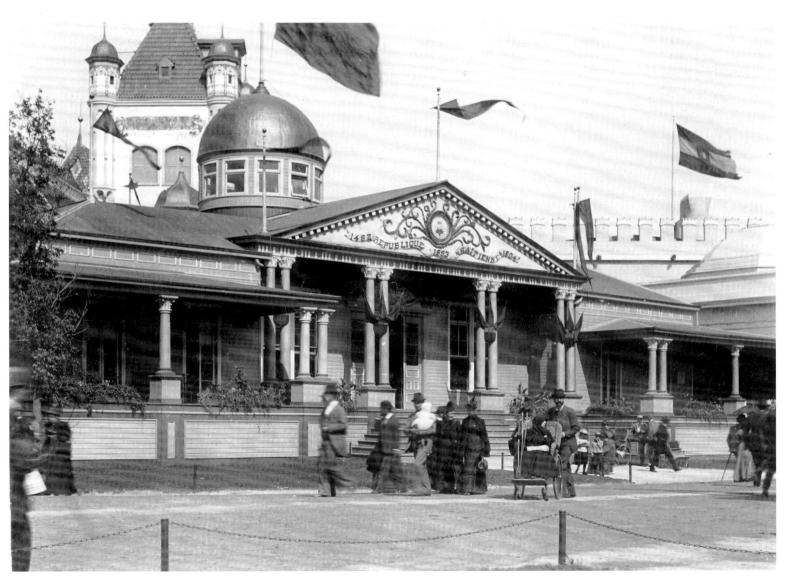

According to activist Ida B. Wells, the Haitian Building became the chosen gathering spot for African Americans who visited the fair, and it also attracted white Americans seeking an audience with Frederick Douglass, U.S. minister to Haiti and the country's chosen commissioner for the fair.

The foreign buildings from Asia generated great excitement among fair visitors. The Ceylon Building, built by native workmen, was inspired by the nation's ancient temple architecture and featured satinwood framing, ornamental scrollwork, and the characteristic large projecting eaves and hammered brass finial.

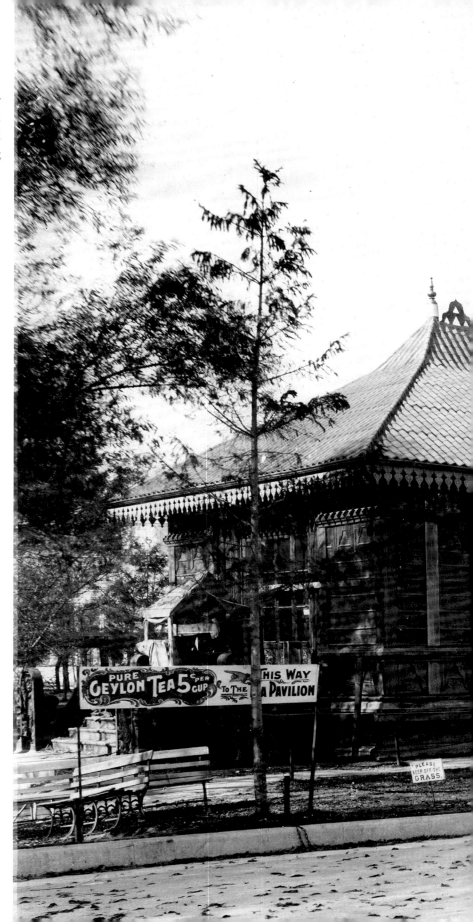

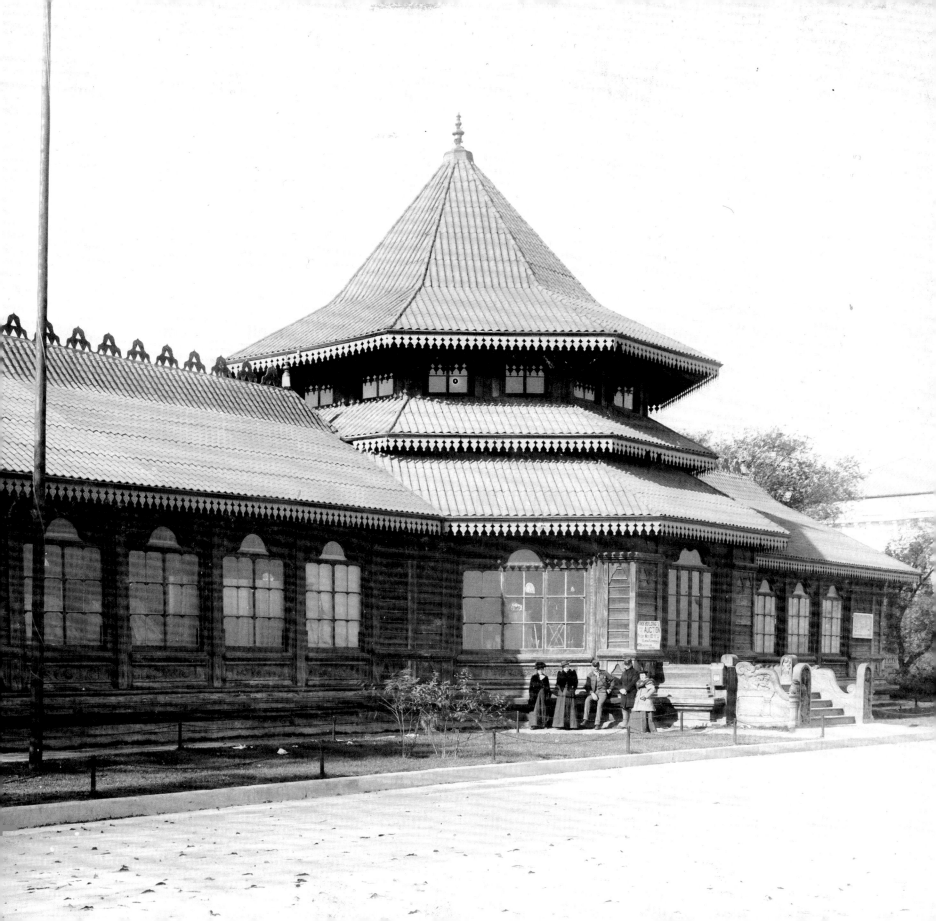

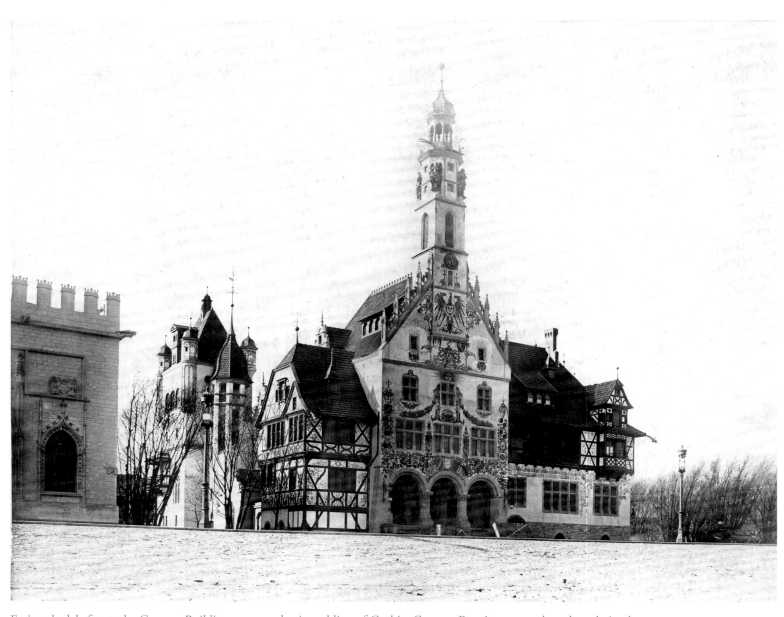

Facing the lakefront, the German Building was an eclectic melding of Gothic, German Renaissance, and modern design by Düsseldorf architect Johannes Radke. The German Building, the Krupp exhibit, and the German Village on the Midway gave Germany the dominant foreign presence on the exposition grounds.

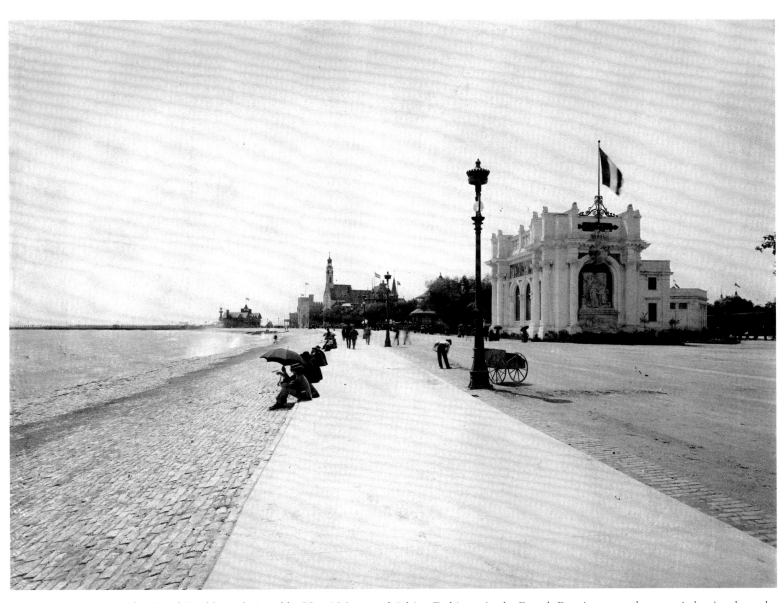

The French Building, designed by Henri Motte and Adrien Dubisson in the French Renaissance style, occupied a site along the lakefront just east of the Fine Arts Building.

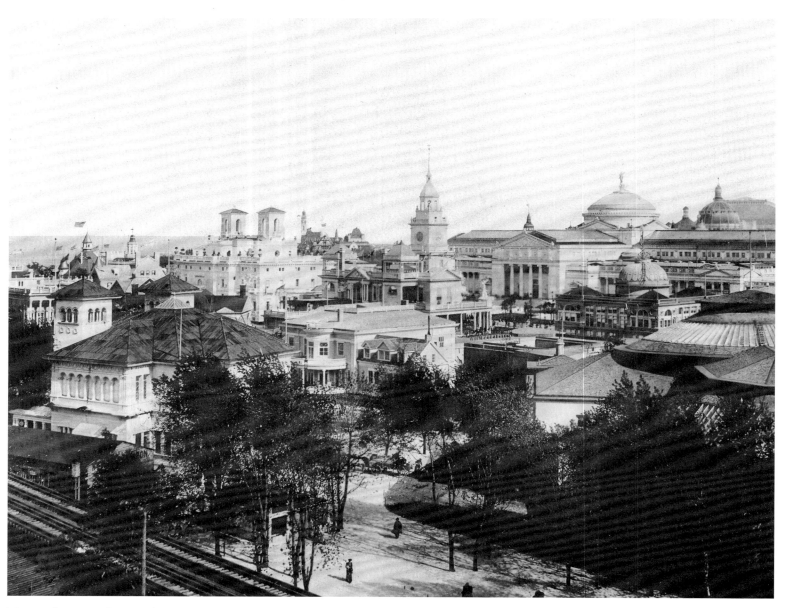

This rooftop view showing the state buildings area from the north end of the fairgrounds faces southeast. The elevated train tracks are visible in the foreground, and the twin square towers of the New York Building stand left of center between the Texas Building (left foreground) and the Kansas Building (right foreground).

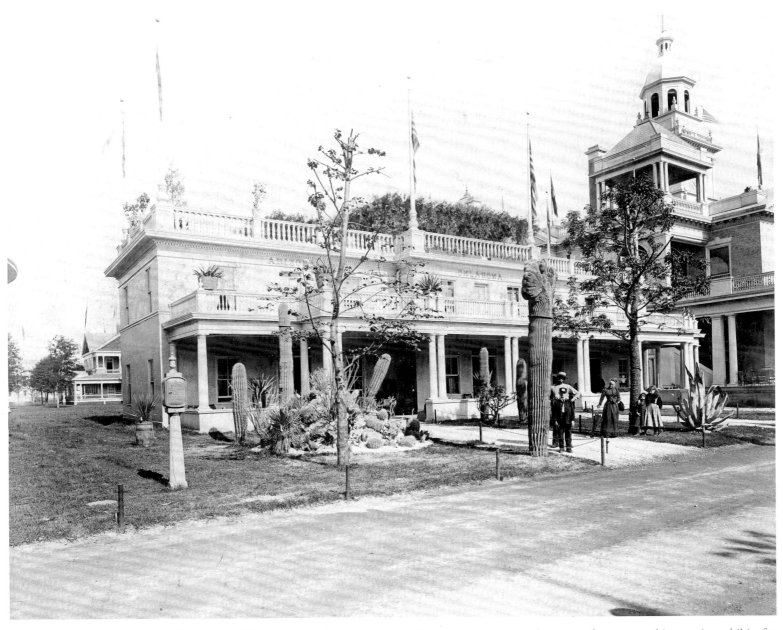

Many of the state buildings served only as headquarters for state commissions, but some also presented impressive exhibits for viewing. The cactus plantings was the most distinctive feature of the building that the territories of Arizona, Oklahoma, and New Mexico shared.

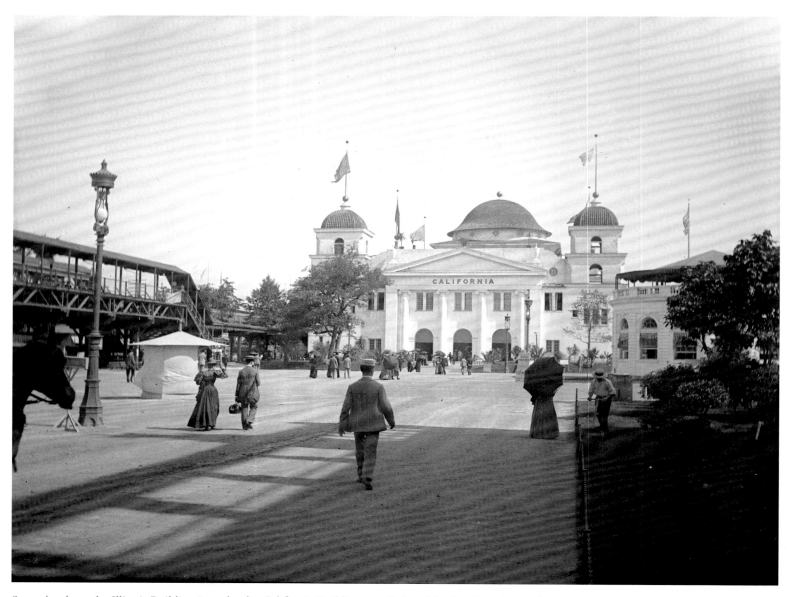

Second only to the Illinois Building in scale, the California Building was designed by San Francisco architect A. Page Brown in the style of the Spanish missions of the state. A simple whitewashed interior and exterior (purposely seamed and cracked to simulate age) and a red-tile roof, shown in this view of the south end of the building, gave the structure its distinctive character. The elevated train station is on the left.

A World of Goods and Astonishment

The 65,000 exhibits found on the fairgrounds ranged from the sublime to the ridiculous; collectively, they aimed to present an "illustrated encyclopedia of civilization." Visitors to the Fine Arts Building could see more than 10,000 works of art in 74 galleries, while the Agriculture Building boasted a cheese from Ontario weighing 22,000 pounds. The largest gold nugget in existence was on display in the Mines and Mining Building, and the Forestry Building featured a plank of California redwood more than 12 feet long and 16 feet wide. Excursions to the Machinery, Electricity, Horticulture, Transportation, and Woman's buildings yielded more wonders and a powerful and inspiring sense of the material progress of the world.

Visitors gasped in astonishment once they entered the exhibition halls, which resembled vast train sheds. Gone were the formal symmetry and carefully orchestrated harmony of the Court of Honor. Instead, visitors viewed a cornucopia of merchandise, machinery, and apparatus that was both dizzying and exhausting. An elaborate organizational scheme divided the world of goods into twelve classifications of exhibits with a separate building for each.

Near the South Inlet, visitors also found historical comparisons to illuminate progress in the replicas of Columbus's famous 1492 caravels and relics from his life and the voyage on view in a re-creation of the La Rabida convent. The Viking ship and the transportation display of railroad evolution gave visitors more opportunities to compare the past with the present. The ethnological and archaeological exhibits were spread throughout the fairgrounds in the Anthropology and U.S. Government buildings, around the South Pond, and on the Midway. Some critics, including Frederick Douglass, argued that these displays overemphasized the "primitive" character of these groups in an effort to further promote a concept of progress dominated by the white race.

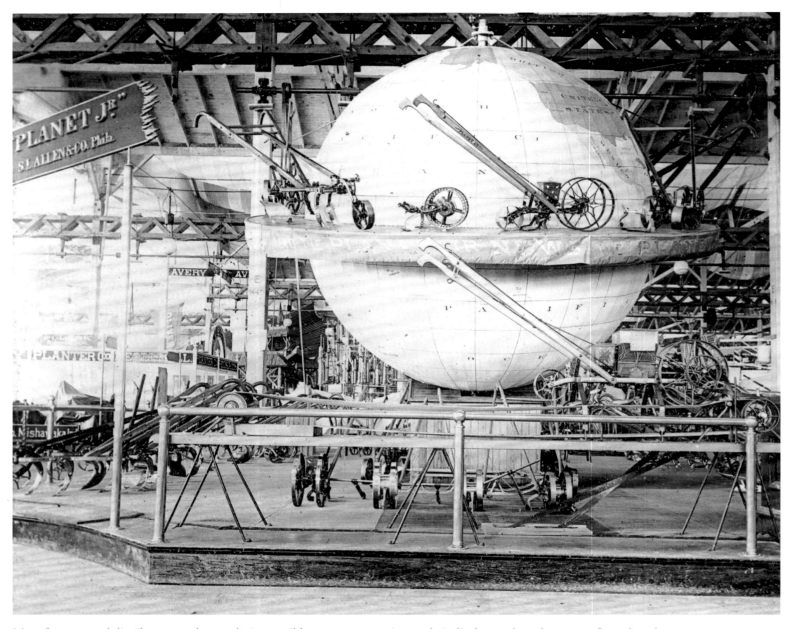

Manufacturers and distributors used every device possible to attract attention to their displays and set them apart from the other exhibits and the millions of items on view. S. L. Allen & Co. of Philadelphia employed a rotating globe to display its planters and cultivators in the Agriculture Building.

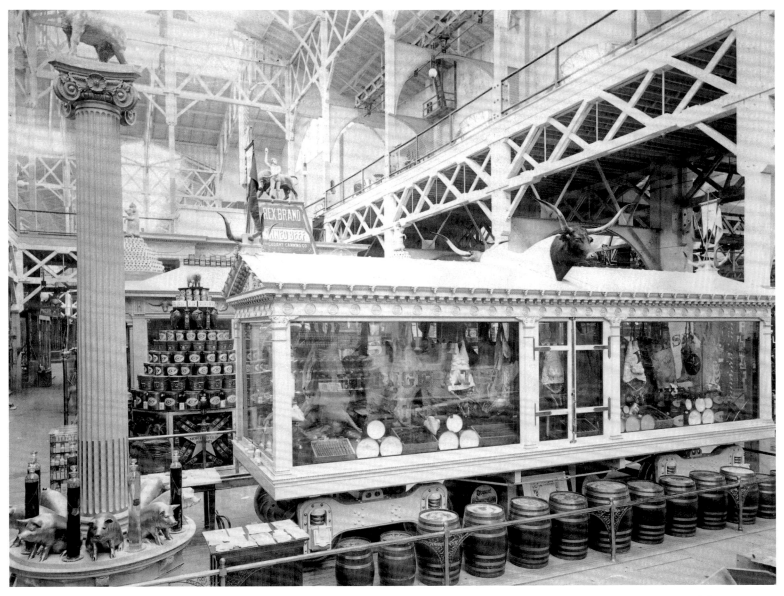

This Swift and Company refrigerated rail car was elaborately decked out as a display case to extol the virtues of shipping meat cross-country. A column with an Ionic capital on the left serves as a pediment for a statue of a sheep, and displays of stacked tins of meat are in the background.

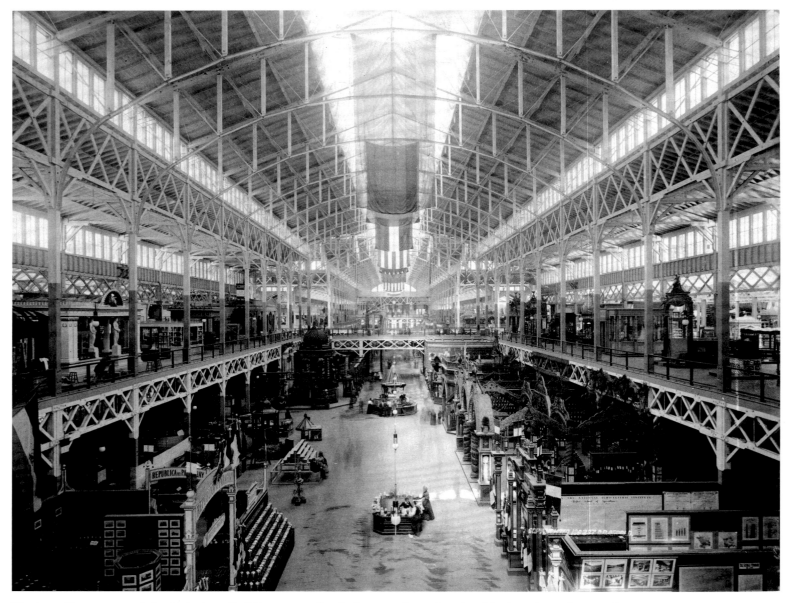

The barn-like structure of the Agriculture Building was perfect for housing the multitude of food products, farm implements, and agricultural items, which were organized and displayed according to groups, classes, and nations. Visitors were fascinated by the eleven-ton block of cheese housed here—the "Mammoth Cheese"—that was imported from Canada.

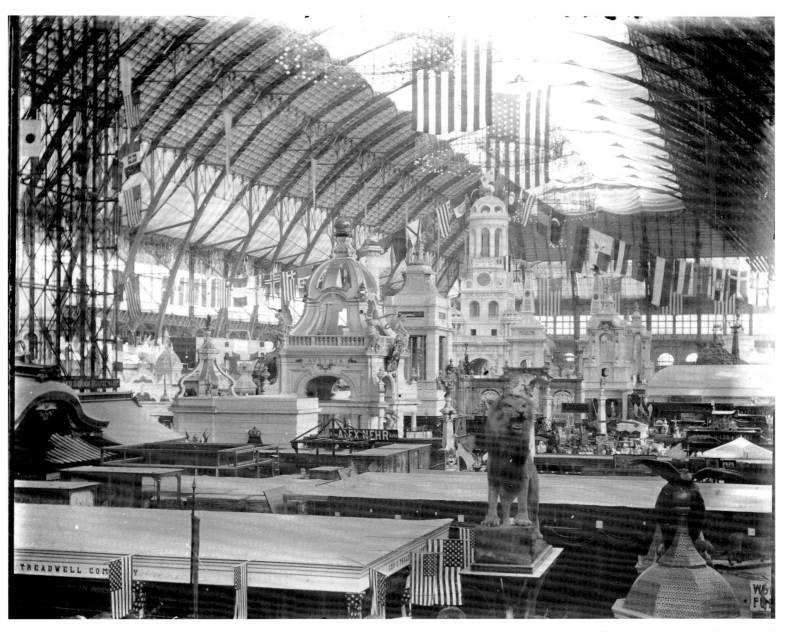

This interior view of the Manufacturers and Liberal Arts Building was recorded looking south from the Austrian exhibits toward the 120-foot-tall clock tower of the American Self-Winding Clock Company. The tower stood at the center of Columbia Avenue, the 50-foot-wide thoroughfare that transversed the north–south length of the building.

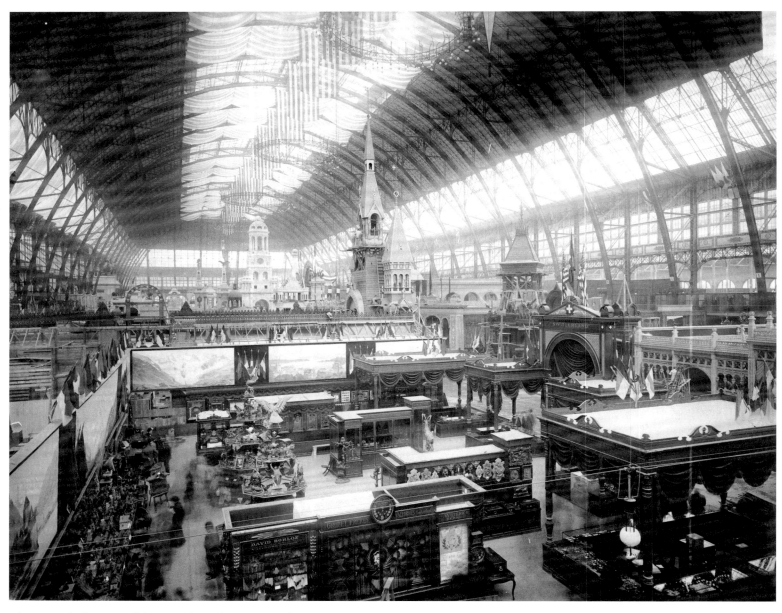

The main clock tower of the Danish pavilion rises 90 feet in the south quarter of the Manufacturers and Liberal Arts Building. The scale of the building interior was immense; exposition publicity claimed that the standing army of Russia could mobilize under its roof.

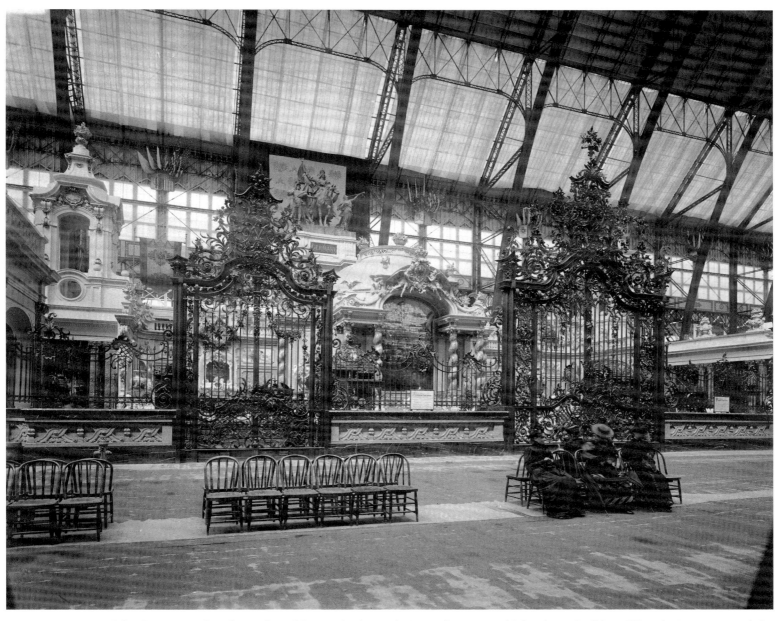

The German pavilion featured an elaborate display in the Manufacturers and Liberal Arts Building. Wrought-iron gates made by Armbruester Brothers of Frankfurt am Main lead off of Columbia Avenue into the exhibits.

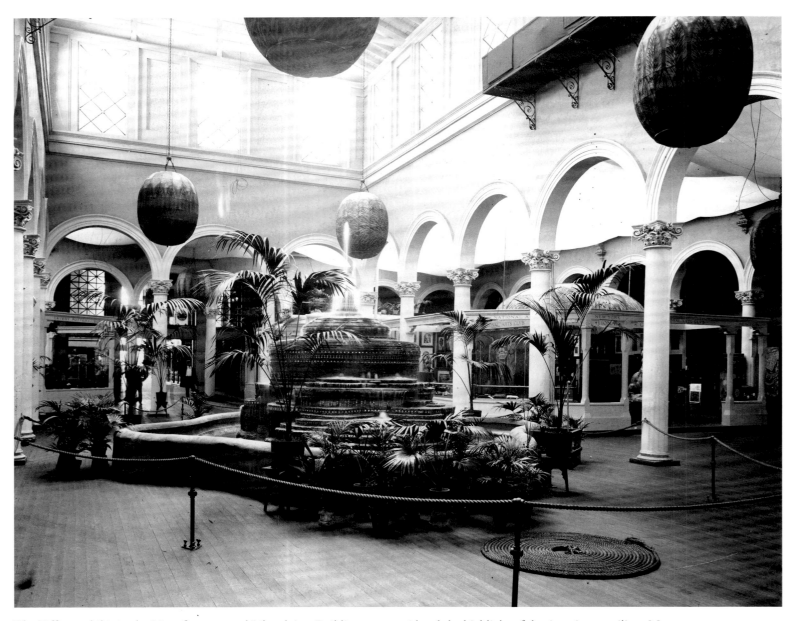

The Tiffany exhibit in the Manufacturers and Liberal Arts Building was considered the highlight of the American pavilion. More than 1.4 million people visited the Romanesque chapel on display.

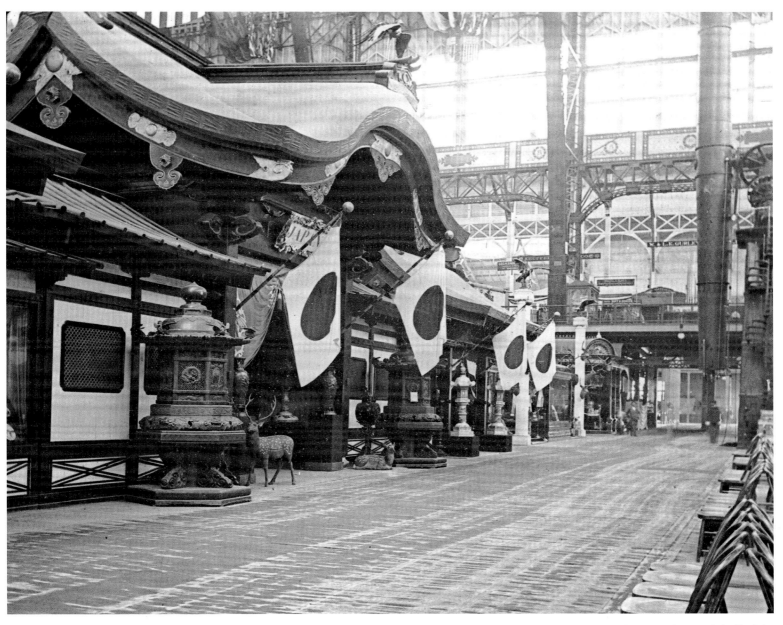

The Japanese pavilion on Columbia Avenue was located between the Austrian and American exhibits in the north half of the
Manufacturers and Liberal Arts Building.

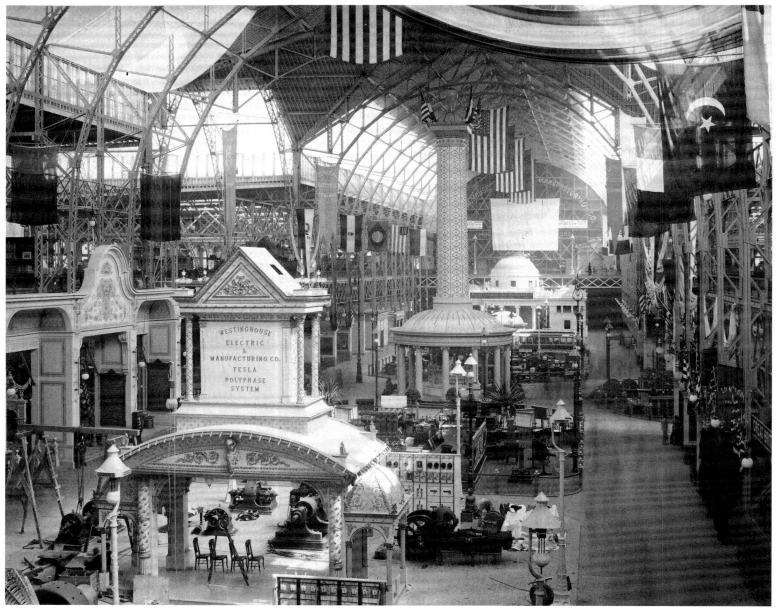

The Edison Tower of Light, a column 30 feet in diameter covered with thousands of incandescent lights and rising 78 feet, dominated the interior of the Electricity Building.

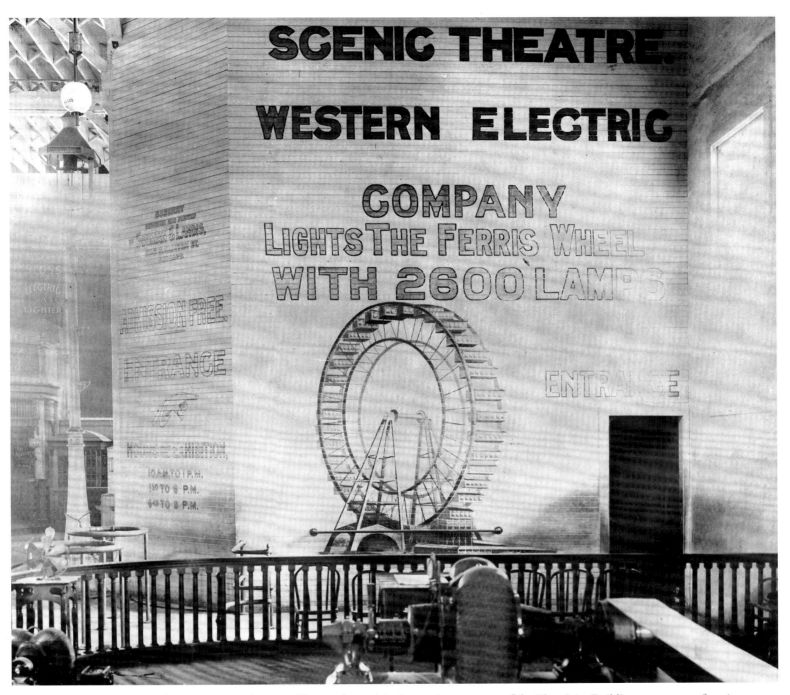

Western Electric Company's Scenic Theatre, located in the southeast corner of the Electricity Building, was a great favorite among fairgoers. Featuring seating for an audience of 175, the theater used incandescent lighting to reveal theatrical effects by simulating the light transitions that take place over one day.

The main hall of Machinery Hall, also called the Palace of Mechanical Arts, was one of three spaces of the structure (about 125 feet wide) defined by the large steel arched trusses. The interior exhibits were displayed in sections: power station, pump house, machine shop, sawmill building, boilerhouse extension, and oil-pump house.

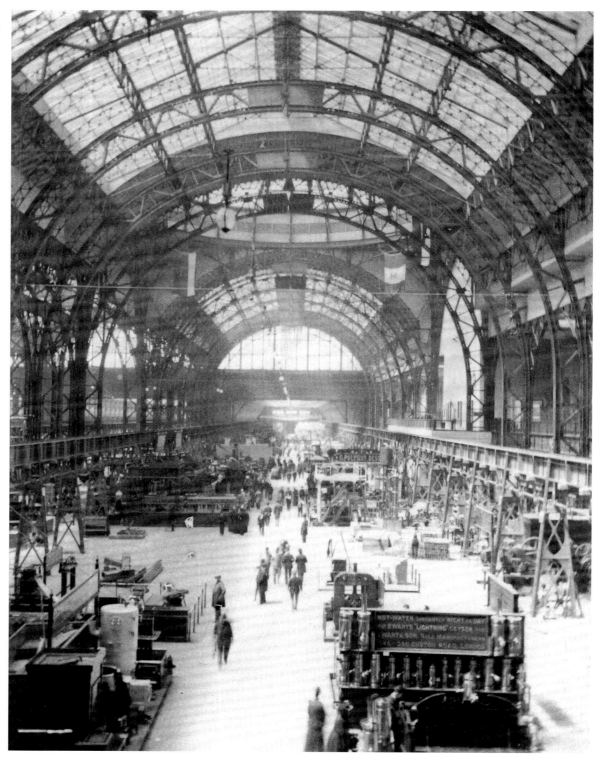

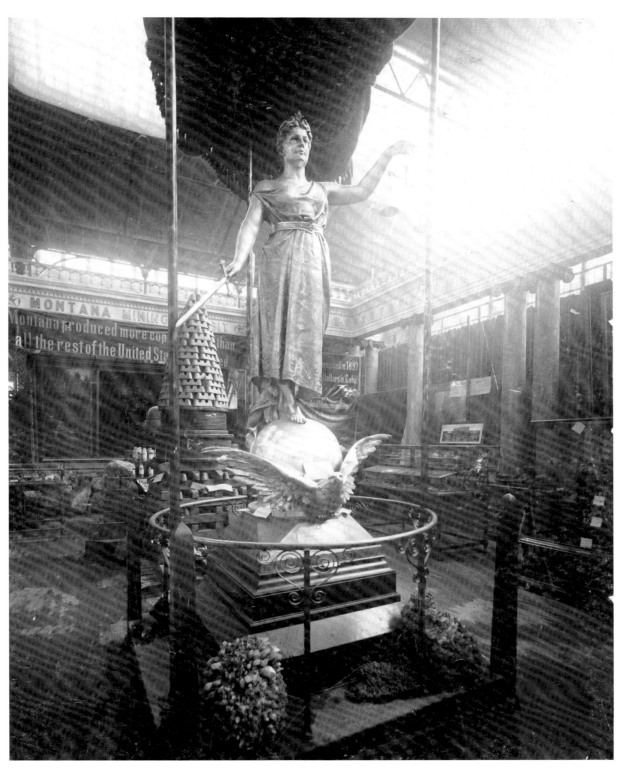

Montana's mining exhibit featured a seven-foot statue of *Justice* (no blindfold but eyes wide open) astride the back of an eagle made entirely of silver.

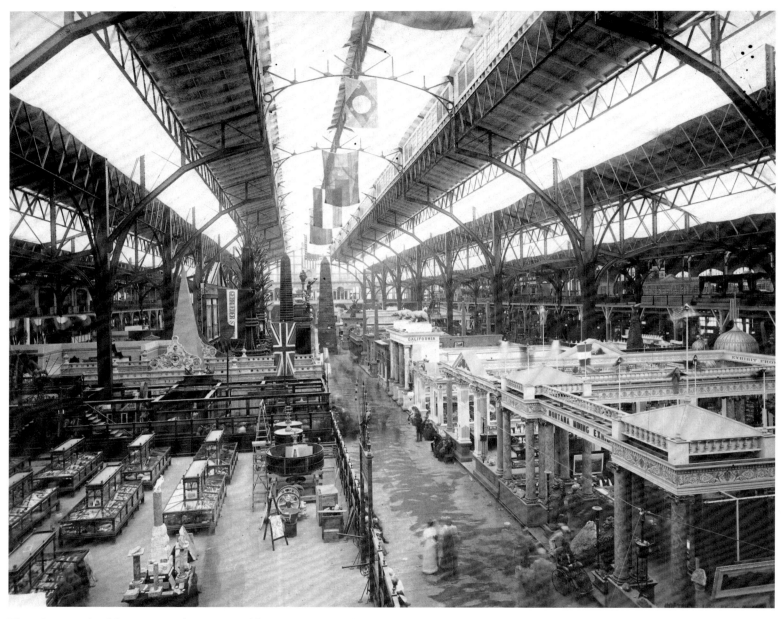

This photograph of the Mines and Mining Building interior was taken looking north toward the obelisk. The main thoroughfare running the length of the structure, called Bullion Boulevard, divided the foreign displays on the west side (left) from the domestic displays on the east side (right).

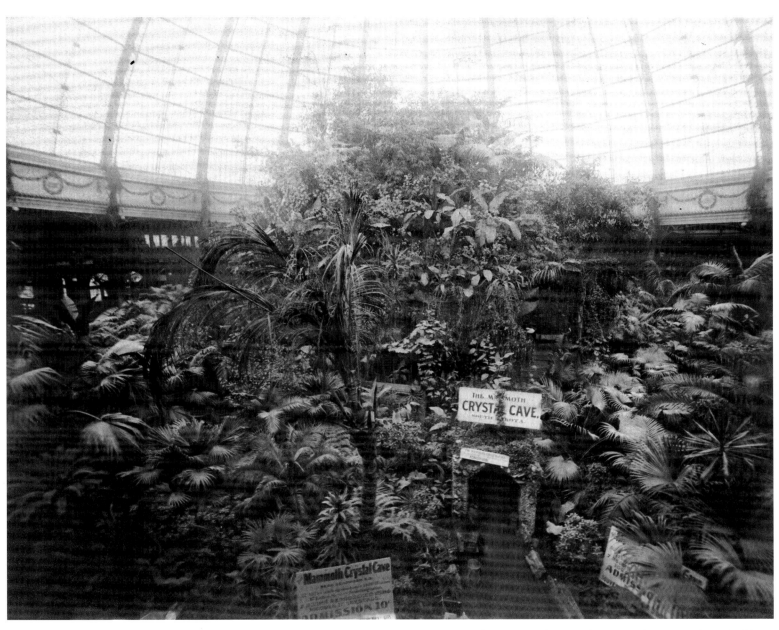

An overabundance of signs greeted visitors at the entrance to the Mammoth Crystal Cave in the Horticulture Building. This reproduction attraction, which required an additional 10-cent entrance fee, was meant to simulate the famous cave near Deadwood, South Dakota.

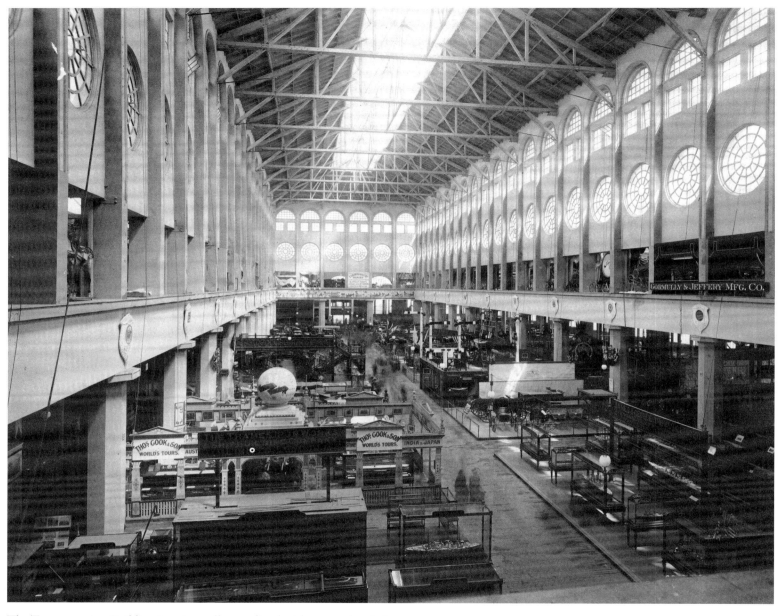

The Transportation Building interior walls were lined with rose-style windows.

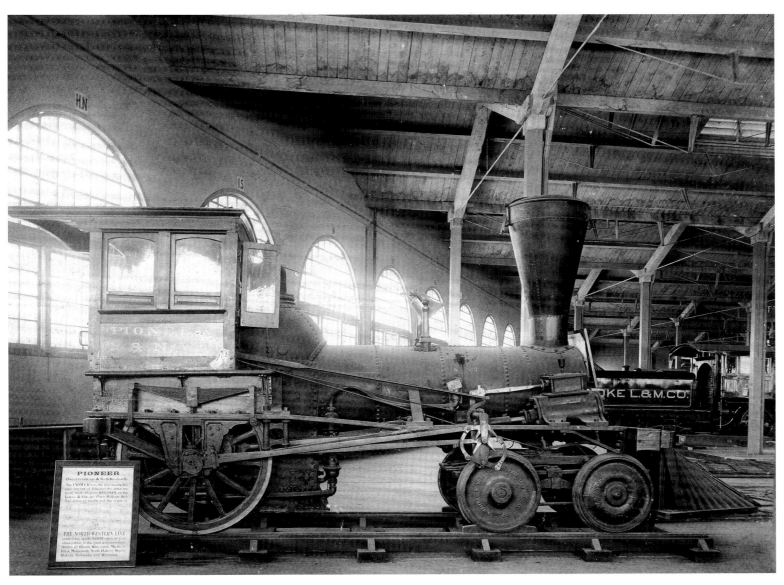

The *Pioneer* locomotive was on exhibit in the annex attached to the Transportation Building. The *Pioneer*, manufactured by Baldwin Locomotive Works, arrived in Chicago in 1848 and was the first railroad locomotive to operate in the city, running on the Galena and Chicago Union Railroad.

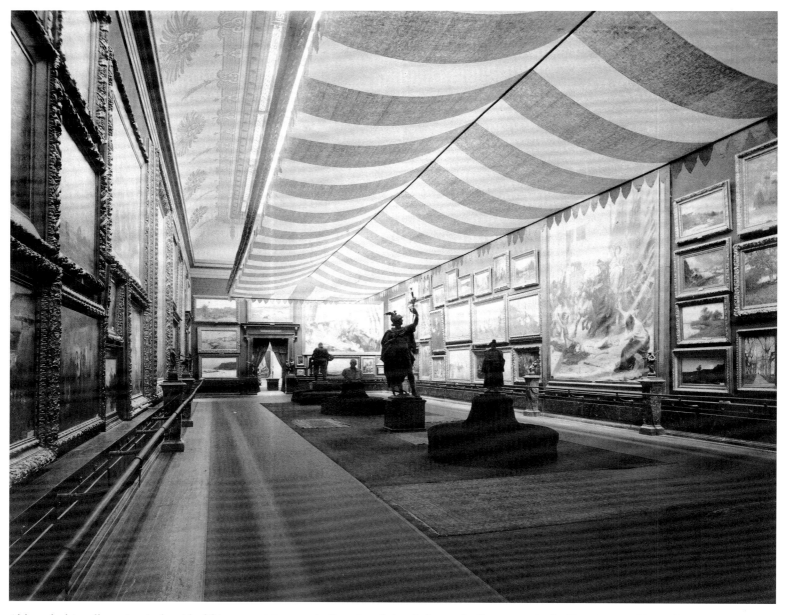

Although this gallery view is devoid of fairgoers, visitors typically enjoyed the plethora of gallery space in the Fine Arts Building, also called the Palace of Fine Arts. The structure featured 10,040 exhibits of paintings, sculptures, etchings, engravings, and watercolors.

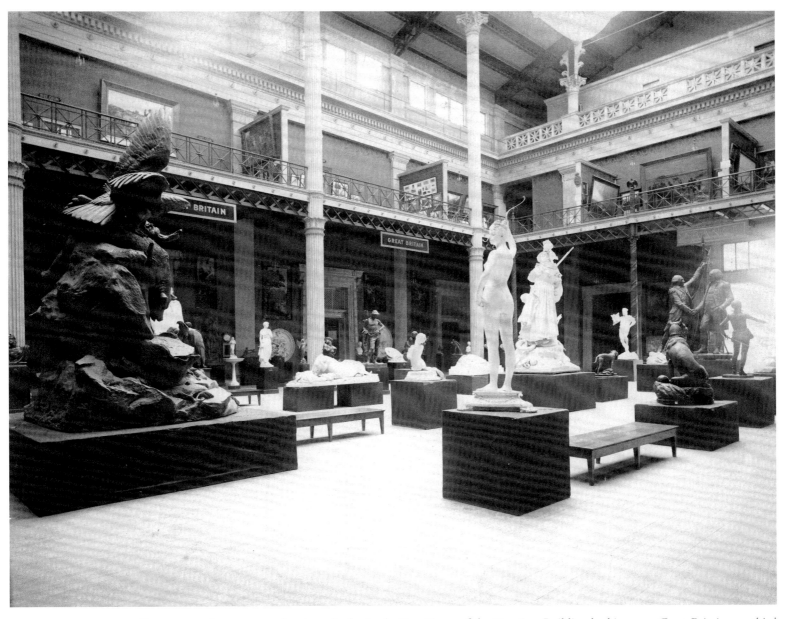

European sculptures were placed on display in the East Court of the Fine Arts Building looking east. Great Britain was third behind France and the United States in space allocated for its art displays.

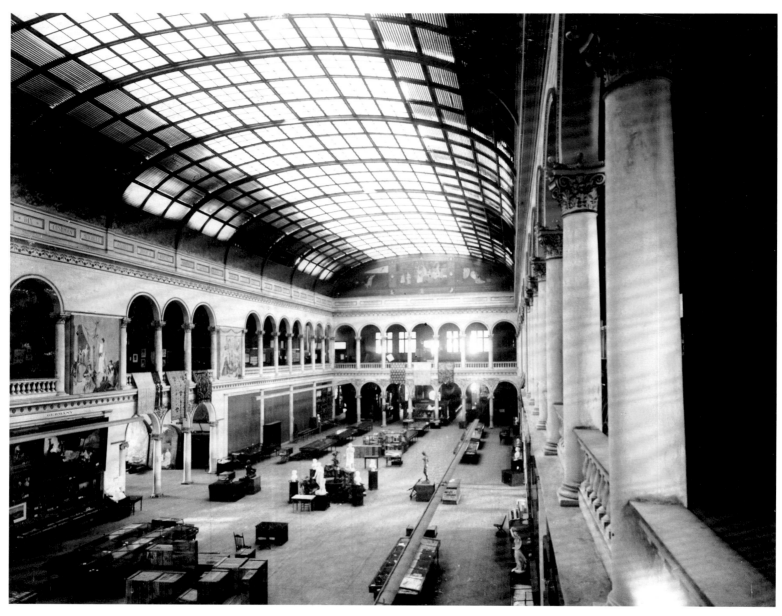

The Woman's Building interior looking south from the balcony shows Mary Cassatt's mural *Modern Woman*, which decorated the south tympanum.

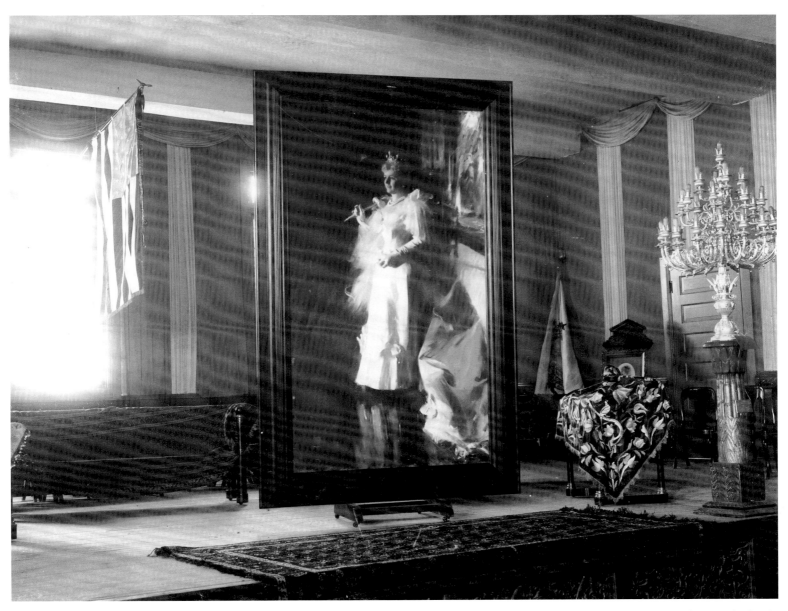

This portrait of Mrs. Bertha Honoré Palmer was displayed in the Assembly Hall of the Woman's Building. The Board of Lady Managers commissioned celebrated artist Anders L. Zorn to paint this portrait of the president of the board to honor her many efforts on behalf of women.

The exhibit of the Berlin
Society for the Education
of the People was displayed
in the German section in
the southeast corner of the
Woman's Building.

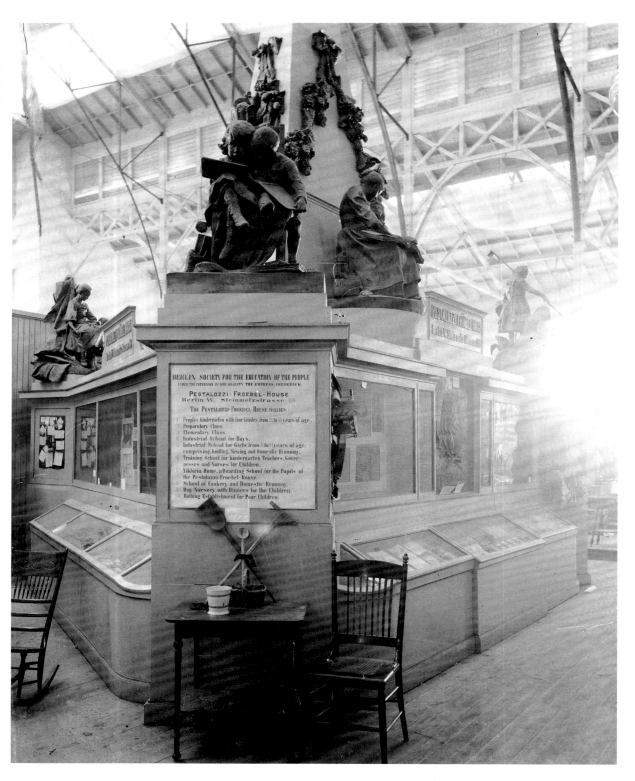

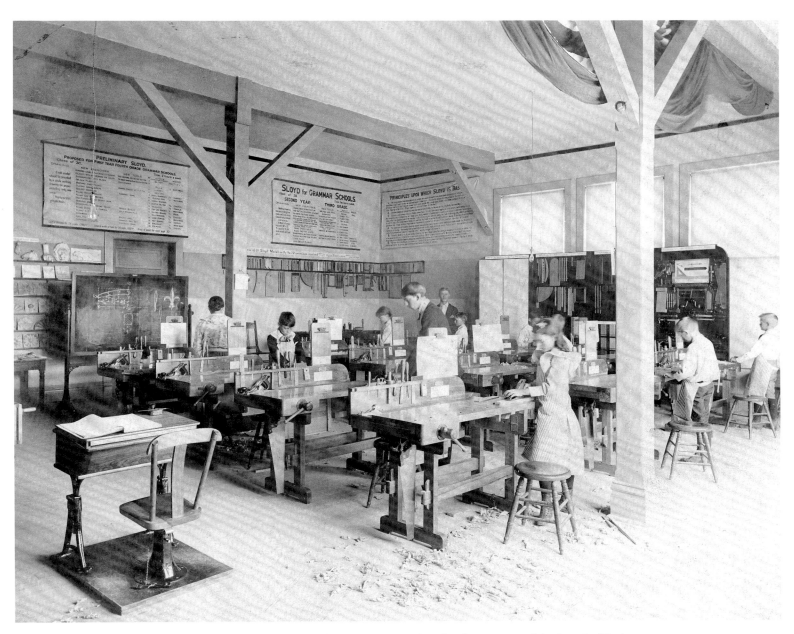

The Children's Building, located south of the Woman's Building, was organized under the auspices of the Board of Lady Managers. Focusing on the education of children, the Children's Building featured a sloyd woodshop, a Swedish educational system structured on handicraft-based learning.

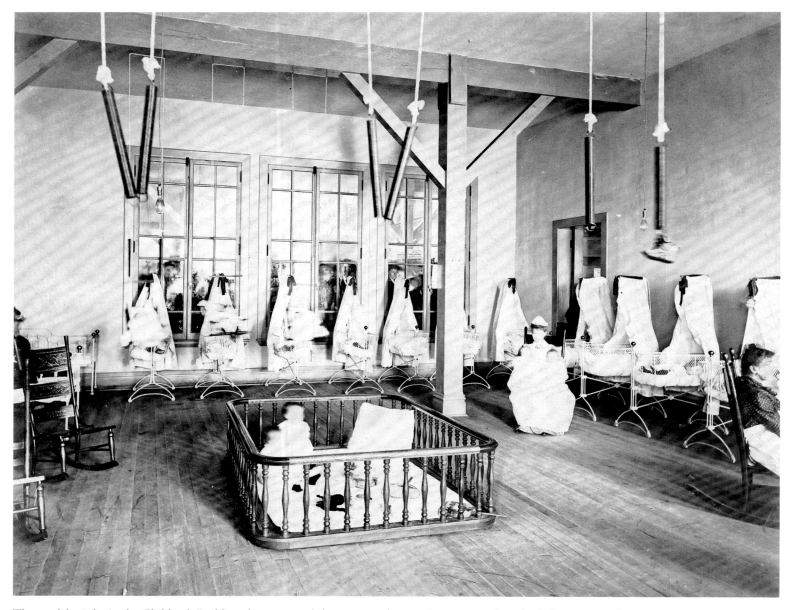

The model crèche in the Children's Building demonstrated the most modern environment and methods for raising infants.

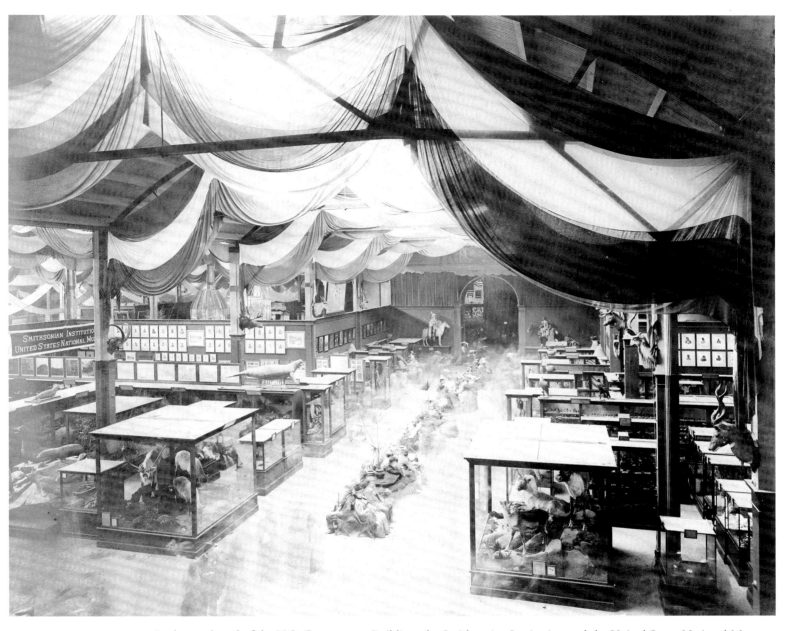

At the south end of the U.S. Government Building, the Smithsonian Institution and the United States National Museum displayed artifacts and specimens from their anthropological and natural history collections. Visitors in the hall pause to sit on benches and view the exhibit.

Columbian souvenir coins, in the form of commemorative half-dollars, were displayed and sold at various locations on the fairgrounds. This model of the U.S. Treasury Building in Washington, D.C., was made of the souvenir coins and displayed in the U.S. Government Building.

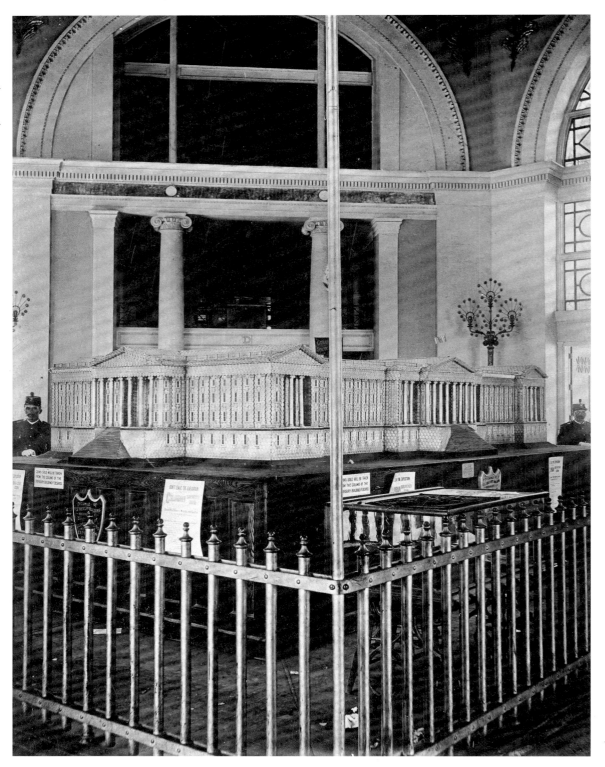

The Utah Building stood at the northern extreme of the fairgrounds next to the Montana Building. Its exterior was designed to simulate various stones from the state, and the interior served as headquarters for the territory commissioners and as a home away from home for visitors from Utah.

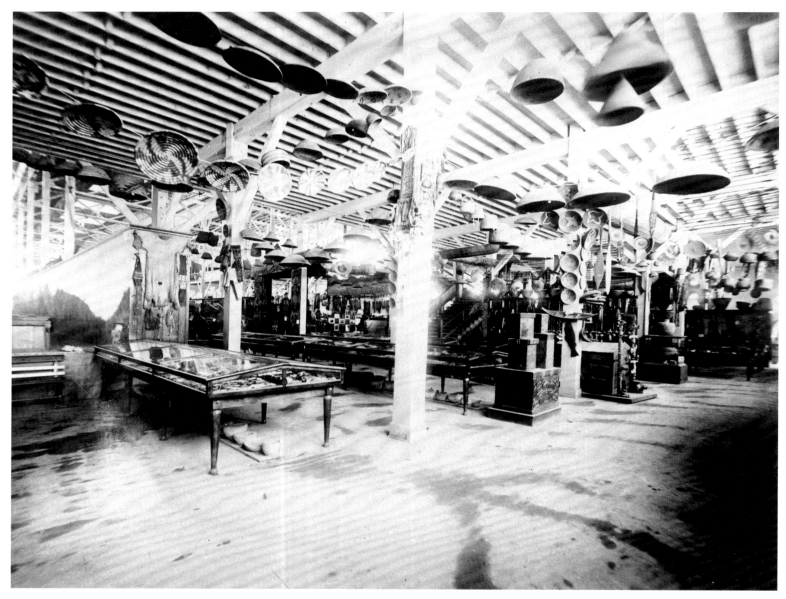

This exhibit of basketry was viewed in the Anthropological Building. Located at the southeastern tip of the fairgrounds just west of the Forestry Building, the Anthropological Building was adjacent to outdoor ethnographic displays. Visitors found additional ethnographic displays on the Midway and in many other buildings.

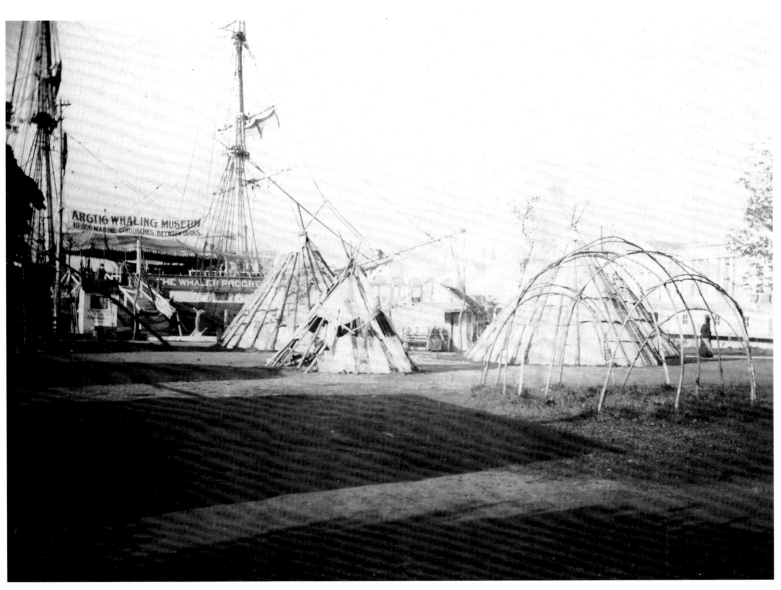

As part of the ethnological exhibit, Native Americans encamped in their indigenous living structures, such as these Penobscot wigwams, along the eastern edge of the South Pond. The masts and rigging of the whaling bark *Progress* is visible in the background.

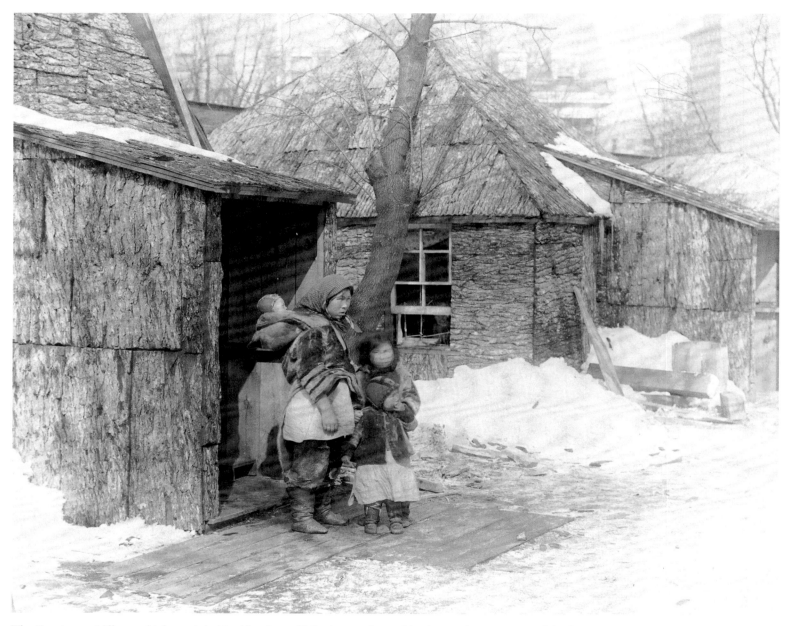

The Esquimaux Village, which was inhabited by about 60 Inuits, was located in the northwest corner of the fairgrounds behind the Nebraska and North Dakota buildings and consisted of bark huts. The Inuits lived in deplorable conditions while in Chicago, and the organizing concessionaire forced them to wear their fur coats during the hot summer months.

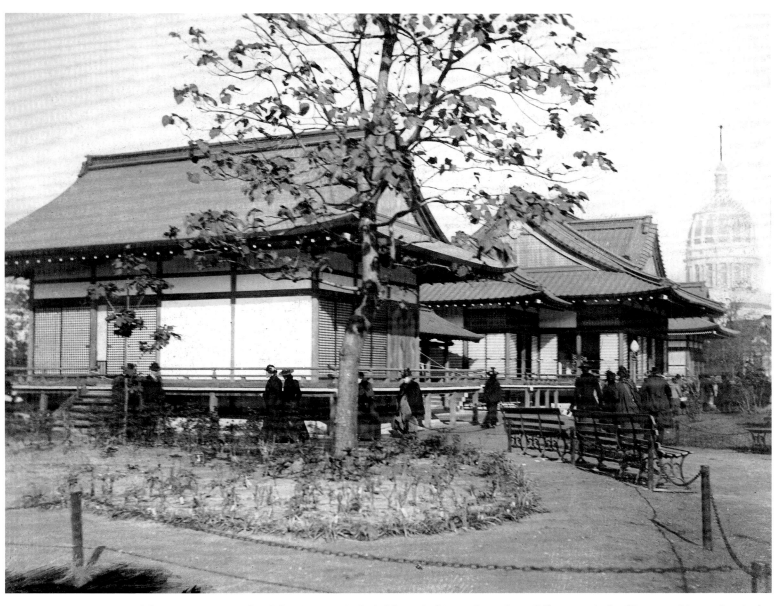

The Japanese Ho-o-den Palace interior included historical items from three different periods of Japanese history, but it also represented the work of contemporary artists, who designed the interior spaces under the auspices of the Tokyo Fine Arts Academy.

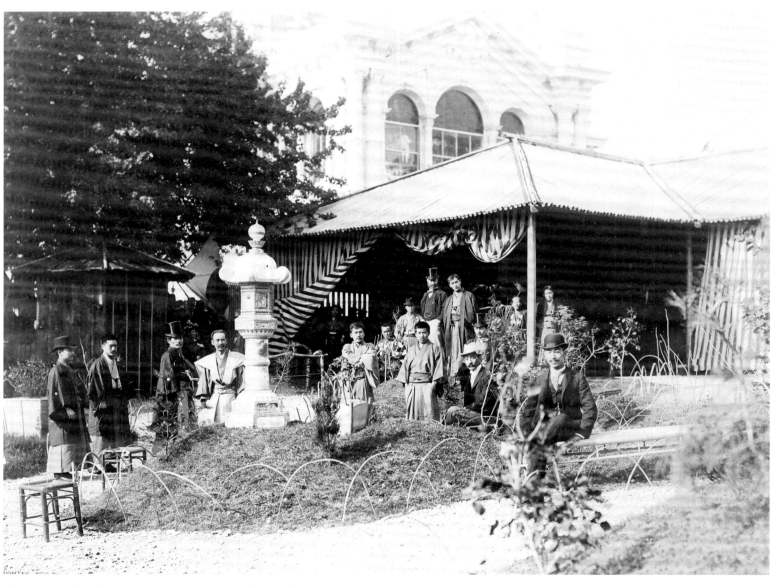

The Japanese Tea House, which was located northeast of the Wooded Island next to the Café De Marine, required separate admission and offered light lunches and tea.

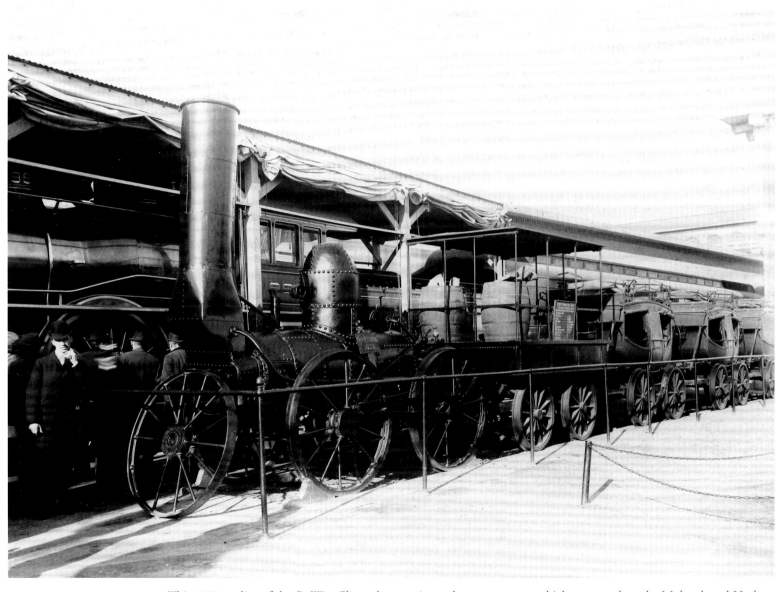

This 1831 replica of the *DeWitt Clinton* locomotive and passenger cars, which were used on the Mohawk and Hudson Railroad, was displayed outside the annex of the Transportation Building as an historical contrast to the examples of contemporary steam engines.

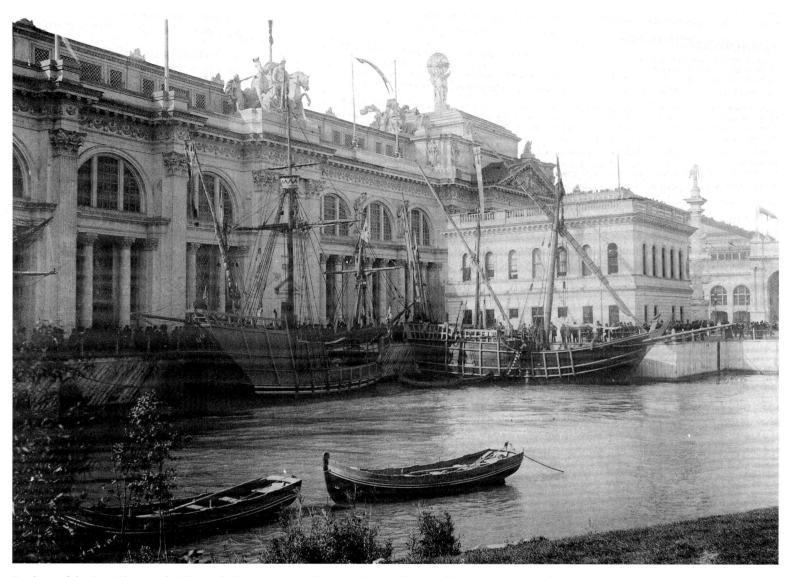

Replicas of the Spanish caravels *Niña* and *Pinta* are moored next to the east facade of the Agriculture Building. The Spanish government provided funds to construct the caravels and sail them to Chicago via the St. Lawrence River and Lake Michigan, where they finally set anchor next to the Convent of La Rabida.

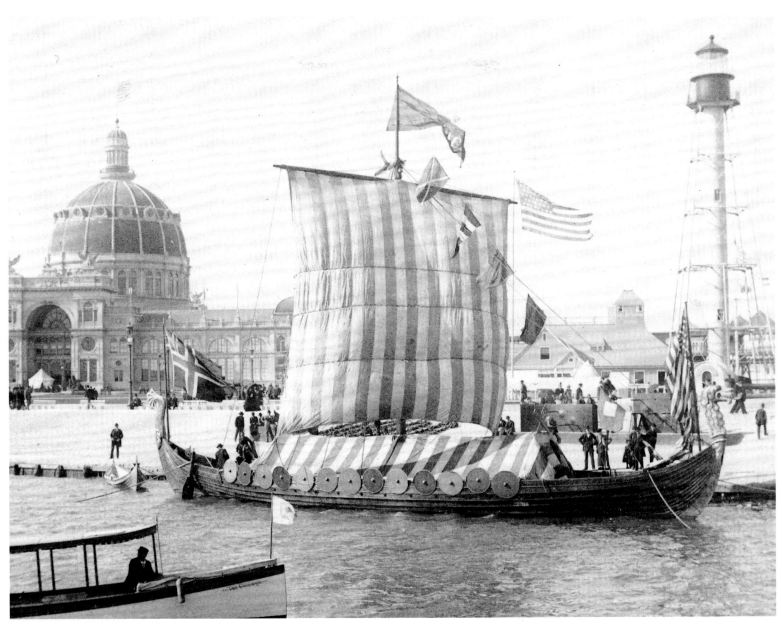

The *Viking,* a replica of the ancient Viking ship *Gokstad,* which had been excavated in 1880, was built in Norway and sailed from Bergen to New York then on to Chicago via the Erie Canal and the Great Lakes. The ship was moored in the naval exhibit area near the battleship *Illinois.*

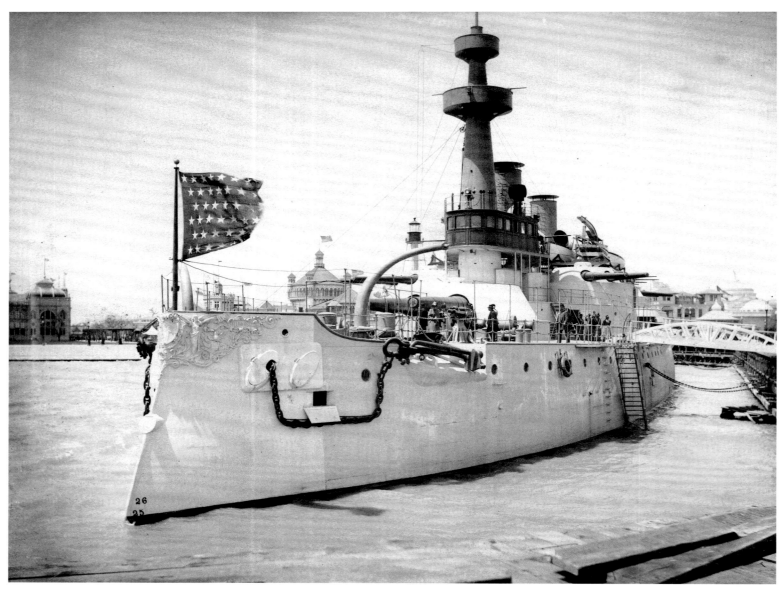

The battleship *Illinois* appeared to be an actual naval vessel. Built on a foundation of brick and concrete, the 348-foot-long ship featured all the fittings of an actual ship, including anchors, guns, turrets, torpedo tubes, awnings, crow's nest, and booms.

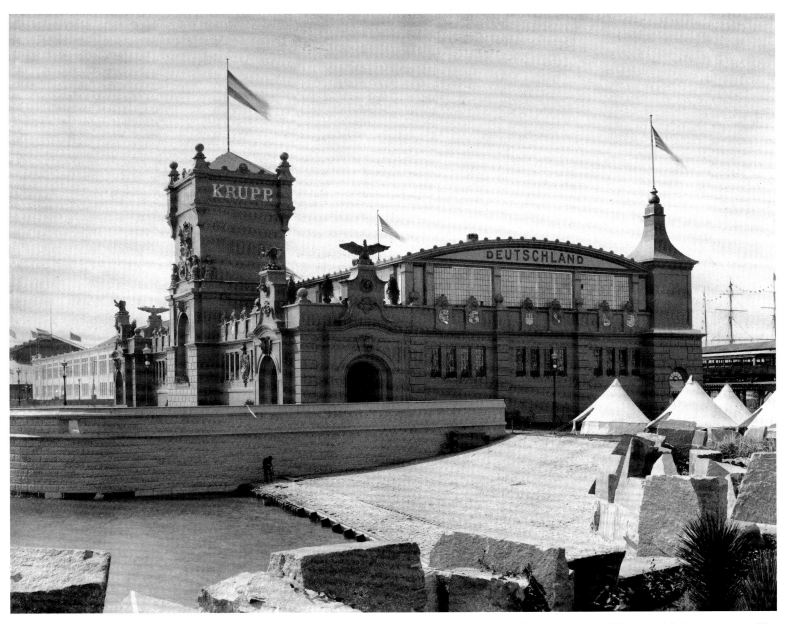

The German gun manufacturer Krupp built a separate building just north of the Forestry Building to exhibit its weapons. The main feature was a massive artillery piece 48 feet long and weighing 122 tons, which fired an explosive 2,300-pound shell a distance of six miles.

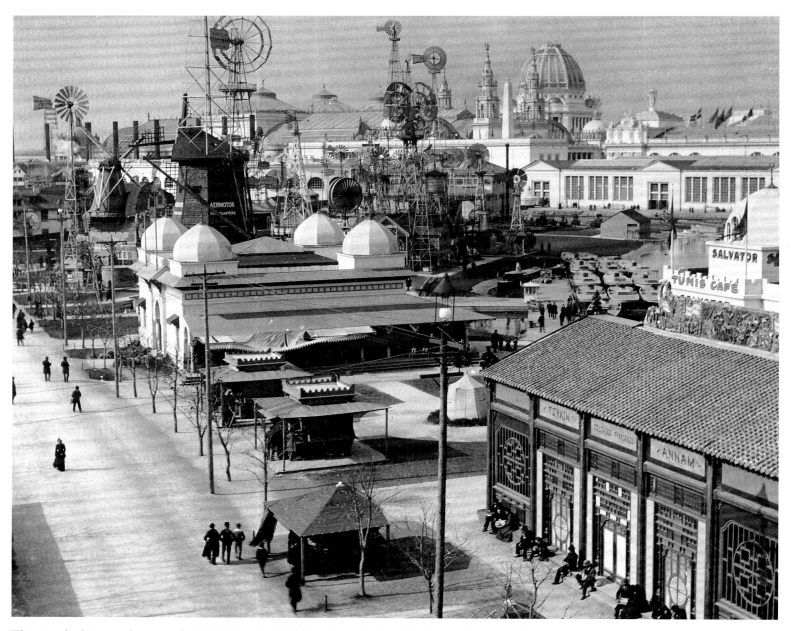

This view looking northwest to the Administration Building shows the French colonies (foreground) and the windmill display. Over 15 windmill companies were featured in the commercial display, with one Dutch windmill that ground cocoa at the fair.

Exhilarating Chaos On The Midway

Originally designed to shepherd overflow crowds from Jackson Park west to Washington Park, the Midway Plaisance emerged as the exposition's center of amusement and entertainment. One mile long and 600 feet wide, the Midway featured structures built without regard to an overall scheme or design; visitors witnessed a collision of styles and experienced a riot of colors, smells, sounds, and people. Theaters, restaurants, villages, models, stores, shops, and amusement rides beckoned the crowds to purchase a ticket, buy a souvenir, or watch a performance.

Arab, Asian, and African villages were commercial ventures that doubled as living educational ethnological exhibits. Organizers presented these cultures as inferior—even barbaric—but the German, Austrian, and Irish villages were embraced as representative of the superior western civilization. The Streets of Cairo boasted re-creations of more than 60 shops and theaters and featured donkey and camel rides and a daily street scene of a wedding or birthday. Many patrons flocked there for the women performing the erotic *danse du ventre* in the Egyptian Theatre. But the Ferris wheel dominated the Midway with its physical presence and its imaginative power. The twin wheels scraped the sky at 262 feet. The 36 cars could carry 2,160 people for two revolutions every 20 minutes for a fee of 50 cents each. The view of the White City from the top of the wheel was spectacular.

The Midway was an overwhelming success. The concentration of concessions brought a steady revenue stream to the corporate coffers, and despite its chaotic look and feel, the smaller-scaled Midway was more manageable to visit and enjoy than the rest of the fairgrounds. Ironically, the juxtaposition and mixing of cultural styles and people, which made many visitors uncomfortable, was, unbeknown to everyone, a glimpse into the future—a harbinger of twenty-first-century America.

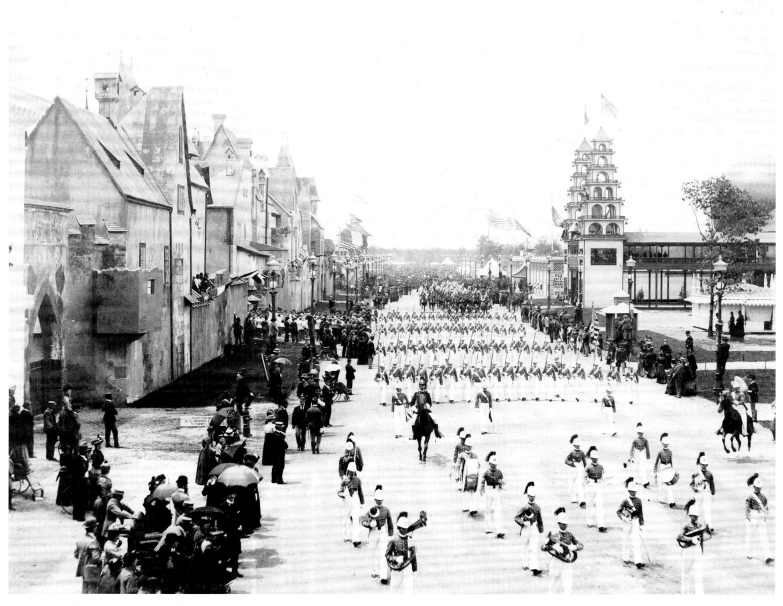

Michigan cadets march west on the Midway past the Old Vienna complex (left) with the Captive Balloon (right) in the distance. The Midway Plaisance featured daily events to attract visitors.

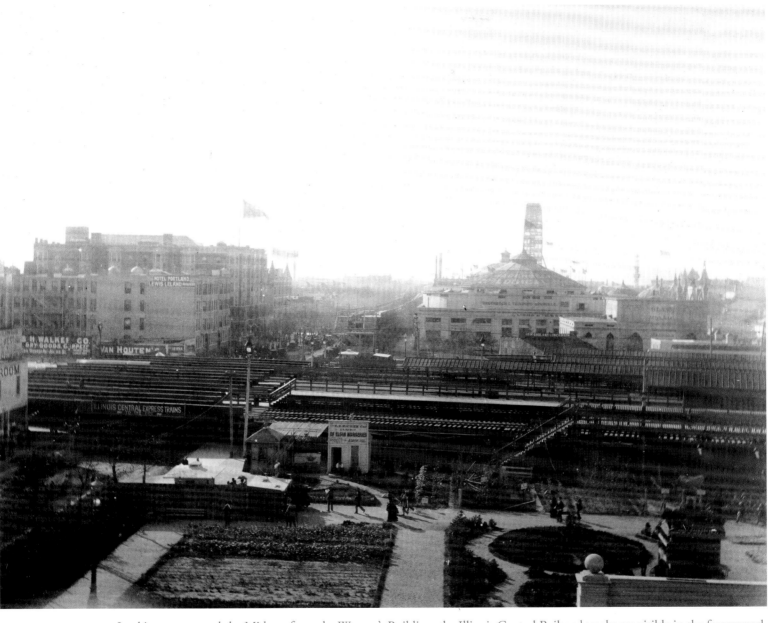

Looking east toward the Midway from the Woman's Building, the Illinois Central Railroad tracks are visible in the foreground, and the Ferris wheel is in the background. Hagenbeck's Zoological Arena Company building, where Karl Hagenbeck trained animals to sell to circuses, is also seen in the distance.

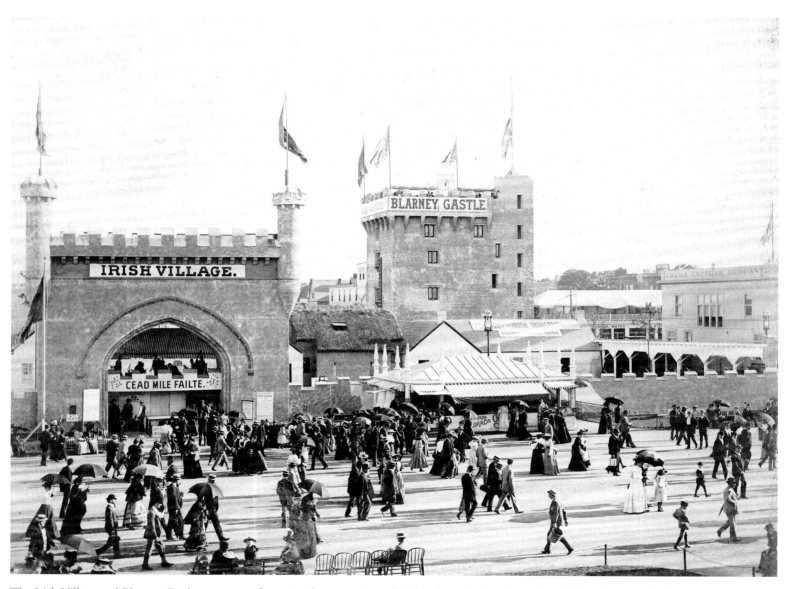

The Irish Village and Blarney Castle were part of a national presentation of Irish culture, industries, and traditions that appealed to the many Americans of Irish decent. A piece of the genuine Blarney Stone, music, food, and a re-creation of Donegal Castle were featured.

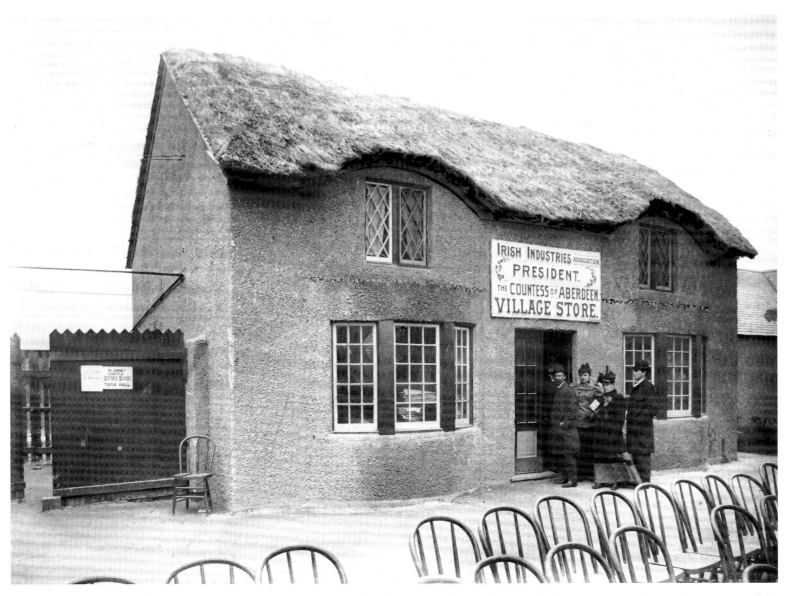

The village store was typical of the thatched-roof stone buildings in the Irish Industries section at the southeast corner of the Midway. Lace makers, weavers, and butter and cheese makers demonstrated their crafts in the village area, and visitors were presented with a genuine piece of sod from Ireland.

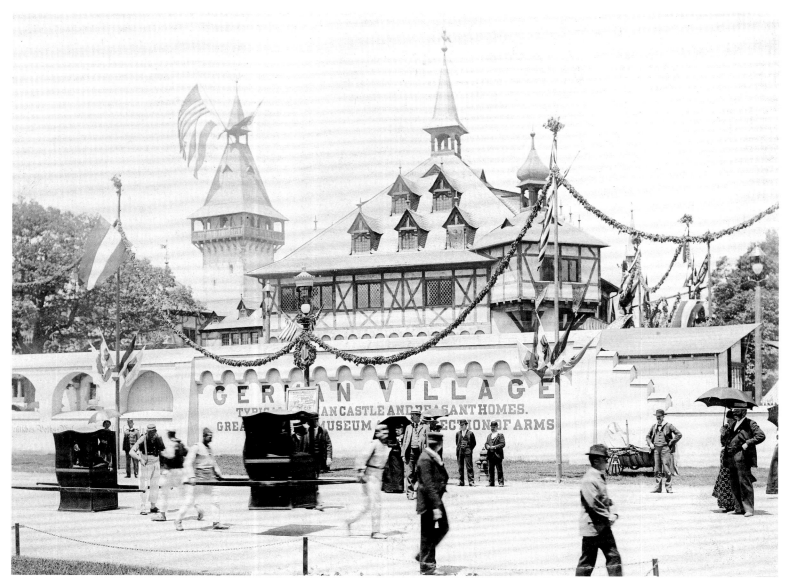

The prominent German presence on the main fairgrounds was reinforced on the Midway. The German Village, located between the Javanese area on the east and the Streets of Cairo on the west, occupied the largest space on the Midway. Visitors could rent the sedan chair to be carried around the Midway.

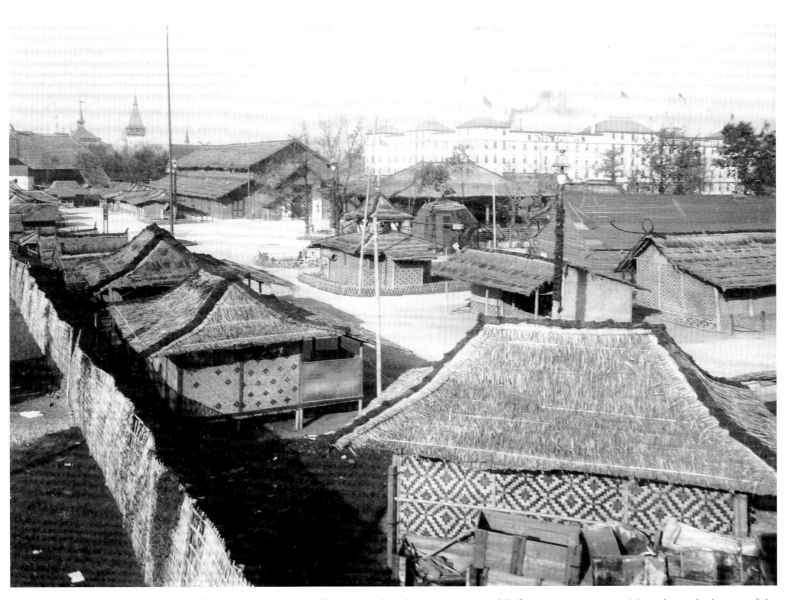

The Java Village, which had originally appeared at the 1889 Paris world's fair, cost 10 cents to visit and was the largest of the South Sea villages comprising the Dutch Settlement exhibition. Made of grasses, leaves, and split bamboo woven together to create intricate designs, the village offered a theater with traditional music, dance, and puppetry, and workshops where Javanese demonstrated their crafts.

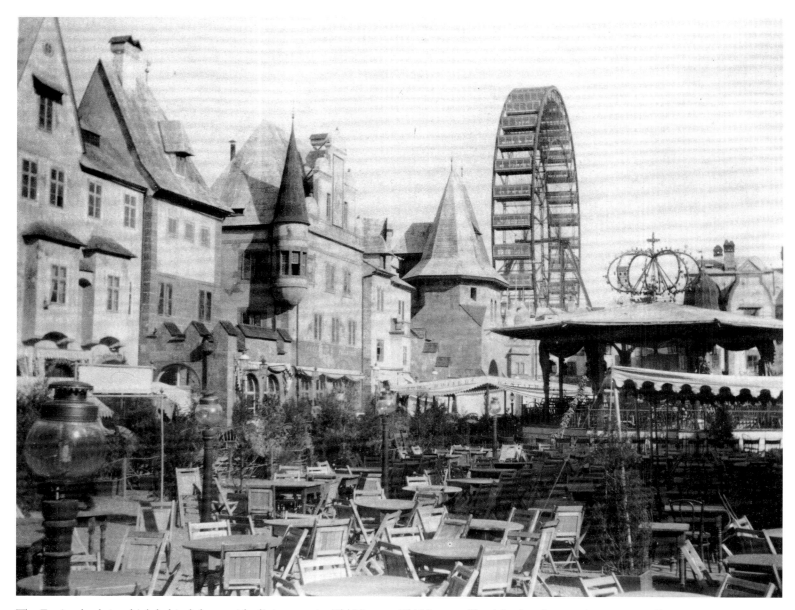

The Ferris wheel rises high behind the outside dining area in Old Vienna. Old Vienna offered food and entertainment, as well an almost complete re-creation of the Viennese street Der Graben as it would have looked around 1750, complete with cafés, shops, homes, and a town hall.

Pictured here is the Old Vienna dining area. Because amateur photographers were not allowed to use tripods with their cameras at the fair, they resorted to creative and ingenious methods to keep the camera steady, including setting it on a tabletop.

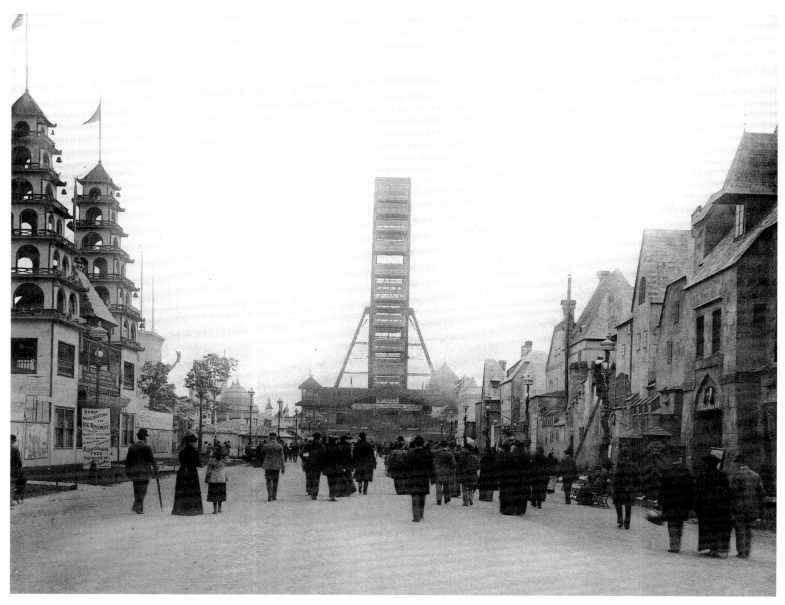

Crowds walk east on the Midway toward the Ferris wheel. The Chinese Theater is on the left and Old Vienna is on the right. A sign at left that reads "Do not miss the Ice Railway, the greatest novelty and attraction on the Midway" entices visitors with free admission.

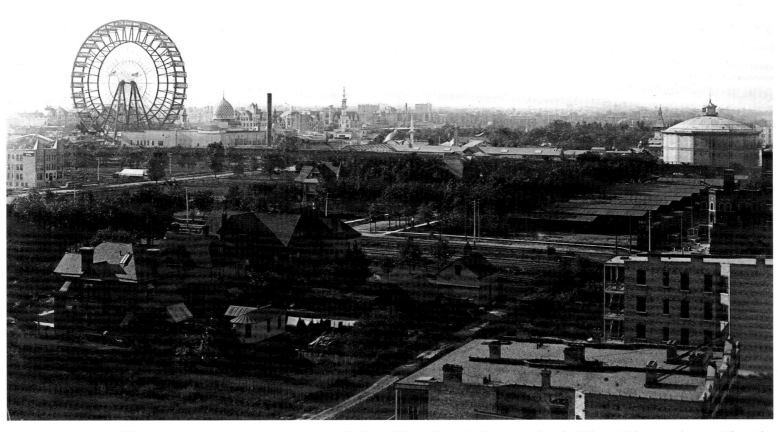

This view facing north shows the eastern half of the Midway from the Ferris wheel to the Kilauea Volcano cyclorama. The mile-long strip of amusements charged extra fees in addition to general admission to the fairgrounds.

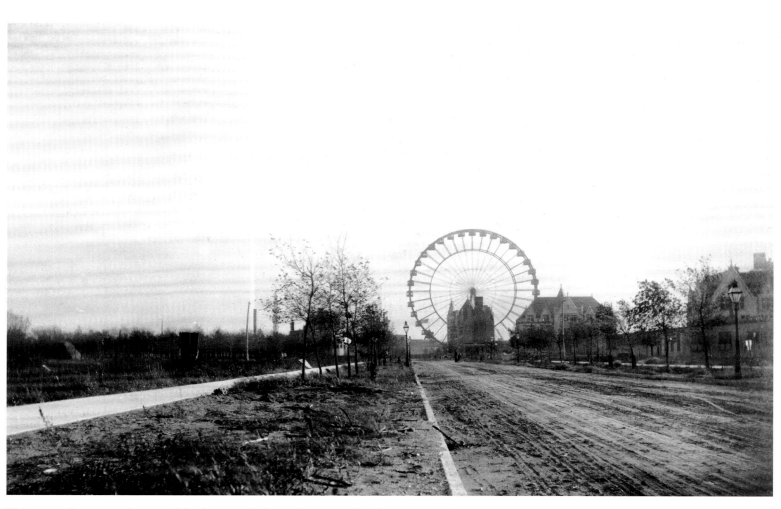

This unusual amateur photograph looking north shows the Ferris wheel looming over the Hyde Park neighborhood, which the Midway cut through on an east–west line.

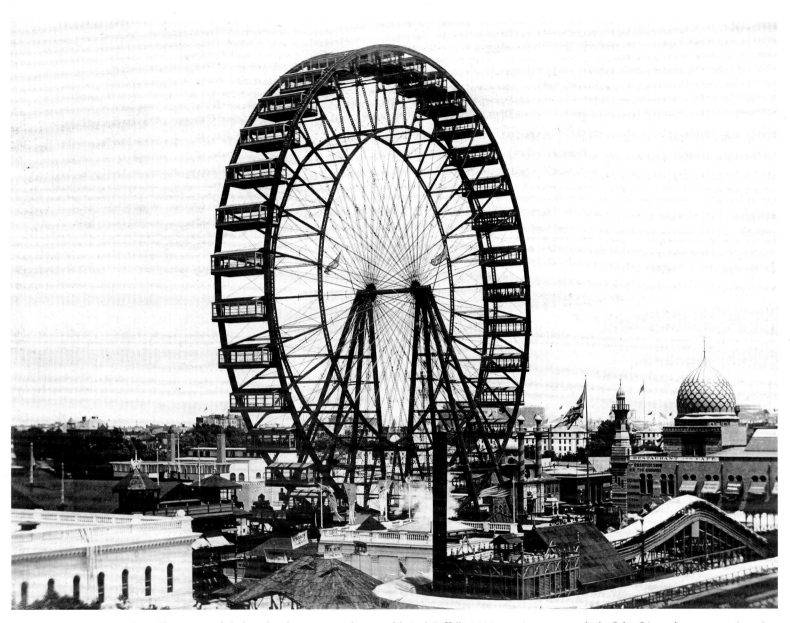

When all attempts failed to develop a tower that would rival Eiffel's 1889 creation as a symbol of the fair and a great engineering feat, fair officials turned to Pittsburgh bridge designer George Washington Ferris, who proposed a massive revolving wheel. The Ice Railway is visible in the foreground, and the dome of the Moorish Palace is on the right.

The 264-foot-tall Ferris wheel carried 36 cars, each with a capacity to hold 60 people. Although the wheel was not finished until June—more than a month after the fair opened—it was an immediate success, and visitors lined up to pay 50 cents to ride two revolutions.

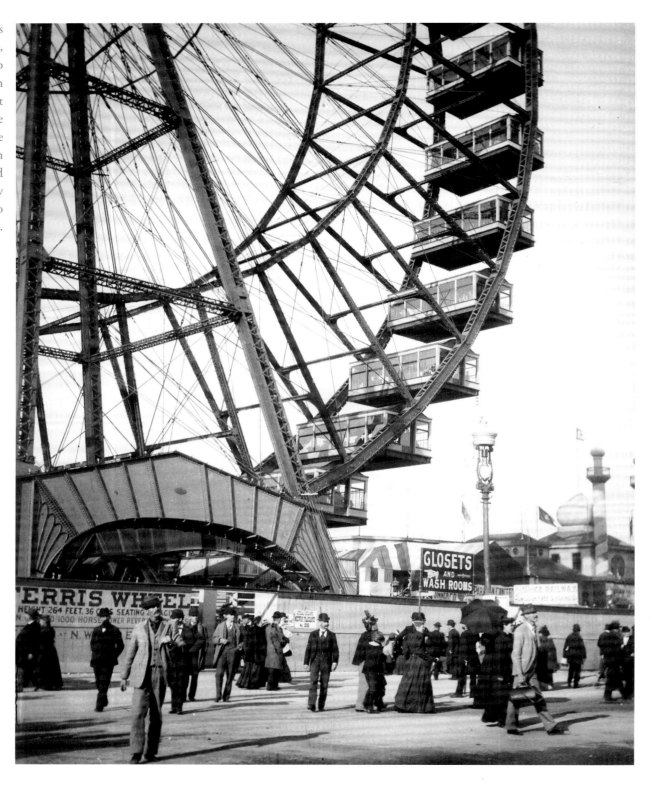

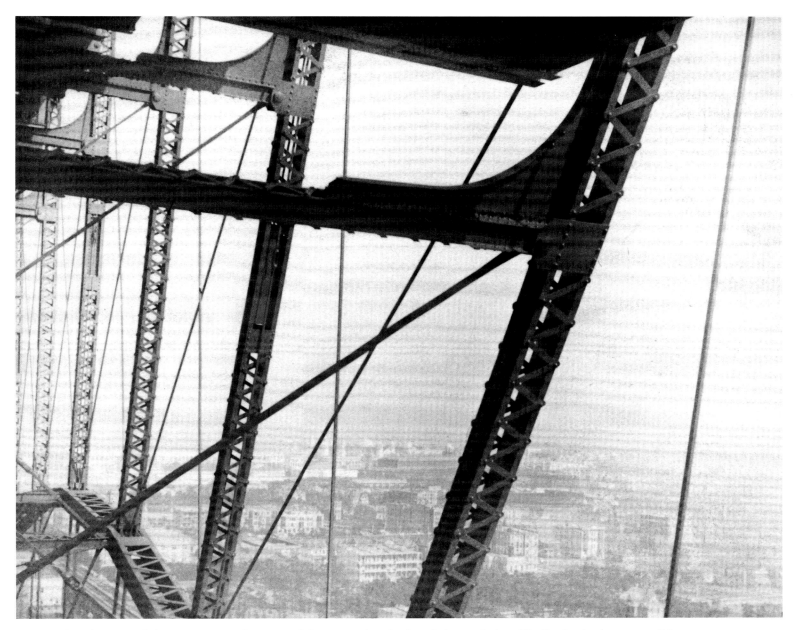

Wires and steel structural elements are seen from one of the cars as the wheel made its revolution. The Ferris wheel was one of the most profitable amusements at the fair, amassing over $300,000 in profits divided between investors and the fair corporation.

Following Spread: A ride on the Ferris wheel offered a spectacular view of the fairgrounds and the Midway to the east. The domes of the Administration Building (right), U.S. Government Building (center), and Illinois Building (left) loom in the distance; the roof of one of the cars is in the foreground.

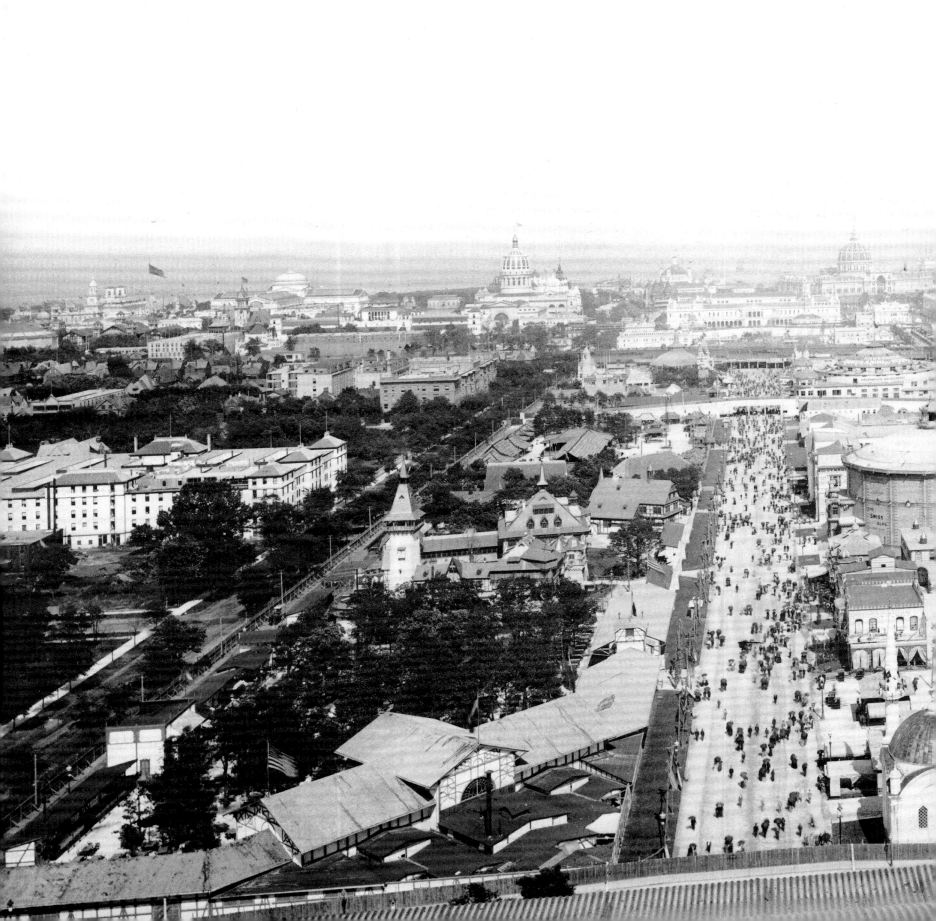

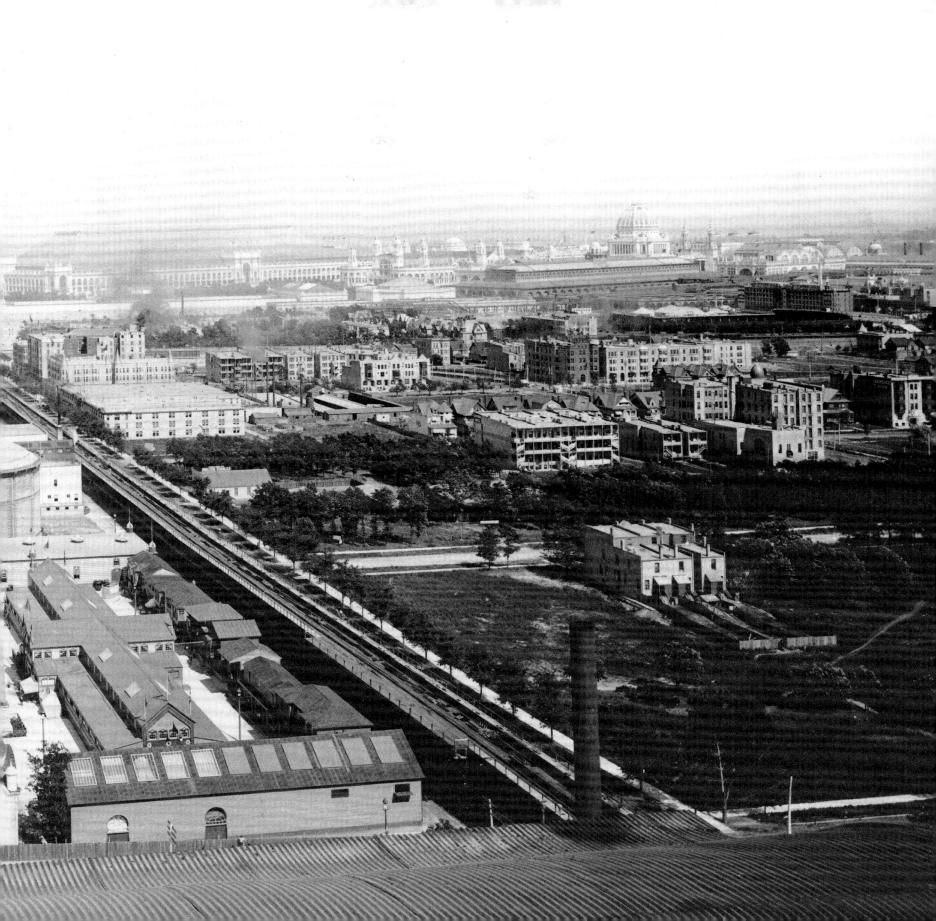

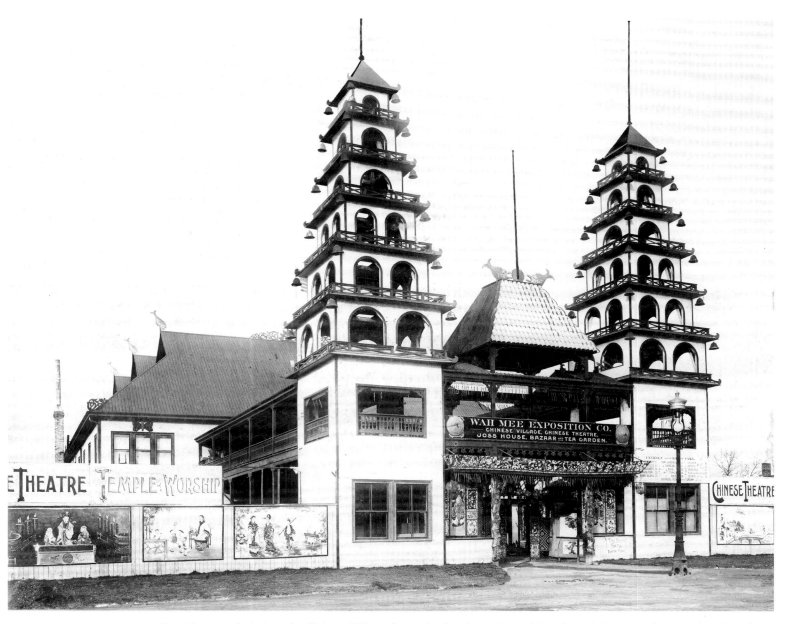

For 25 cents admission, the Chinese Village featured a Joss house (temple), café, and theater with musical and acrobatic performances. A sign lists prices for an assortment of foods, including various meats, rice, and Chinese pudding with cream.

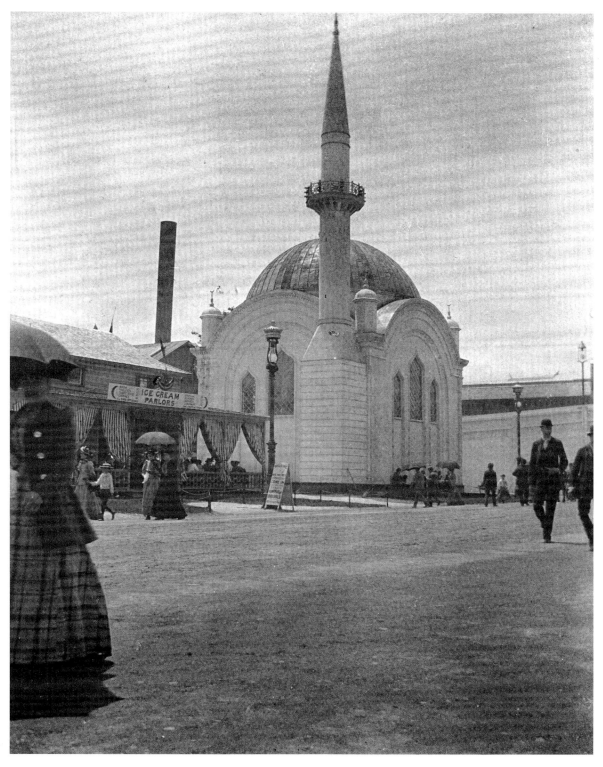

East meets West—with the Turkish Mosque and an ice-cream stand. The juxtaposition of cultural styles, culinary treats, clothing, and personal features delighted some visitors, but others expressed shock and disgust.

The Turkish Village included an obelisk in its Midway compound, and two more obelisks marked the Egyptian Temple. A fourth obelisk was located just north of the Colonnade, south of the Great Basin. This wooden obelisk was a replica of the Egyptian obelisk in the Hippodrome square in Istanbul.

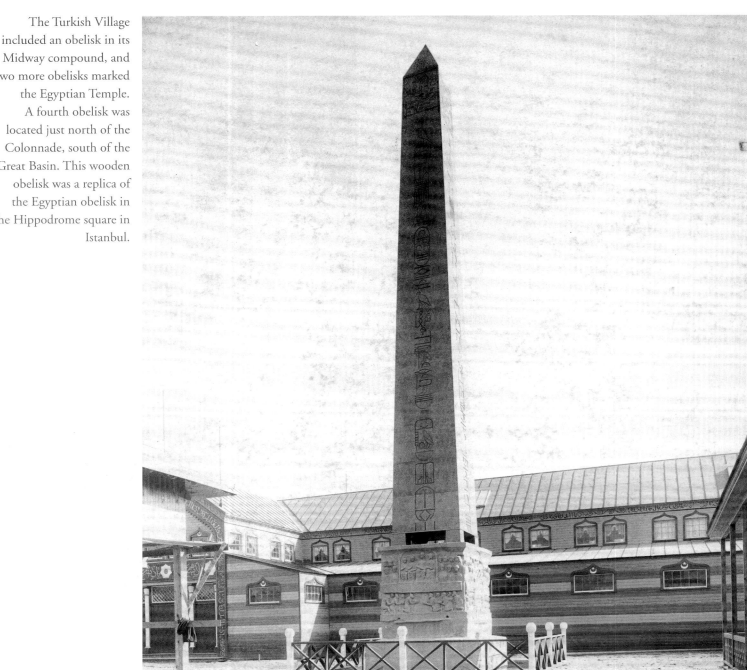

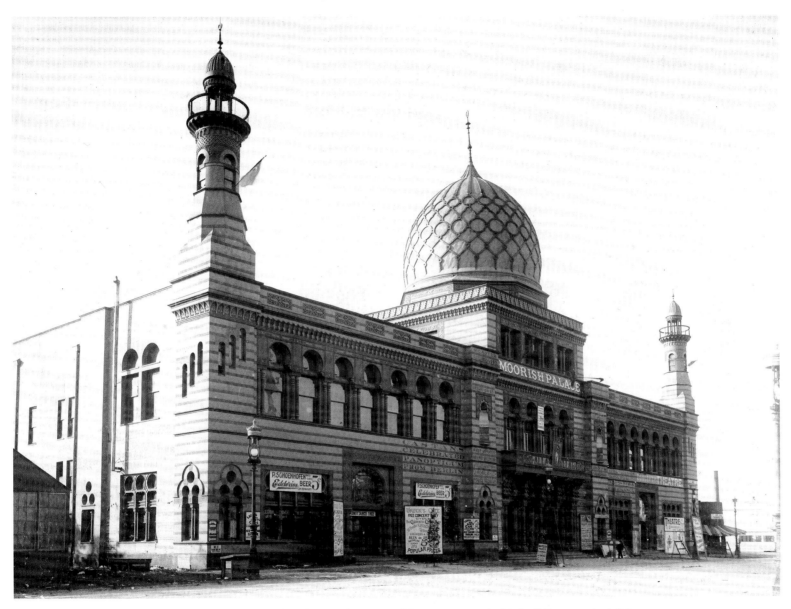

The dome and distinctive architecture of the Moorish Palace made it one of the most recognizable buildings on the Midway. In addition to a café and theater, the Palace offered a hodgepodge of attractions and displays, many of which were unrelated to Moorish culture and life.

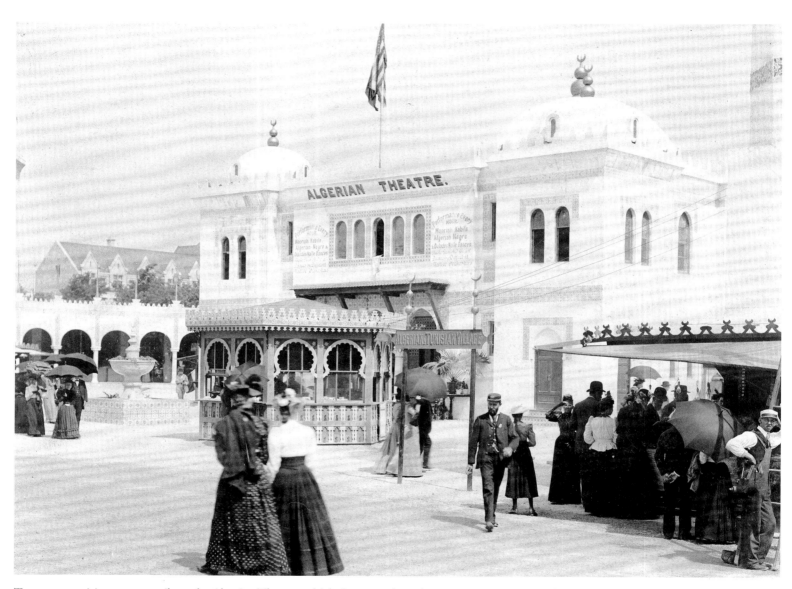

Two women visitors peer warily at the Algerian Theatre, which drew mostly male patrons to view exotic dancers perform in a 1,000-seat auditorium. The theater was part of the Algerian and Tunisian Village and a repeat amusement from the 1889 Paris world's fair. Fairgoers flocked to the re-created Algerian and Tunisian streets, where, for 25 cents, you could see snake charmers, watch jugglers, hear an orchestra perform, and buy souvenirs.

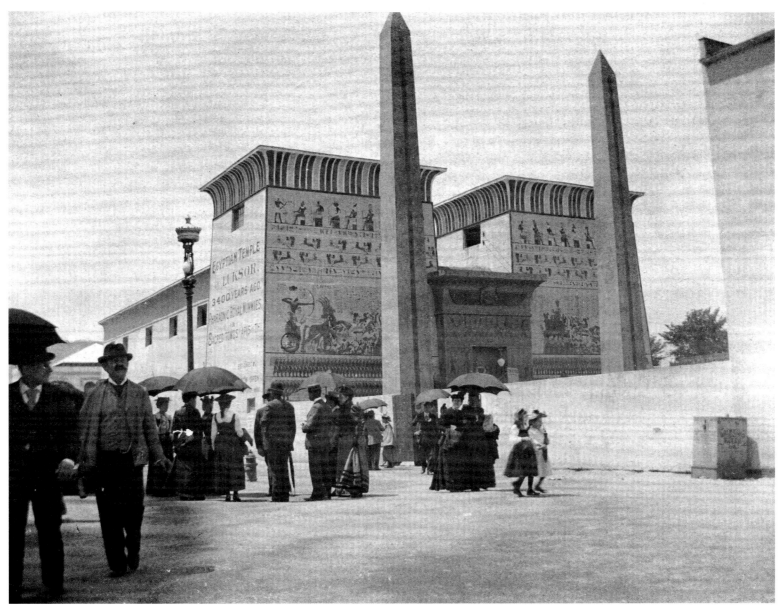

The Egyptian Temple was part of the Streets of Cairo section of the Midway. Egyptian antiquities were on view inside the structure.

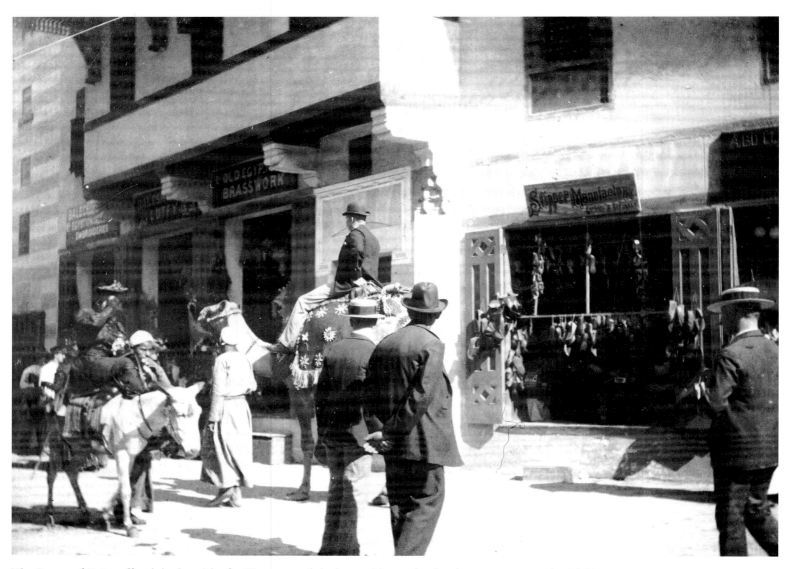

The Streets of Cairo offered donkey rides for 25 cents, and the brave visitors who dared to mount a camel paid 50 cents.

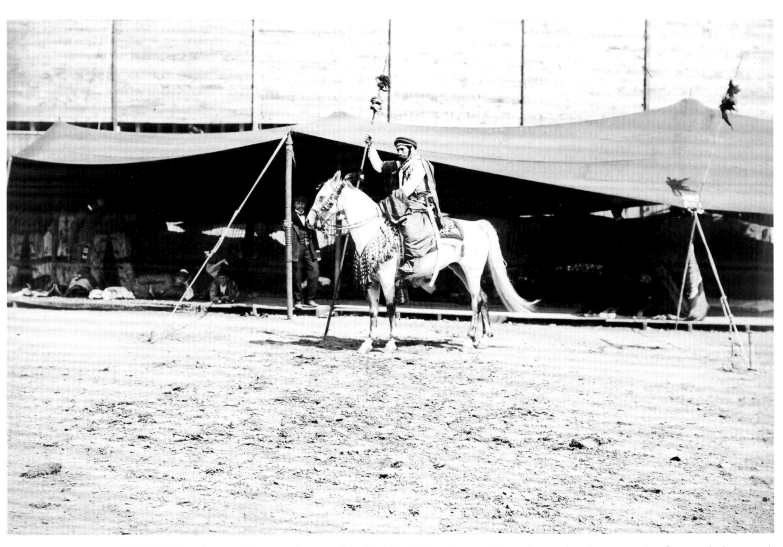

The Wild East show, which was a feature of the Turkish Village, featured Bedouins performing equestrian feats, including mock battles with spears and swords. This show was complimented by Buffalo Bill's Wild West show, which was not affiliated with the exposition or the Midway, but was an independent attraction near the fairgrounds. Because of its location, Buffalo Bill's show, which had been rejected to participate in the fair, took away potential exposition patrons.

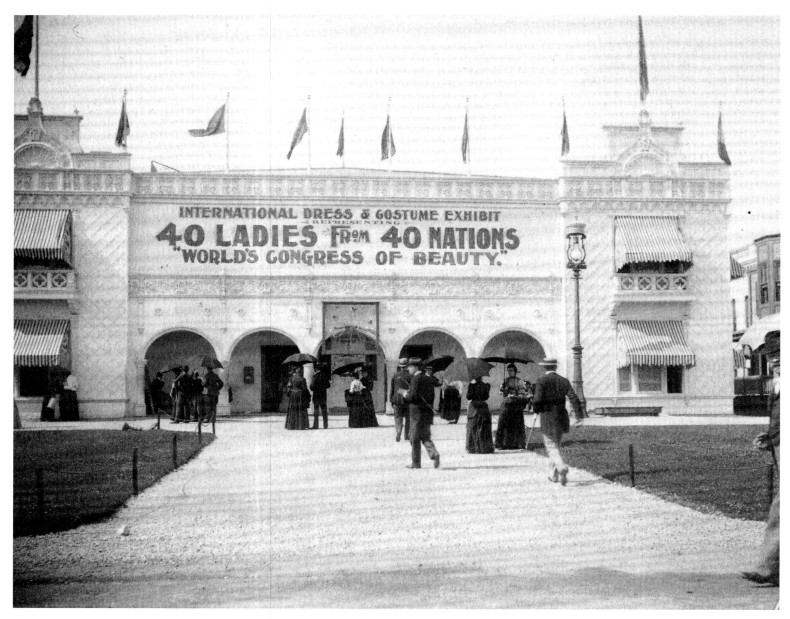

Billing itself as the World's Congress of Beauty, a reference to the many legitimate international meetings on key world topics that the fair sponsored, this display of women wearing native costume sought to brand itself as an educational experience. Some visitors complained that many of the women were not from the nations they represented.

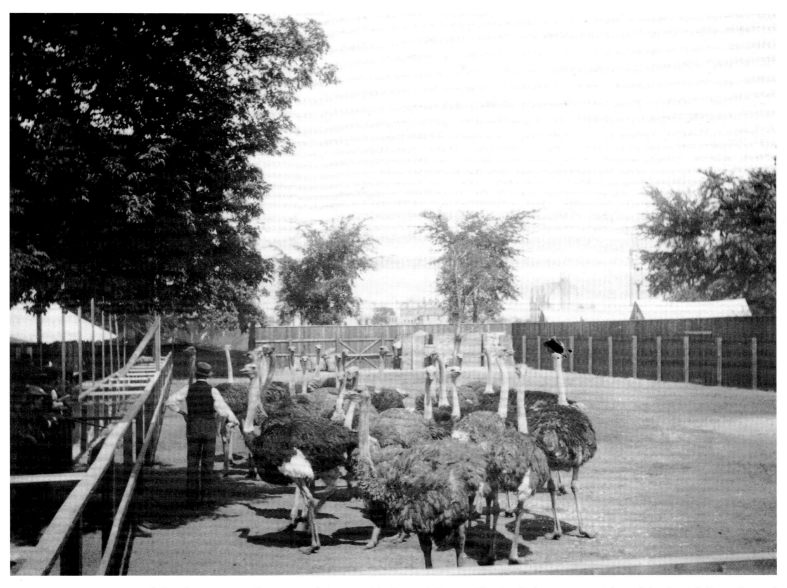

With familiar names such as General Grant, Old Abe, and Grover Cleveland, the exotic ostriches of the Ostrich Farm, located next to the Captive Balloon attraction, provided hours of amusement and wonder for visitors who paid the dime admission.

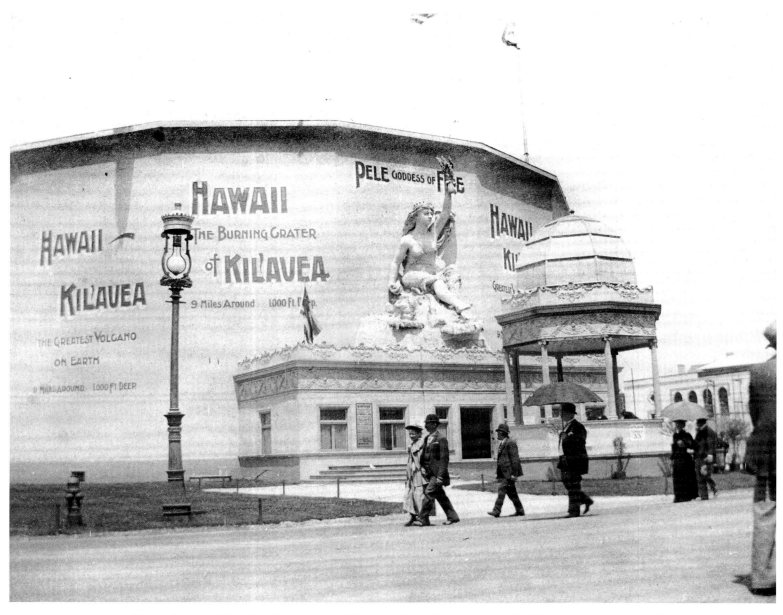

The cyclorama of the Hawaiian volcano Kilauea was housed in the largest building on the Midway and cost 50 cents to enter. Cycloramas, panoramic paintings inside a round or hectagon building that were often accompanied by narration and music, had become popular urban spectacles during the late nineteenth century, and people marveled at these realistic visual illusions.

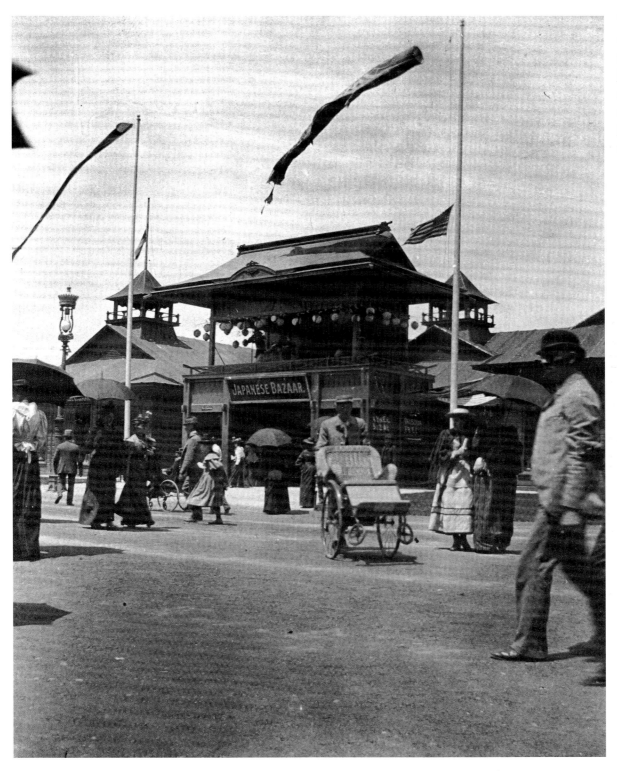

The Japanese Bazaar, which was located between the Irish Village and the Javanese settlement, was a retail operation that was not affiliated with the official Japanese exhibits and structures on the fairgrounds.

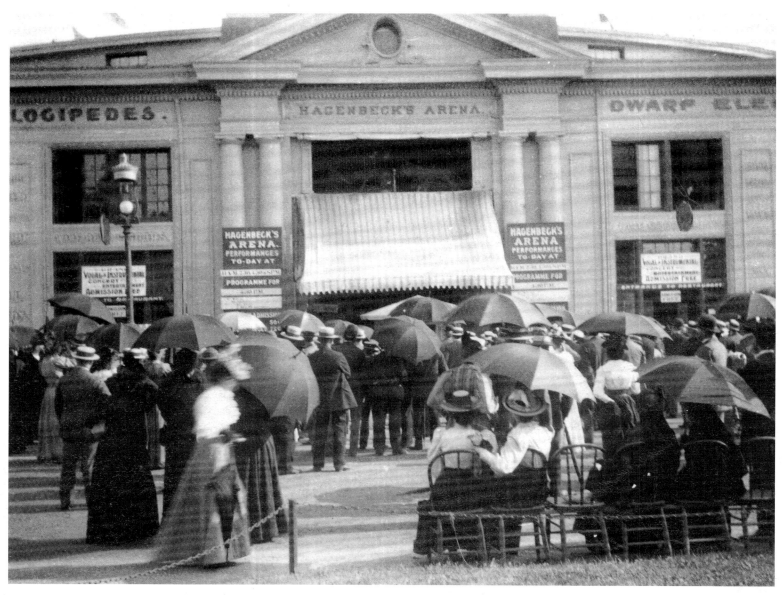

The famous German zoo director Karl Hagenbeck built a complex that included an amphitheater modeled after the Coliseum in Rome and an arena, with admission ranging from 25 cents to one dollar. Under the direction of trainer Miss Liebemich, a cast of exotic animals, including a dwarf elephant, performed unusual feats of skill—including lions riding horses, bears walking tightropes, and tigers riding velocipedes.

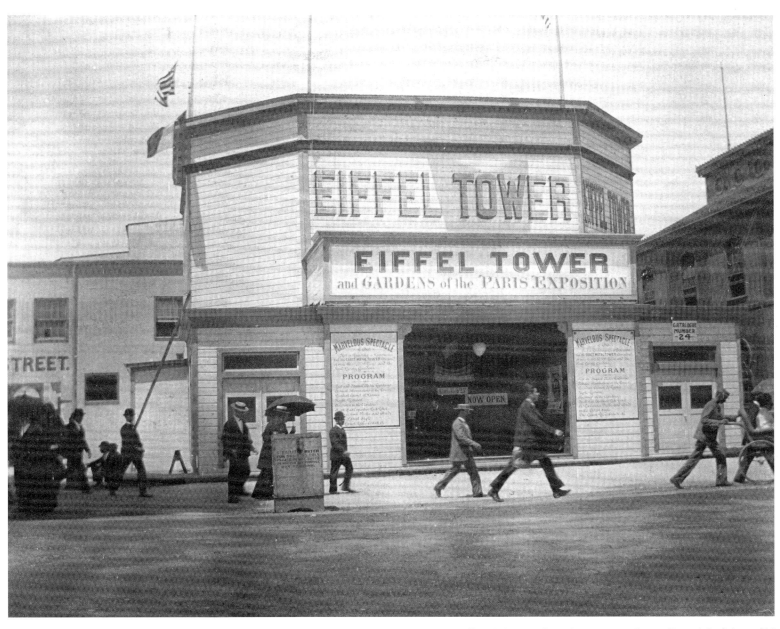

For visitors who missed the Paris 1889 world's fair, the Midway offered the next best thing—a 25-foot-tall model of the Eiffel Tower complete with working elevators and lights.

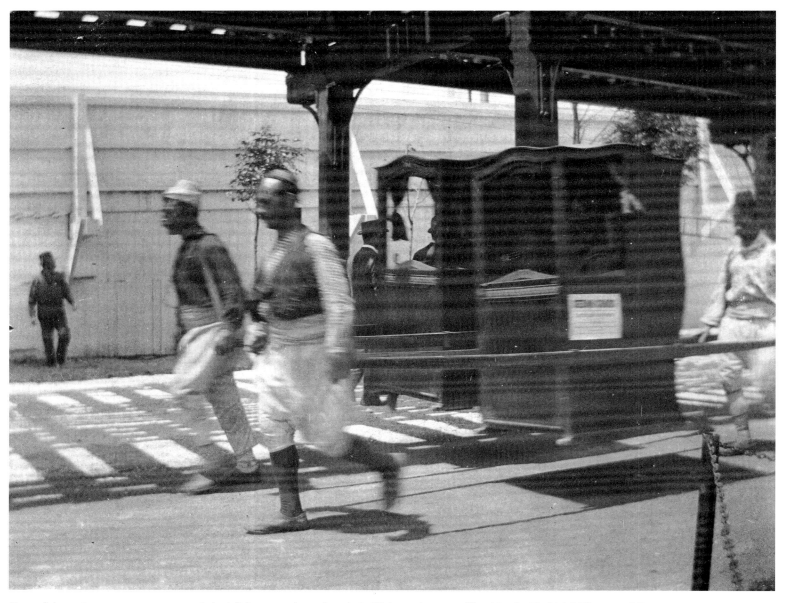

One of the unique ways to get around the Midway was by sedan chair. This service was offered in the Turkish Village, and for 75 cents, four men would race you to your destination.

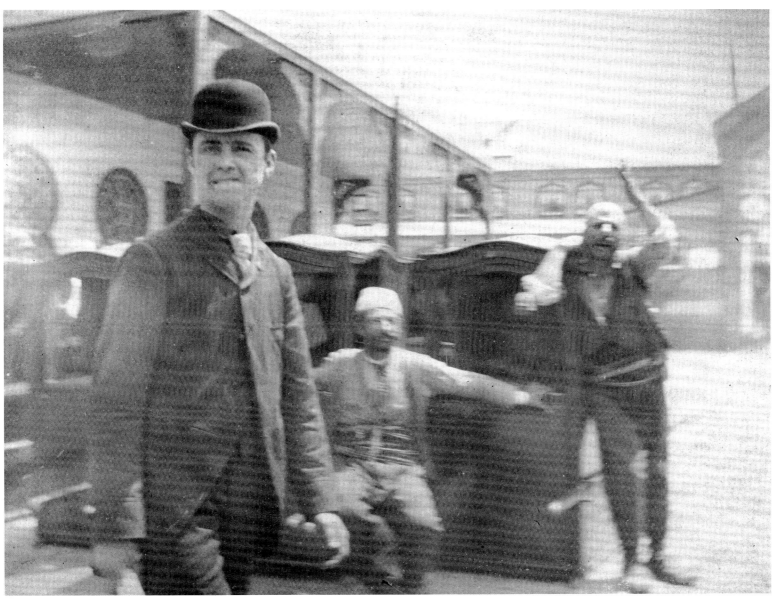

Sedan carriers, waiting for their next fare in the Turkish Village, are sharply contrasted with American fairgoers in their dress and behavior.

This amateur photograph taken in the *Streets of Cairo* captures the surprise and sometimes discomfort many Americans felt when encountering the broad range of people of color on the Midway.

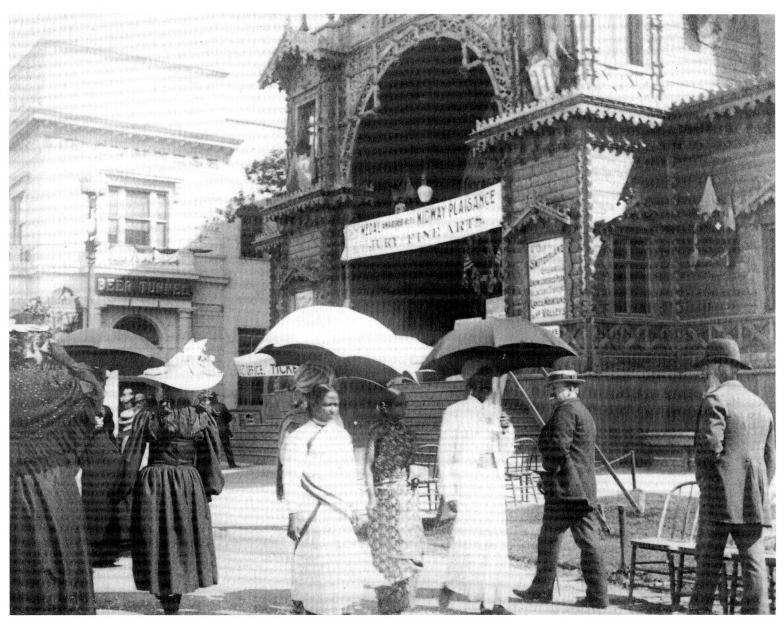

Native people in national dress walking the Midway were considered a great curiosity that elicited constant staring and attention by visitors.

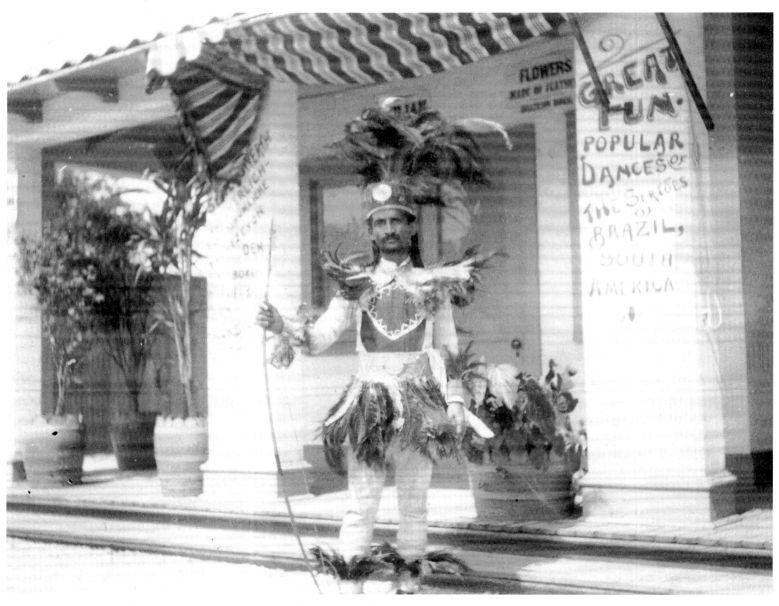

A dancer pauses to pose for an amateur photographer on his way to perform in the Brazilian Music Hall.

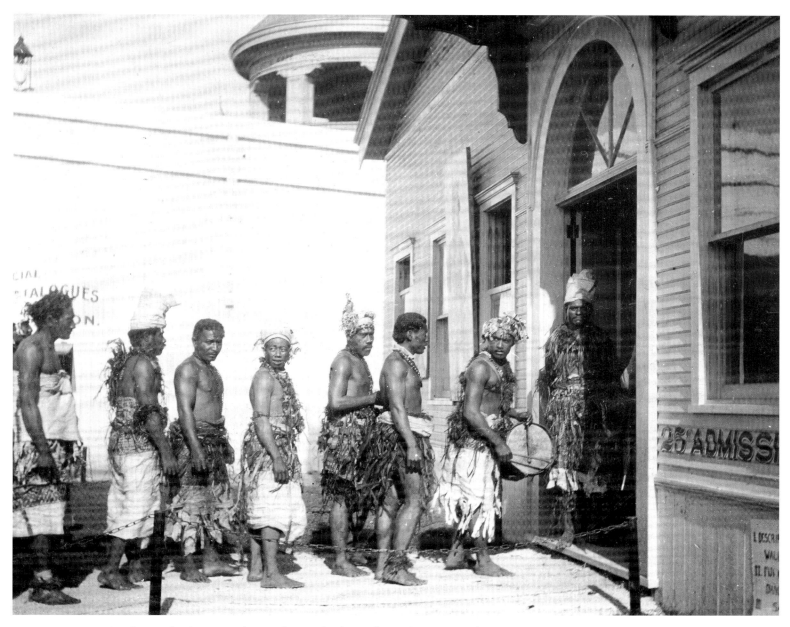

South Sea Islanders enter the South Sea Islanders Village Theatre to perform. Over 300 people resided in the fair's South Sea Island Village from the islands of Borneo, Fiji, Java, Jehore, New Zealand, Samoa, and Sumatra.

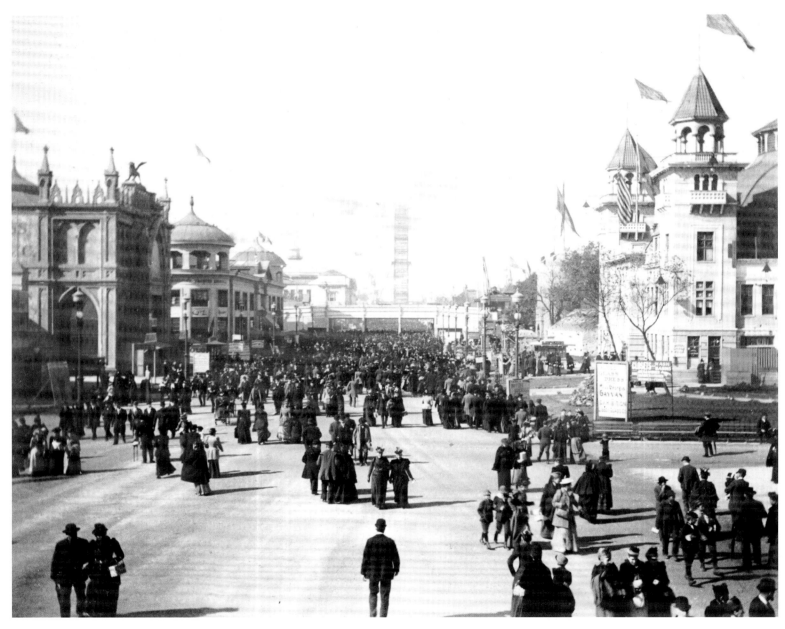

The crowds visiting the Midway made the exposition financially successful. The fair corporation negotiated lucrative concession agreements with Midway amusements, and the Midway became a model for organizing commercial attractions for all future world's fairs.

A City Beautiful

Visitors used electric launches, gondolas from Italy, and other kinds of boats to move about the fairgrounds via the connecting waterways. The intramural railway linked other key points around the perimeter of the exposition. But walking was the most popular and effective way to see the fair. Private vehicles, horse-drawn wagons, and bicycles were banned from the grounds; pedestrians felt safe and enjoyed strolling free from the commercial nuisances of the city. The captivating arrangement of the buildings, the inspiring sculptures encountered at every turn, and the well-maintained grounds convinced some visitors that a city could function efficiently and also be beautiful.

The Bureau of Public Comfort saw to the needs of the exposition visitors. It maintained clean toilets, provided first aid and medical care, and offered waiting and reception rooms, ladies' parlors, coat and package check, lost and found, barber shop and shoe shine, and telegraph services. Visitors found ample supplies of free and low-cost drinking water, as well as lunch counters and cafés with reasonable prices in most of the major buildings and on the Midway. The Columbian Guard monitored the cleanliness of the food concessions and ensured the personal safety of visitors on the fairgrounds.

Some of the most popular military bands, including John Philip Sousa's, played free concerts almost daily in the bandstands scattered on the fairgrounds. Concert orchestras and choral groups performed in the Music Hall, and the Midway featured popular as well as exotic music. Nighttime illuminations of the buildings with electrical lighting and visual effects created breathtaking spectacles. In addition to special daily events on the fairgrounds, celebration days feted different nations, states, ethnic groups, and anniversaries, including Colored People's Day on August 25 and Chicago Day on October 9, the anniversary of the Great Chicago Fire.

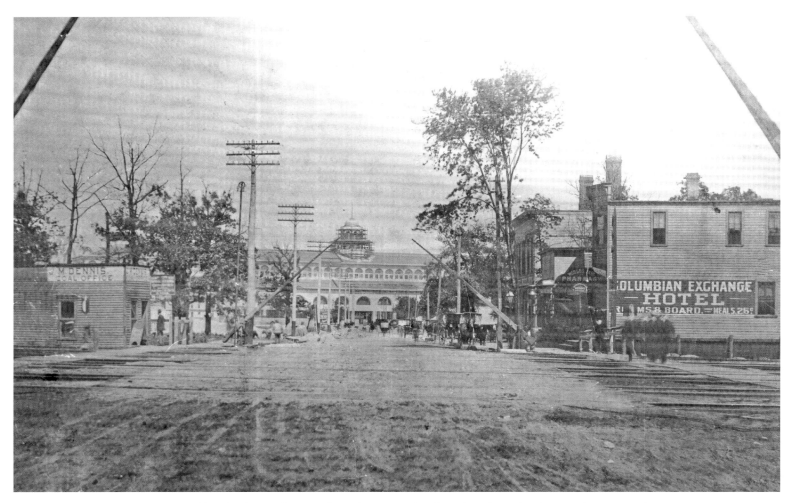

This view of the Transportation Building looks east from Hyde Park across railroad tracks. The Columbian Exchange Hotel (right) was likely one of the many speculative ventures that developed around the fairgrounds to take advantage of the crowds visiting the exposition.

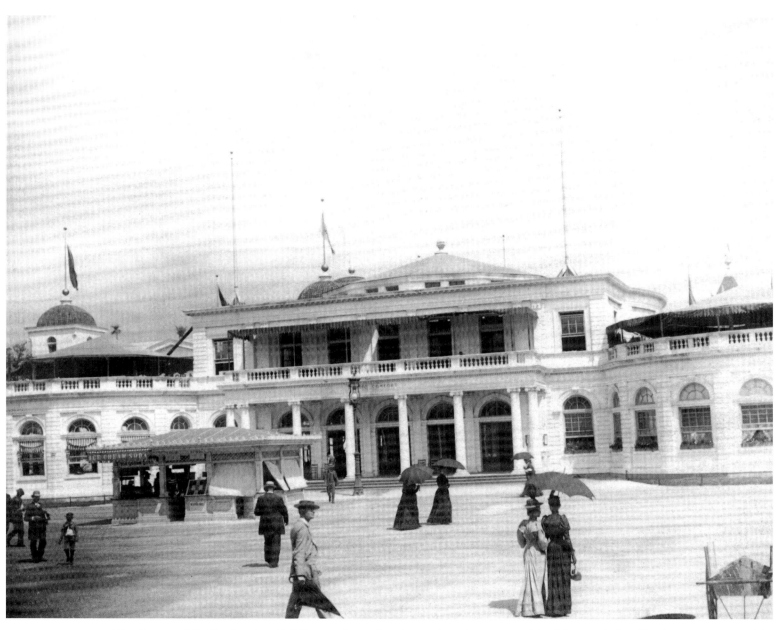

The Bureau of Public Comfort Building was located at the north-end entrance of the fairgrounds. It offered numerous amenities for visitors—including telegraph and telephone services, toilets, parlors, reading rooms, a barbershop, a check room, lost and found, and the sale of toiletries, stamps, stationery, and newspapers at a moderate price—and staff were on hand to provide information and directions. Some of the larger buildings on the fairgrounds incorporated public comfort amenities.

Members of the Columbian Guard pose in their light blue sackcloth coats trimmed in five rows of black braid with the distinctive cloverleaf knot. The 2,000 members of the Columbian Guard, an independent paramilitary exposition police force organized by fair officials under the command of Colonel Edmund Rice, performed routine police and fire patrol duties that kept the grounds secure and peaceful.

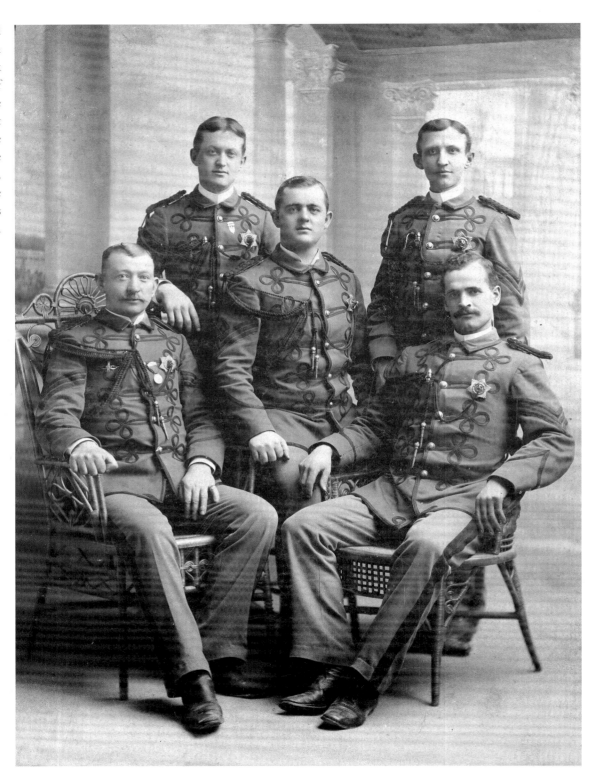

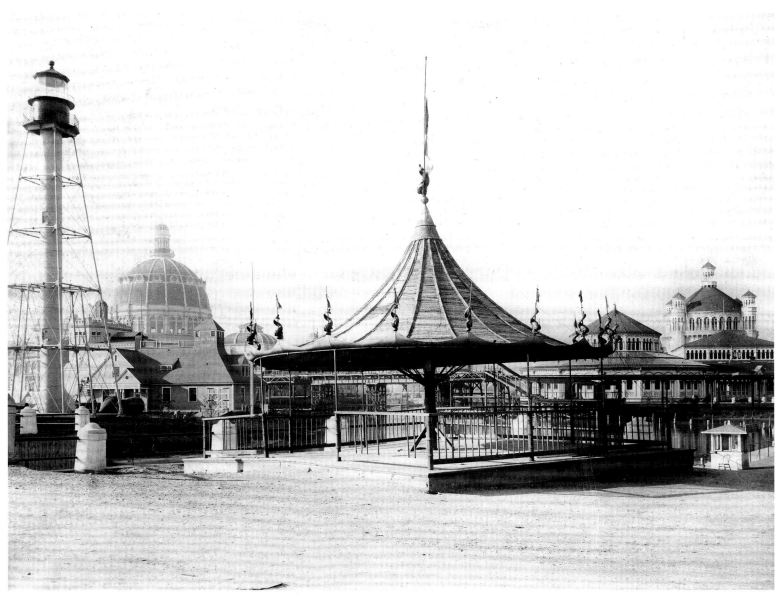

This tent structure, located near the North Inlet in the U.S. Government area, was a small but distinctive structure on the fairgrounds. Easily identified by its twisted finial and flag, the tent provided shade and was used by fair employees for multiple purposes.

The ice cream stand (left) at the west entrance to the Illinois State Building offered visitors a cold treat during the hot Chicago summer months. The Wellington Catering Company of Chicago had the concession for food on the fairgrounds, including ice cream. Wellington's food operation covered nine acres of the fairgrounds and employed a staff of 2,000.

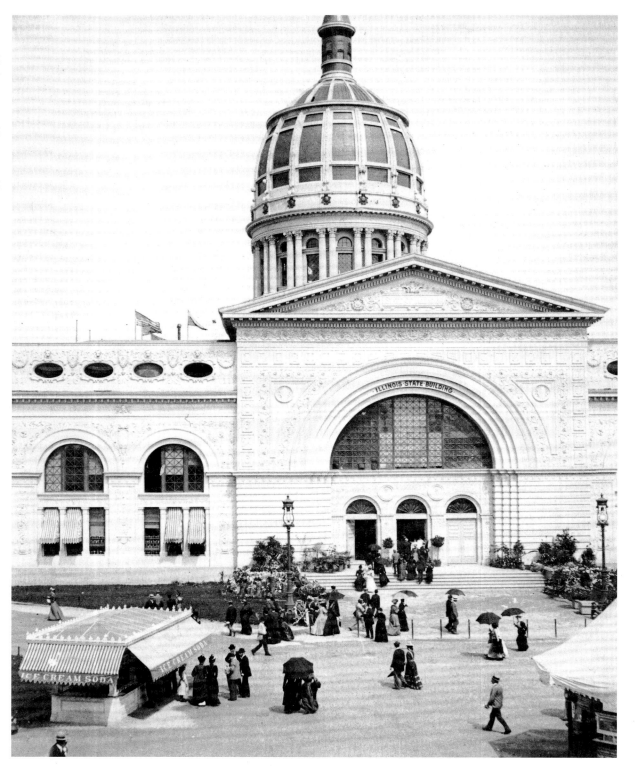

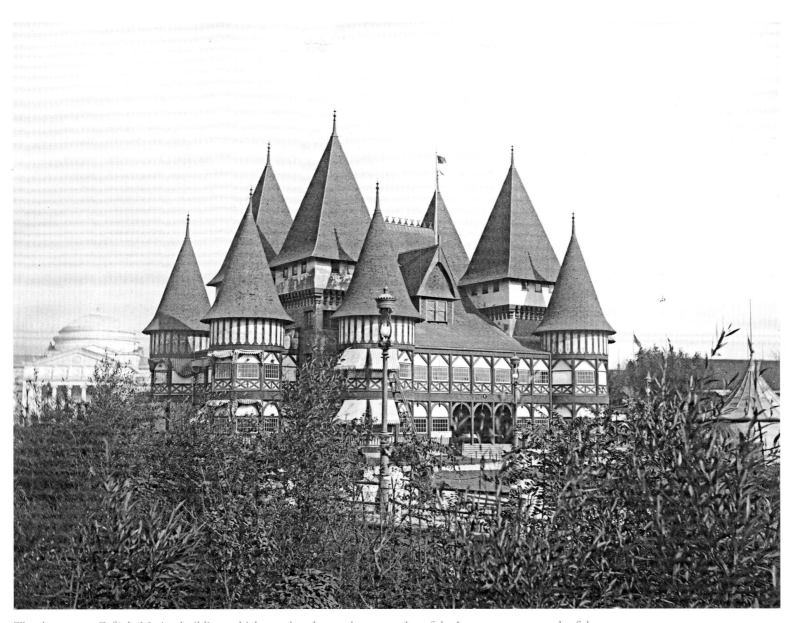

The three-story Café de Marine building, which stood at the northeastern edge of the Lagoon, was a popular fish restaurant. Other restaurants nearby—including the Japanese Tea House, the Swedish Restaurant, and the Polish Café—drew many hungry visitors to this area.

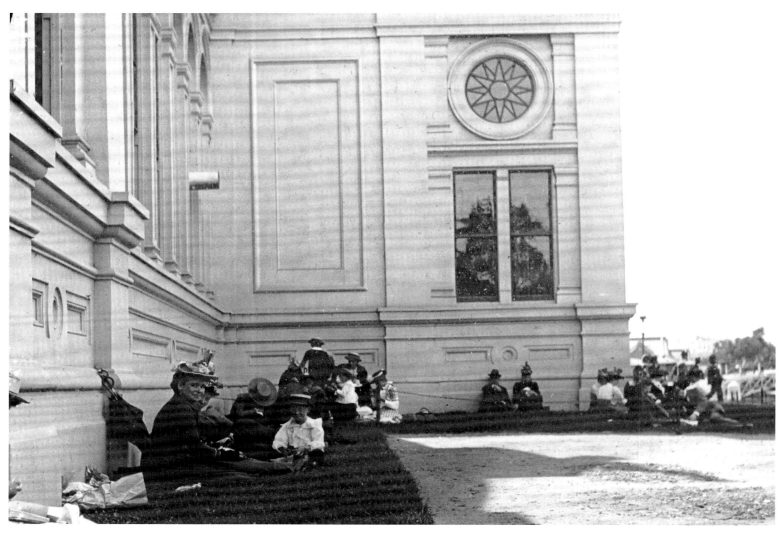

Visitors rest and eat a picnic lunch in the shade along the U.S. Government Building. Although fair officials discouraged eating and resting in non-designated areas, visitors nevertheless found convenient spots throughout the fairgrounds.

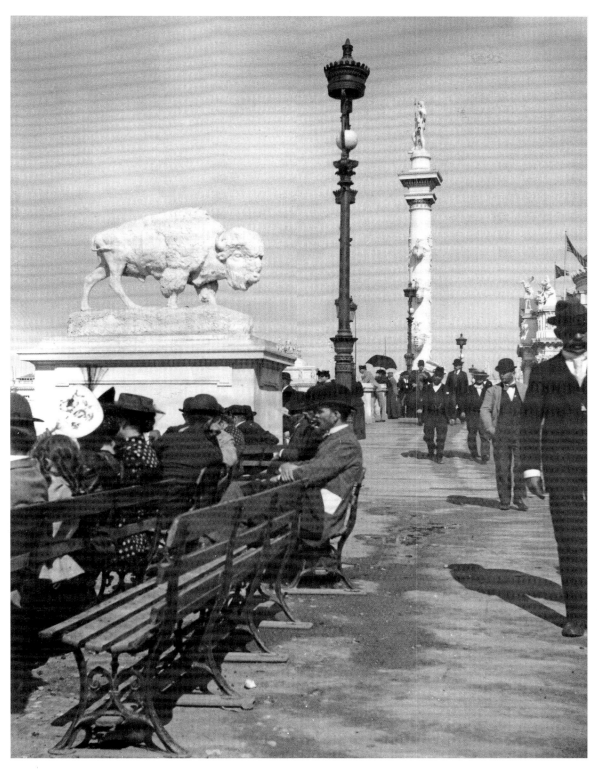

Visitors were struck by the plethora of sculpture on the fairgrounds and their easy access to it. The area around the Great Basin provided a powerful encounter with art. This buffalo by sculptors Edward Kemeys and Alexander Phimister Proctor stood at the southwest corner of the bridge over the South Canal.

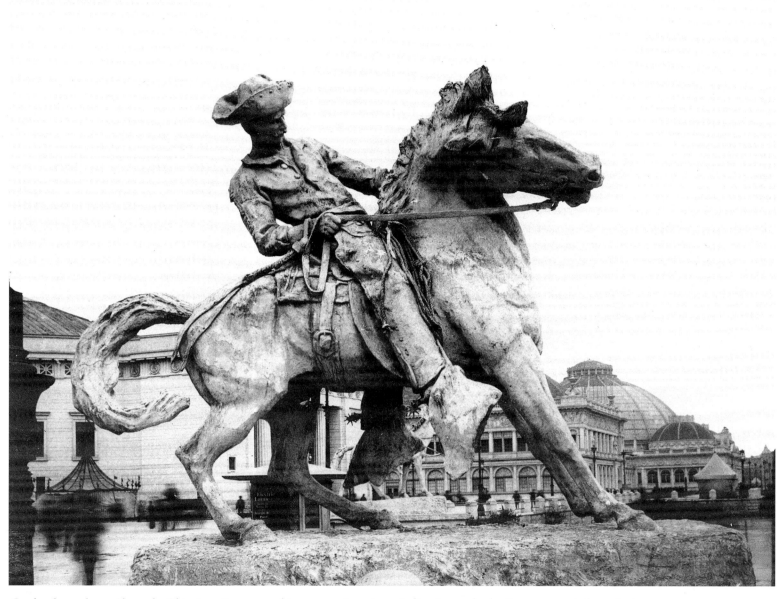

Cowboy, by sculptor Alexander Phimister Proctor, and its companion piece, *Indian Scout,* also by Proctor, stood along the Lagoon in front of the Transportation Building.

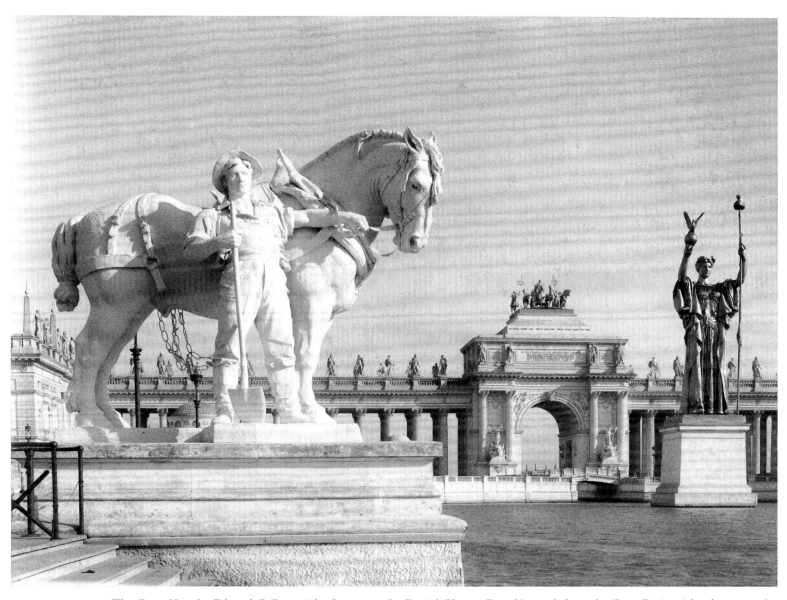

The *Farm Horse* by Edward C. Potter (the farmer was by Daniel Chester French) stood along the Great Basin with other examples of horses and an ox.

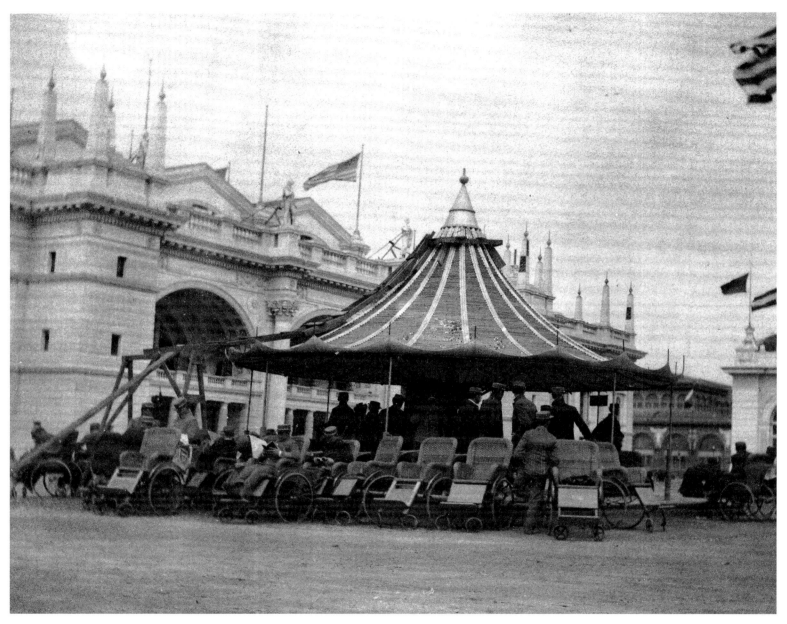

Attendants wait for customers to rent rolling chairs. A total of 2,500 Columbia rolling chairs were available from 21 pavilions spread across the fairgrounds. Visitors could rent a single chair with a guide pushing them for 75 cents an hour.

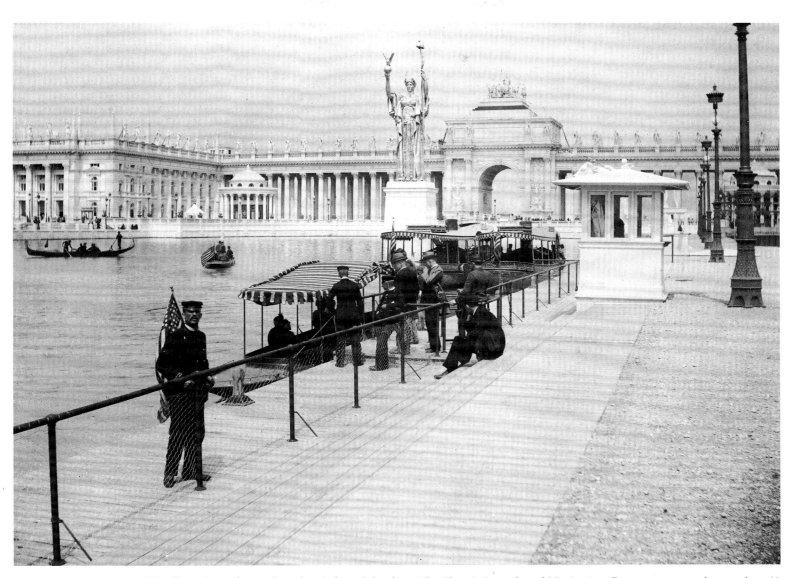

The Great Basin featured an electric launch landing. The Electric Launch and Navigation Company operated more than 40 electric launches at the fair. The three-mile circuit began in the Great Basin and ended in the North Pond at the landing on the south entrance of the Fine Arts Building. With a capacity of 24 passengers each, the electric launches, with their distinctive red and yellow awnings, were an ideal way to move about the fairgrounds and see the buildings.

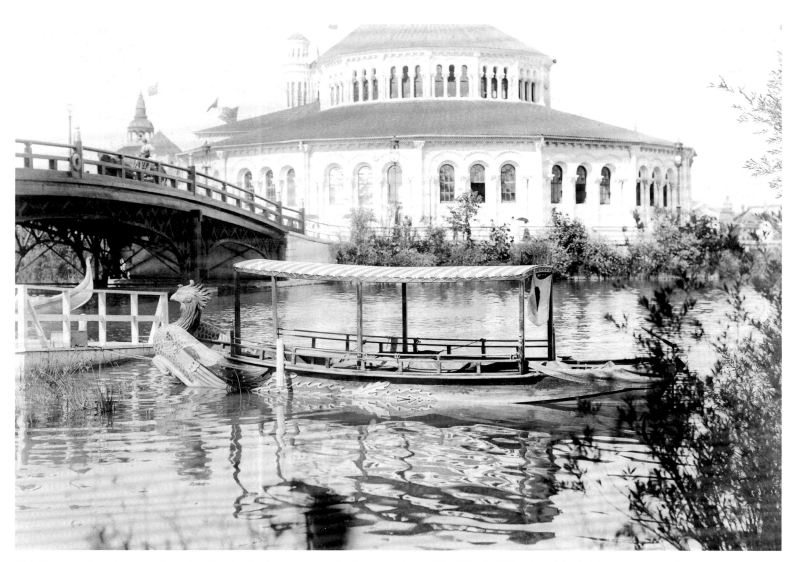

This Japanese boat is moored at a landing in the Lagoon near the Japan section of the Wooded Island and the bridge connecting it to the Fisheries Building. The boat was used for decorative and ceremonial purposes but not for regular excursions of the fairgrounds.

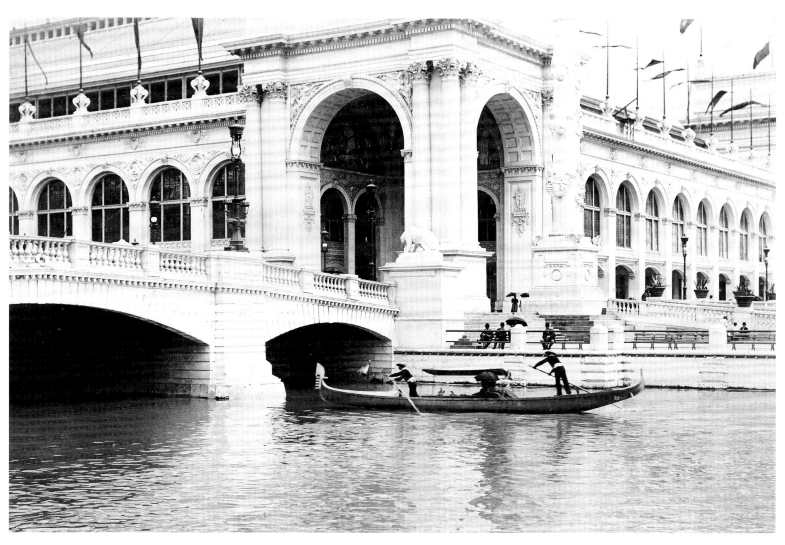

Visitors could elect a slower but more romantic journey on the fair's waterway by gondola. The Gondola Company featured 20 regular gondolas and four larger state gondolas guided by 60 gondoliers from Venice, who were attired in fourteenth-century costumes.

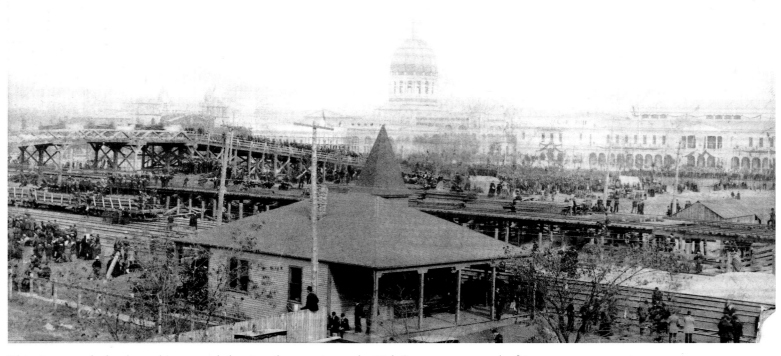

This view records the elevated intramural electric railway station at the 59th Street entrance to the fair.

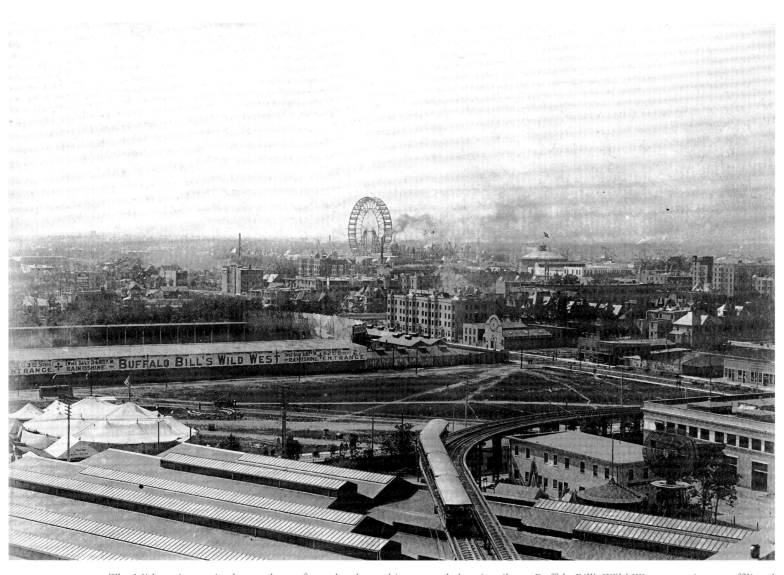

The Midway is seen in the northwest from the elevated intramural electric railway. Buffalo Bill's Wild West attraction, unaffiliated with the fair, advertises two shows daily, "Rain or Shine."

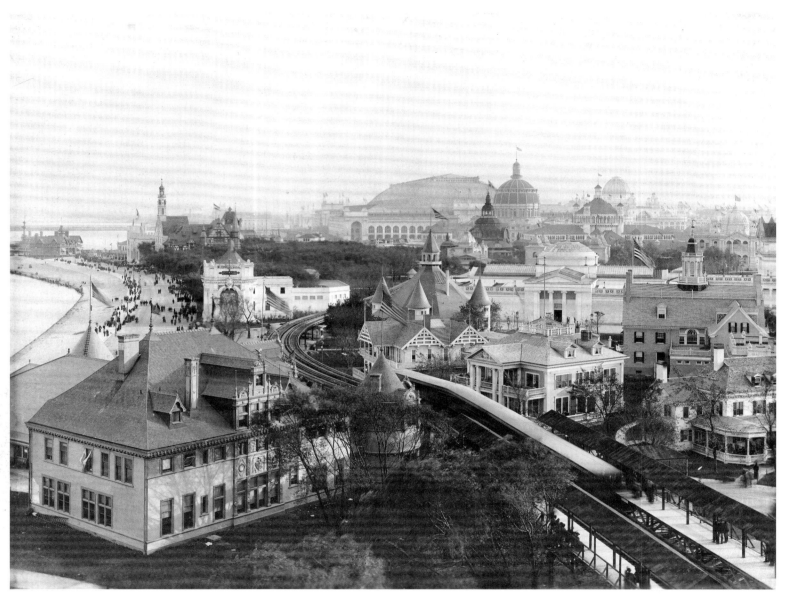

The elevated intramural electric railway snakes through the state buildings at the north end of the fairgrounds on its way to the final stop near the Fisheries Building.

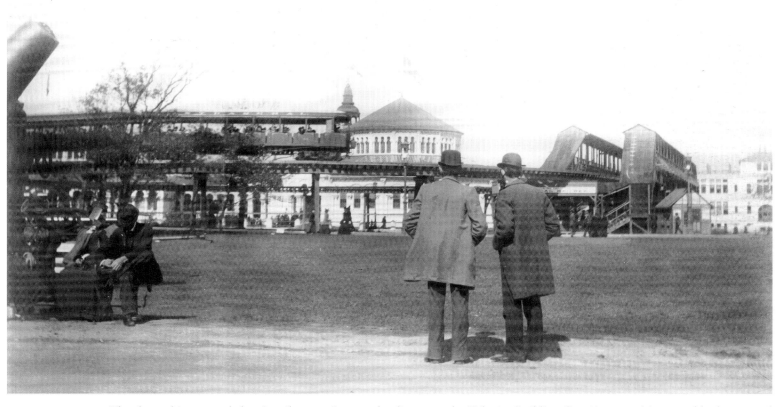

The elevated intramural electric railway station stands adjacent to the Fisheries Building. For 10 cents, visitors could take a round trip from the ethnographical exhibits near the South Pond to the Fisheries Building and the North Inlet.

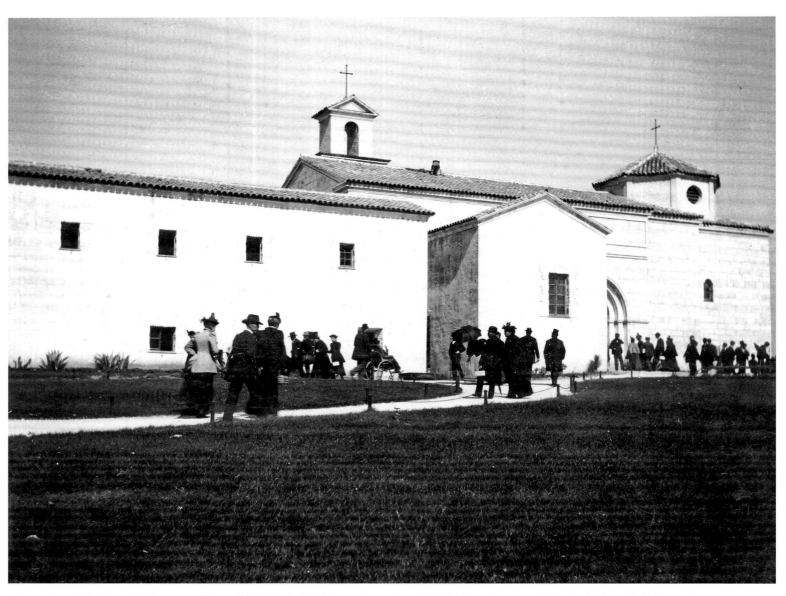

The replica of the Spanish Convent of Santa Maria de la Rabida was located on the lakeshore just east of the Agriculture Building and just south of the Casino Building. Columbus stayed at the convent while his three-ship expedition to the New World was readied at a nearby port. Fair visitors could see the most important Columbus artifacts and documents on display in the replica convent.

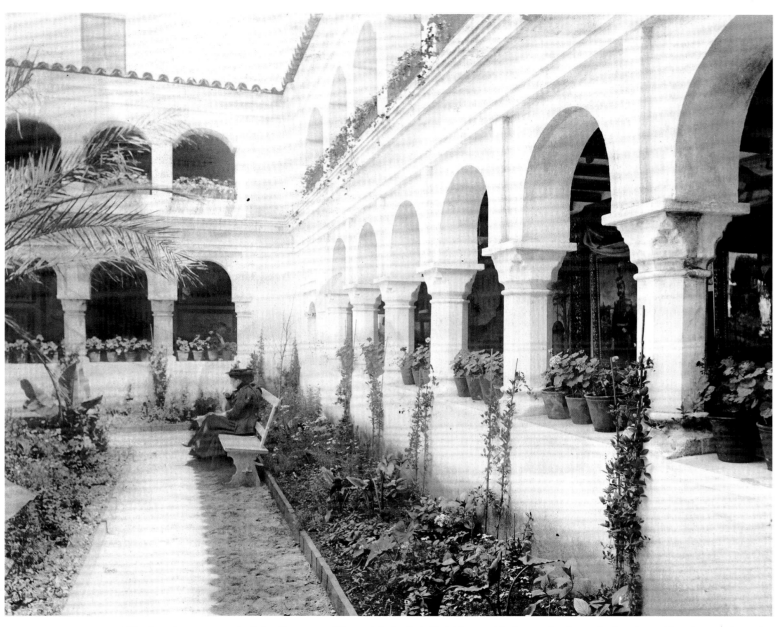

The interior courtyard of the Convent of Santa Maria de la Rabida provided a respite from the hustle and bustle and the noise of the fairgrounds.

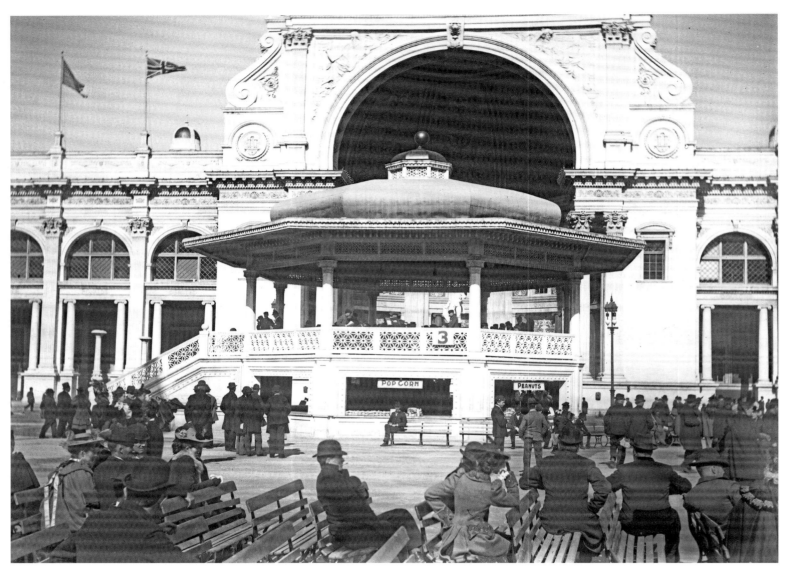

The bandstand and concession stand were built directly in front of the Electricity Building. Bands performed popular music in daily and evening concerts in a variety of fairground settings, including these bandstands. John Philip Sousa was a popular performer at the fair.

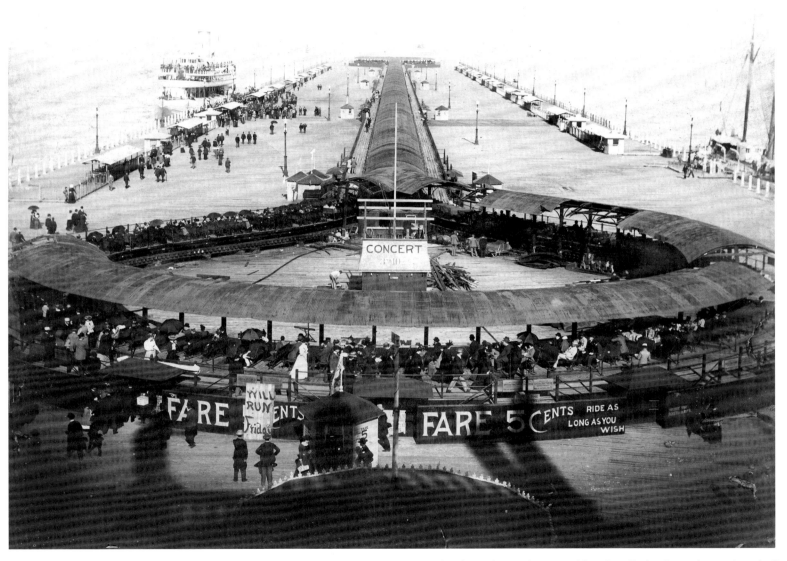

The Park Haven Pier, which measured 250 feet wide by 2,500 feet long, featured a moveable sidewalk that looped at each end of the pier. Bands seated inside the west loop played popular music concerts.

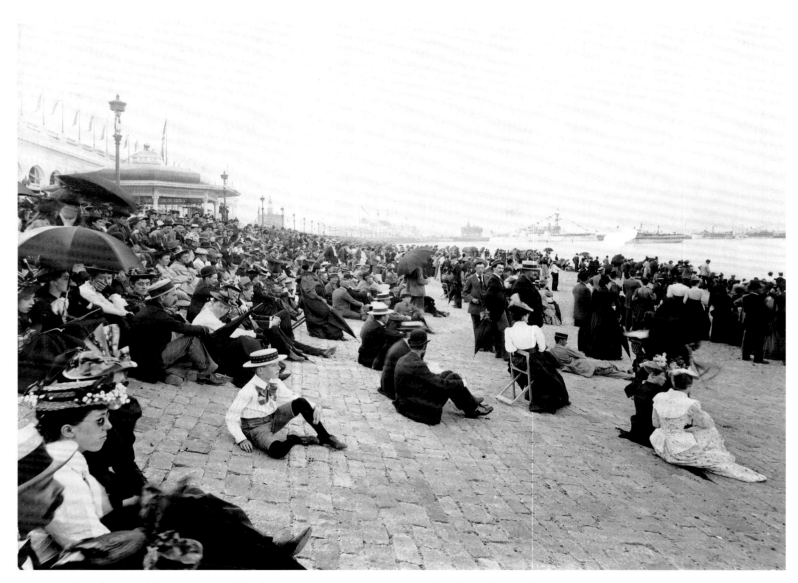

Visitors gather along the lakeshore edge of the fairgrounds to watch the arrival of the Spanish caravels. Hats and sunglasses helped keep the summer sun at bay.

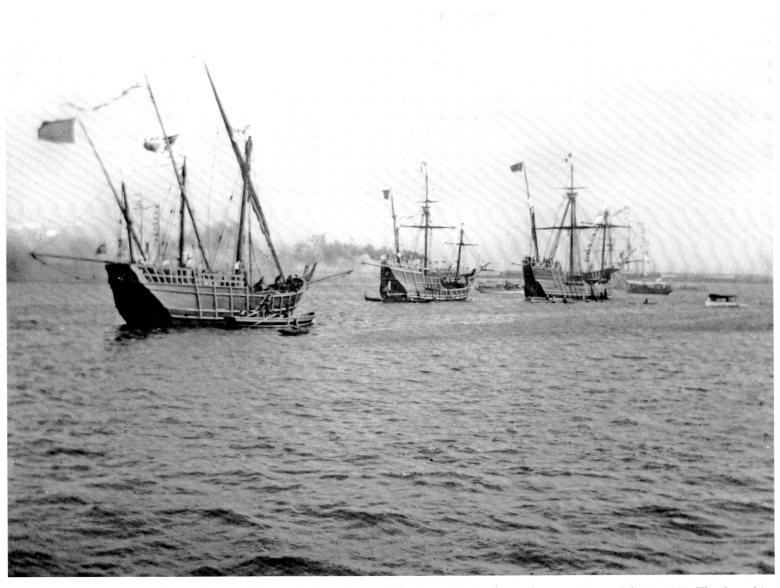

Replicas of the Spanish caravels *Niña, Pinta,* and the *Santa Maria* arrive at the exposition on July 12, 1893. The three ships dropped anchor behind the Agriculture Building and adjacent to the Convent of Santa Maria de la Rabida.

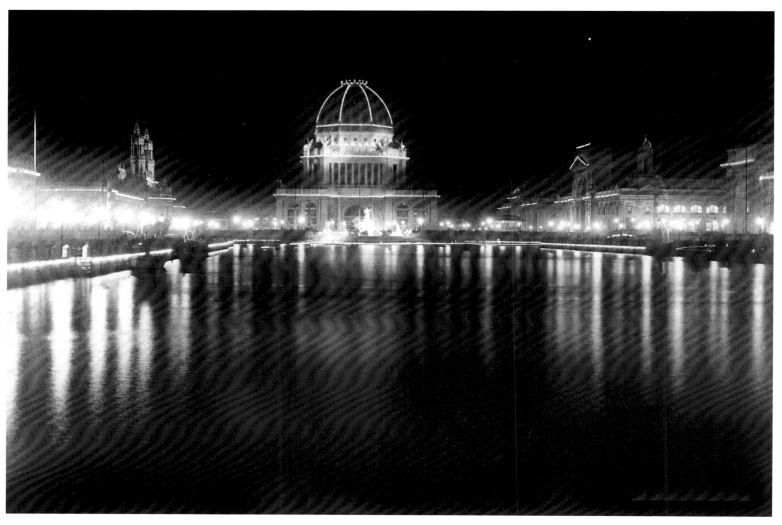

The Court of Honor is illuminated at night by electricity. The Columbian Exposition was the first electric world's fair in history. Strings of incandescent electric lights and searchlights mounted on top of buildings created an incredible nighttime spectacle for visitors, and served as a memorable demonstration of the power of electricity.

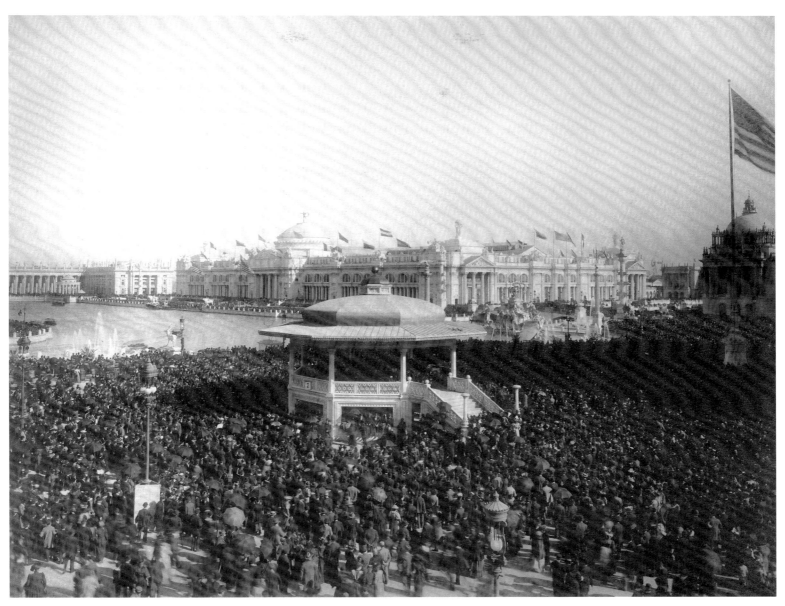

On October 9, the 22nd anniversary of the Great Chicago Fire, crowds jammed the bandstand area on the north side of the Columbian Fountain for the Chicago Day celebration. A total of 716,881 people flooded Jackson Park to acknowledge and celebrate the city's progress following its fiery destruction.

Smoke billows from the tower of the Cold Storage Building on July 10, 1893. One of the largest utility buildings on the fairgrounds, the Cold Storage Building was called the world's largest refrigerator. Twelve firefighters perished in the blaze, as well as two storage employees.

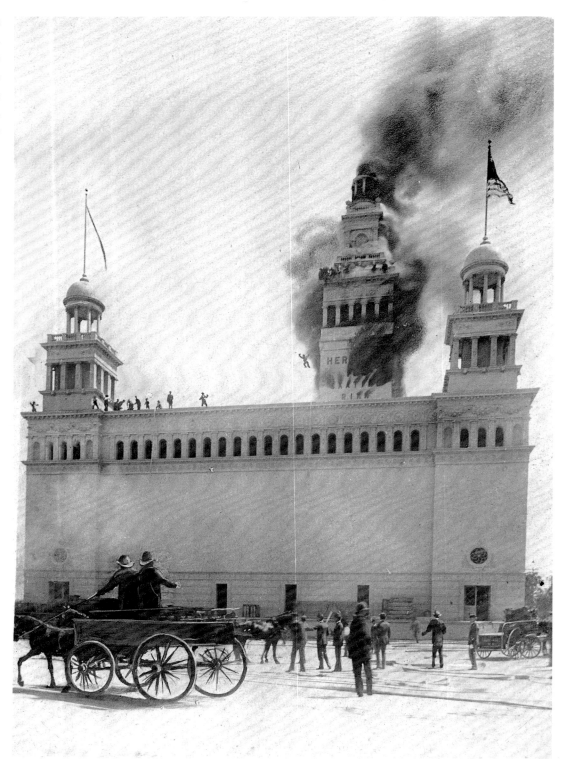

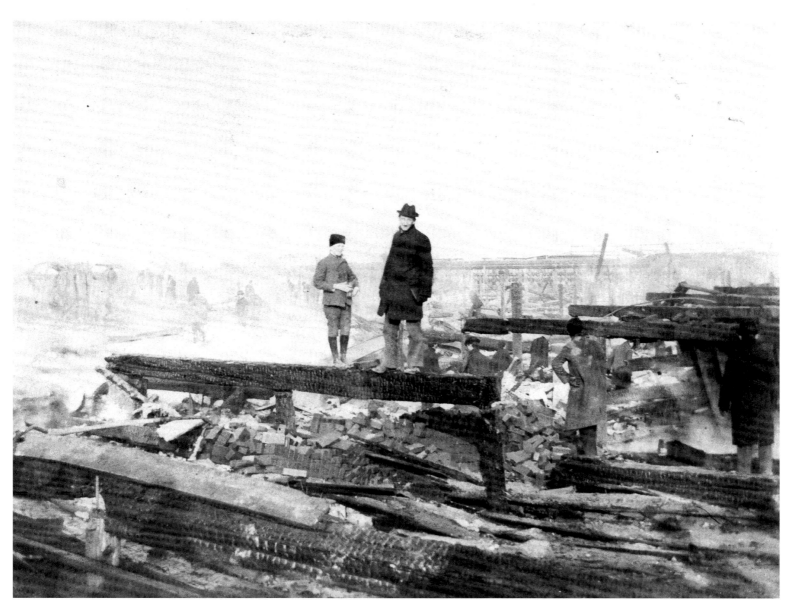

After the exposition closed on October 31, 1893, the fairgrounds were plagued by a series of fires. A major fire destroyed many of the buildings around the Court of Honor on January 9, 1894, including the Music Hall.

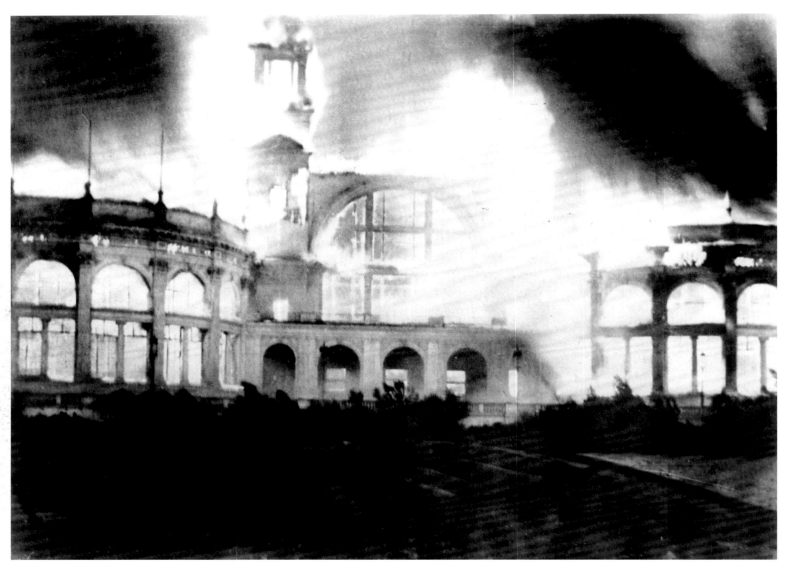

Two additional fires in February and July of 1894 consumed the Colonnade and the remaining Court of Honor buildings, leaving much of the fairgrounds in ruins.

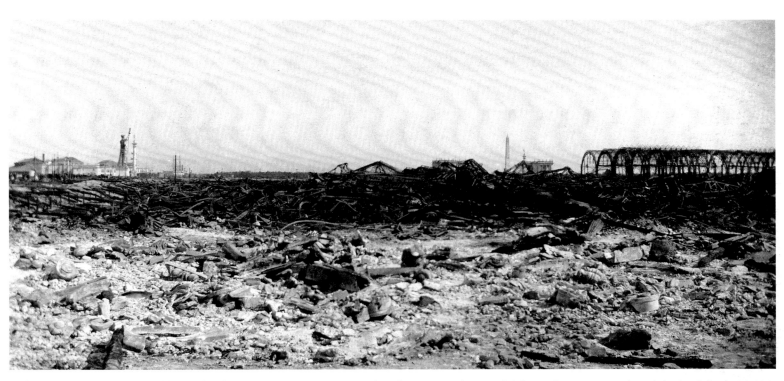

The World's Columbian Exposition is in ruins. The Chicago Wrecking and Salvage Company purchased the land for $100,000.

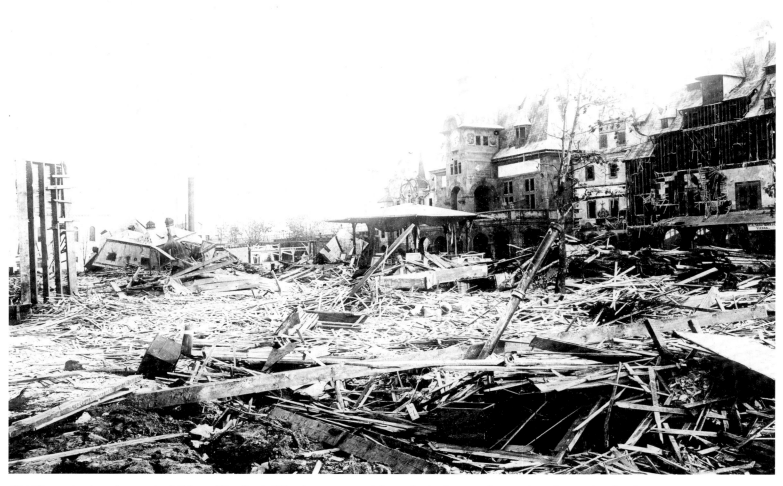

Old Vienna lay in ruins on the Midway. The Ferris Wheel was removed from the Midway and erected on the north side of Chicago, where it operated until it was dismantled and shipped to St. Louis for the 1904 world's fair.

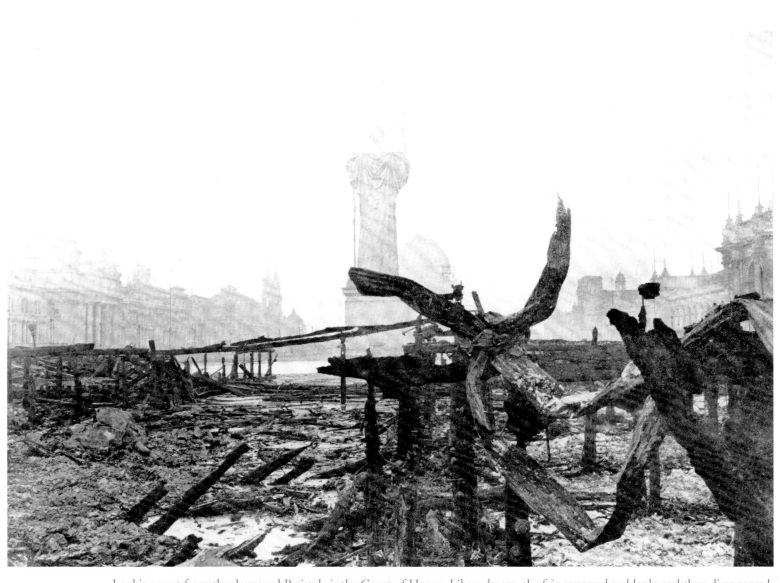

Looking west from the destroyed Peristyle is the Court of Honor. Like a dream, the fair appeared suddenly and then disappeared.

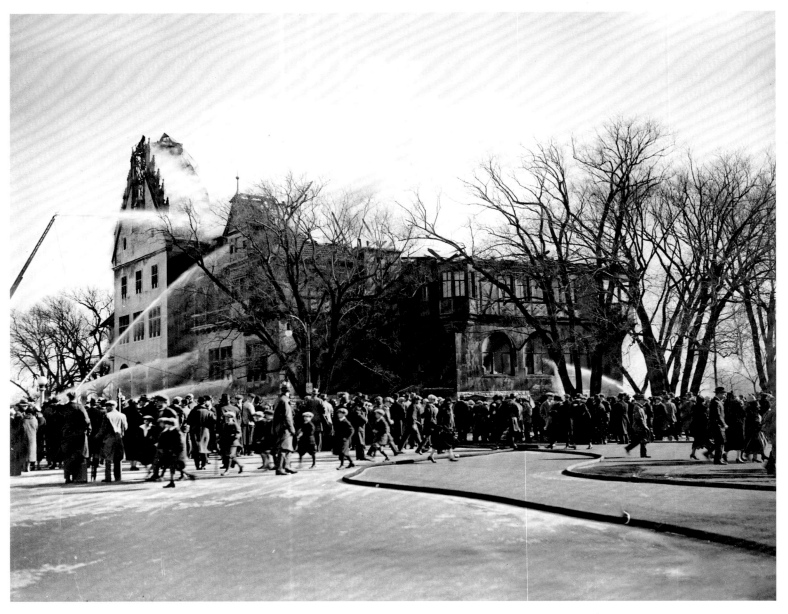

The Germany Building stood in Jackson Park until fire destroyed it on March 31, 1925. The only fair building still standing in Jackson Park is the Fine Arts Building, which is now home to the Museum of Science and Industry.

Notes on the Photographs

These notes, listed by page number, attempt to include all aspects known of the photographs. Each of the photographs is identified by the page number, photograph's title or description, photographer and collection, archive, and call or box number when applicable. Although every attempt was made to collect all data, in some cases complete data may have been unavailable due to the age and condition of some of the photographs and records.